The Nikon Field Guide

A Photographer's Portable Reference
Second Edition

by Thom Hogan

SILVER PIXEL PRESS®

The Nikon Field Guide
A Photographer's Portable Reference
Second Edition

Second printing 2001
Published in the United States of America by
Silver Pixel Press®
A Tiffen® Company
21 Jet View Drive
Rochester, NY 14624
www.silverpixelpress.com

ISBN 1-883403-58-8

©2000 Thom Hogan
All Rights Reserved
Printed in Belgium
Creative photography ©Thom Hogan
Product photographs © Silver Pixel Press

Library of Congress Cataloging-in-Publication Data
Hogan, Thom, 1952–
 The Nikon field guide : a photographer's portable reference/
 by Thom Hogan.—2nd ed.
 p. cm.
 ISBN 1-883403-58-8 (pbk.)
 1. Nikon camera Handbooks, manuals, etc.
 2. Photography Handbooks, manuals, etc. I. Title.
TR263.N5H53 1998
771.3'1--dc21 99-36397
 CIP

Contents

Contents

Introduction

Photographers are always learning. Every day we learn something new about the nature of light, the equipment we use, the way the film we use reacts to certain situations, and how others we meet in the field handle similar situations. Every roll of film we shoot tells us something new, too. What we think we've captured in the field often turns out to be something different when viewed under a loupe in the light of a slide box.

It is hard to remember techniques you don't use very often, so experimenting in the field can be difficult. I have often been out on a shoot after a month-long hiatus only to forget the reciprocity characteristics of the film I'm using, the factor for the filter I'm using, or how to set my Speedlight to a particular fill-flash setting. In such cases I eventually remember the answer or bracket my exposures and techniques to try to ensure I get an acceptable shot, but I never know quite what I've gotten until the film comes back from the lab.

Over the years I've collected numerous notes, reference articles, and data from a wide variety of sources. But no matter how good that information is, it doesn't do me any good sitting in my office. I need it when I'm in the middle of the Okavango Delta knee-deep in water trying to take a picture of a monitor lizard and unable to remember what the hyperfocal distance is for my wide-angle lens set at f/11.

Not long ago I looked at my notes, camera manuals, book-shelves, and files and thought, "What if I could take all this information with me?" I'd be able to look up the solution to a problem I was facing or verify my memory of a particular fact. This book is a product of that need. You'll find several key areas covered here:

- Exposure guidelines and shortcuts
- Filters and special effects
- Photographing outdoors
- Macro photography calculations
- Lenses and teleconverters
- Instructions for the SB-28, SB-27, SB-26, and SB-25 Speedlights
- Instructions for the F100, F5, F4, N90s/F90X, N70/F70, N60/F60, and FM2n cameras
- Useful photography-related equations
- Field kit lists and model releases

Some of this information is absolute and factual, such as the camera instructions and many of the tables. Other data are subjective, such as the exposure information. Still other information is simply idea-provoking, such as the posing and shot idea sections.

For convenience, I've specified all data for ISO 100. If you use a different ISO speed regularly, just grab a pen and convert all the relevant data, or remember to make the adjustment in the field.

Don't be afraid to customize the information to reflect your tastes or knowledge. For example, the exposures I've given for lightning are a little less than those recommended by some other sources and vary depending upon the distance you are from the lightning. That's because most lightning pictures I've seen overexpose the lightning, and thus much of the subtlety of the strike is lost, especially if you're close to the strike. But maybe you like the overpowering force conveyed by the overexposed bolt. That's fine.

You can use this book in four ways:

1. *During downtime out in the field, browse through the book and look for ideas.* By drumming this information deeper into your subconscious, you won't have to look it up next time.

2. *When a question comes up in the field, look up the answer.* If the answer isn't here, write the question down so that you will remember to research it later.

3. *Back home, research answers to those questions that came up in the field.* Add new information to this book based upon your field notes, information you've learned from others, and articles or books you've read.

4. *Before heading out to another shoot, check your equipment bag against the field checklists in this book to make sure you're not forgetting anything important.* Remember to update your personal equipment table with any new equipment you purchase.

And the learning continues, thanks to all the readers who sent in additions and corrections for this new edition. If you have information you'd like to see expanded, changed, deleted, or added, let me know. You can write to me care of Silver Pixel Press, or send me e-mail at: thom_hogan@msn.com Also, be sure to check my website www.bythom.com for the latest Nikon information and reviews of significant Nikon products.

May all your exposures be perfect and your depth of field infinite. —teh

Shooting Tips

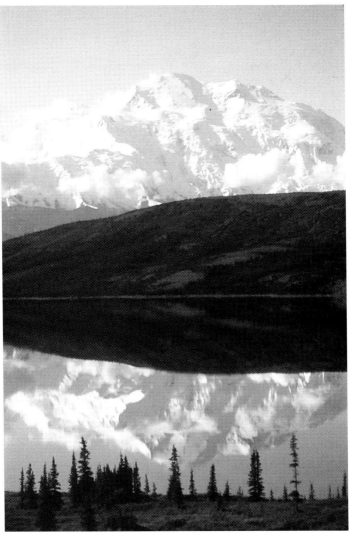

Scenes containing both extremely bright and dark areas can pose difficulties in setting exposure. For this shot of Mt. McKinley, I chose to let the land in the foreground and middle ground go a little dark rather than lose detail in the mountain and its reflection.

Pre-shoot Checklist

- Check batteries (camera, flash, etc.); replace those that are old or near-dead.
- Check film load status; finish current roll, if possible.
- Check and clean camera.
- Load camera with film; check for proper loading, check for proper ISO setting.
- Pack camera bag (see "Field Equipment List" on page 251). Don't forget the survival and emergency essentials.
- Let someone know where you're headed.

Warm-up Times for Cold Film

Film needs time to adjust to severe temperature changes. For a 25° F (10–15° C) temperature rise (typical for film stored in a refrigerator), do not open the film's vapor-tight packaging for one hour. This prevents condensation of moisture on film surfaces. Add another hour if the film was stored in a freezer.

Self-Assignment Ideas for the Field

A day in the life of...

Tell a story (pretend you're a photojournalist)

Selective focus

Letters or numbers

Closer looks

Self-portrait

Scale (large vs. small)

View from the ground

View from above

Textures or patterns: Irregular, regular, progressive, symmetrical, flawed (missing element), natural, manmade

Try a different film or processing method

Moods, atmosphere

Color: Accent, monochrome, intensity

People interacting with the environment
People at work

Keeping Steady

• Brace yourself against a tree, pole, or other solid object.

• Sit down. Brace your elbows on your thighs.

• Lie on the ground and brace your camera on your pack.

• Put the camera on a stable surface—fallen tree trunk, stump, rock, ground, etc.—and use a self-timer or remote release to trigger the shutter.

• Use a beanbag or a crumpled up heavy sweatshirt or jacket to support your camera and/or lens.

• Use two sticks or two ski poles in an X, and brace the lens in the top portion (V) of the X.

• Hang a weight from your tripod to increase its steadiness.

• Avoid extending the center post of your tripod. Some professionals remove it completely, saving a bit of weight in the process (go to your local hardware store and buy an appropriate bolt and washer to hold the tripod head in place).

• When shooting from the car, turn off the engine! Ask passengers to keep still. Park out of direct wind or airstream generated by passing vehicles.

• Note that camera vibration (mirror-slap) is most prevalent at shutter speeds of 1/8 to 1/30 second. Avoid those shutter speeds whenever possible, or use the camera's mirror lock-up facility.

Posing

Things to consider:
• Direction of gaze—Left, right, up, down, head-on.

• Eye contact—Have the subject look away, then look back at the camera (this prevents the subject from staring).

• Head and shoulder orientation—At an angle to the camera; head-on; model looking back at the camera.

• Expression—Smiling, pouting, grinning.

• Body position—Standing, sitting, crouching, lying; stiff, loose.

- Chin position.
- Hands—Not in front of the face! Holding back hair; hand holding chin; closed hand on one side of the face; hand resting near the mouth, relaxed; open hand on the side of the face (index finger up, thumb below ear).
- Props—Consider the mood you're after.
- Clothing—Color!
- Look for triangular relationships and use them—Face, hands.

Exposure Rules of Thumb

"Sunny 16" Rule

The Sunny 16 Rule is one of the most basic rules for determining exposure. If your meter is broken, this formula gives you a place to start. It states: When shooting a frontlit, average subject in bright midday sunshine on a cloudless or nearly cloudless day, set the aperture to f/16 and use the reciprocal of the film speed as the shutter speed.

Daylight Exposure = $\dfrac{1}{\text{ISO}}$ second at f/16

What follows are some typical adjustments from that rule during the day (– means close down to a smaller aperture; + means open up to a larger aperture).

Lighting Conditions	Exposure Adjustment
Snow or white sand	–1 stop
Bright sun on snow or sand	–2 stops
Clear, sunny day	0 stop
Light haze	+1/2 stop
Weak sun (soft shadows)	+1 stop
Heavy haze	+1 stop
Thin, high clouds	+1-1/2 stops
Bright, but cloudy day	+2 stops
Cloudy (no shadows)	+2 stops
Open shade	+3 stops
Moderately overcast	+3 stops
Heavily overcast	+4 stops

Lighting Conditions	*Exposure Adjustment*
Sidelight	+1 stop
Backlight	+2 stops
Subject against light background	+1 to 2 stops
Subject against bright, predominant sky	+1 to 2 stops
Subject against dark background	−1 to 2 stops
Subject lighter than normal	−1 stop
Subject darker than normal	+1 stop

Sunsets

Set the shutter speed at the reciprocal of the film speed (1/ISO) and the aperture at f/8 or f/11. Or spot meter an area of sky just to the side of the sun (excluding the sun from the reading area). These guidelines assume that you want to silhouette any objects in the foreground.

The highlight of an out-of-focus sun behind a silhouette will take on the shape of the lens diaphragm (hexagonal, typically) unless you shoot wide open.

Snow

When your subject is on a large area of snow in sunlight (e.g., a skier on a slope), meter normally, and try setting your exposure compensation at 2 stops of overexposure to make sure the snow is rendered white.

Underwater

To take a non-flash photo of an underwater subject, take an incident light meter reading above the water's surface, and adjust the aperture as follows:

Depth of Subject	*Aperture Adjustment*
Immediately under the surface	+1-1/2 stops
6 feet (2 m) underwater	+2 stops
20 feet (6 m) underwater	+2-1/2 stops
30 feet (10 m) underwater	+3 stops
50 feet (16 m) underwater	+4 stops

Aerial Views

Use the "Sunny 16" Rule and adjust the aperture from the surface exposure reading as follows:

Altitude	Aperture Adjustment
2,000 feet (~700 m)	−1/2 stop
4,000 feet (~1,500 m)	−1 stop

- Use shutter speeds faster than 1/250 second at altitudes above 1,000 feet (~300 m).

- Use shutter speeds faster than 1/500 second at lower altitudes.

- In general, the faster the shutter speed, the sharper the image you'll get, so always use your fastest lens and consider using higher ISO film.

- Shoot aerial photographs during early morning or late afternoon. During midday, the high sun reduces shadows and apparent image depth.

- You won't need really wide or really long lenses. An 85mm f/1.4 or f/1.8 lens is often perfect for most uses and allows you to keep the plane's wings out of the picture. To include part of the plane in the picture, often a 28mm is all that's needed.

- Prepare to compensate for window color (especially Cessna single-engine planes, whose windows tend to have a greenish cast; I've found a Tiffen fluorescent filter [FLD] compensates well for this).

- Use a UV or skylight filter to reduce blue haze when using color film.

- Use a #15 yellow filter to reduce haze when using black-and-white film.

- Bring a large piece of black fabric to shade the window (and wear black clothing) if you need to shoot through the windows, otherwise you're likely to record your own reflection.

- DO NOT brace yourself against the plane, as the vibrations will make your picture unsharp. Tuck your arms in at your sides and brace the camera against yourself. The only alternative to handholding the camera is to use a commercial gyroscopic mount.

Simple Color Zone System

This system can be used *for slide film only*. Meters read what is known as a "medium" value, creating a correct exposure for a subject that is 18% gray. But most subjects reflect more or less light than 18% gray. Ansel Adams developed the zone system as a way of producing repeatable, consistent results. Adams' original zone system was designed for black-and-white negative film and required users to do their own processing and make a number of calibration tests before using it.

Many attempts have been made to convert Adams' original system to color photography. The table that follows has been derived from my experience with color slide films, which have the ability to capture about five stops of detail, from lightest to darkest. I make no claims that this is a "perfect" system. And it might not work for you due to variations in processing and other subjective variables. I present it here as a starting point for you to think about when determining exposure for a scene.

Exposure	*Object Reflectivity*	*Zone*￨	*Example*
+2-1/2 stops	White, textureless	IX	Broad expanse of snow (overcast)
+2 stops	White with little detail	VIII	Textured snow, sand dune
+1-1/2 stops	Very light color	VII	Birch bark
+1 stop	Light color		Khaki skirt
+1/2 stop	Near-gray value	VI	Caucasian skin in sun
0	Gray	V	Most grass, green leaves
–1/2 stop	Near-gray value	IV	Caucasian skin in shadow
–1 stop	Dark color		Animals with dark hide, e.g., a hippopotamus
–1-1/2 stops	Very dark color	III	Dark shadows with texture, e.g., pine tree bark
–2 stops	Black with little detail	II	Fur on a black cat
–2-1/2 stops	Black, no detail	I	Night sky

*￨Each zone designation is an arbitrary number assigned to a

particular film density, black being zone I (high density) and white being zone IX (low density). Because the zone system was developed and calibrated for black-and-white negative film and does not translate perfectly to color slide film, the numbers in this chart are only approximations.

Slide film has only about five stops of tonality. The trick is to adapt your vision and metering techniques to this limited range. Here are some recommendations for setting exposure:

- I'll meter off grass or average green leaves, which have 18% reflectance (like a gray card), and set that as my exposure value.

- I'll spot meter off my hand and open up the lens a half stop. (**Note:** Your skin may not be as fair as mine, so you'll need to experiment to see where you skin tones fall vis-à-vis 18% gray reflectance).

- I'll spot meter the brightest highlight in a scene in which I want to have some detail and open up exposure by 2 stops.

- I might meter the snow and decide whether I want it to have no detail (+2-1/2 stops), a little detail (+2 stops), or a fair amount of detail (+1-1/2 stops).

- I'll spot meter the darkest shadow area in a scene in which I want to have some detail and close down the exposure by 2 stops.

- I'll spot meter a dark-colored animal and close down a half or a full stop, depending upon the animal (a half stop for an elephant, a full stop for a hippopotamus, for example).

Sometimes I meter two or more of the above examples. I look for the brightest highlight in which I want to preserve detail and the darkest shadow in which I want detail and see if they are within a 4-stop range (I'd actually like it to be less, but this is the absolute maximum). Use the descriptions in the "Object Reflectivity" and "Example" columns of the table as a starting place. Just remember that what I think of as "fur on a black cat" may be something different from what you think; come up with your own examples by experimenting.

Reciprocity Effects

When exposure times are extremely short or long, additional exposure, beyond what is indicated by the meter, is necessary. In addition, color films may produce or experience color shifts. Though such shifts are generally insignificant at exposures of less than 1 minute, beyond that, try adding a CC10M or CC20M (color correcting) filter. Adjust exposure from the meter reading in the number of stops as follows:

Film	1 sec.	2 sec.	4 sec.	8 sec.	15 sec.	30 sec.	60 sec.
Fuji RF 50	None	None	+1/3	+1/2	+1	+1-1/2	+3
Fuji Velvia RVP 50	None	None	+1/3	+1/2	+1	+1	+2-1/2
Fuji Sensia RD 100	None	None	None	None	None	+1/2	+1/2
Fuji RDP 100	None	None	None	+1	+1	+1-1/2	+3
Fuji Provia RDP II	None	None	None	None	None	+1/2	+1/2
Kodachrome 25 KM	+1/2	+1	+1-1/3	+1-1/2	+2	+2-1/2	+3-1/2
Kodachrome 64 KR	None	+1/2	+1-1/2	+2	+2-1/2	+3-1/3	+4
Kodachrome 200 KL	+1/2	+1	+1-1/2	+2	+2-1/2	+3-1/2	+4-1/2
Ektachrome 100 Plus EPP	None	+1/2	+1-1/3	+1-1/3	+1-1/2	+1-1/2	+1-1/2
Agfachrome RSX50	None	None	None	+2/3	+2/3	+2/3	+1
Agfachrome RSX100	None	None	None	+1/2	+1/2	+1/2	+1
Agfachrome 200 RS	+1/2*	+1/2*	+2/3*	+1*	NR	NR	NR
Kodak Gold 100/200	+1	NR	NR	NR	NR	NR	NR
Kodak Gold 400	None	None	None	None	NR	NR	NR
Kodak Gold 1600	None	None	+1/2	+1	+1	+1-1/2	NR
Ektachrome E100S/SW	None	None	None	None	None	None	+1/3

Assumes use of a CC25 filter for shorter exposures, a CC50 for 10-second exposures
None = No compensation required
NR = Not recommended

Film manufacturers introduce new emulsions frequently. Nevertheless, film families tend to have similar tendencies. For example, when Fujichrome Provia (RDP II) was introduced to replace Fujichrome 100 (RDP), it shared the original's excellent reciprocity characteristics and remained one of the few films that

did not require any adjustment with exposures up to 4 seconds. Thus, while some of the films listed are no longer produced, I've left the data for them here. Further, I've left space for you to add your own data and additional films as they are introduced.

For critical applications, Kodak doesn't recommend exposures of 10 seconds or longer with most of their color slide films and suggests the following combination of exposure compensation and filtration for 1-second exposures:

Film	Correction	Filter
Kodachrome 25 (KM)	+1/2 stop	CC05R
Kodachrome 64 (KR)	NR	NR
Kodachrome 200 (KL)	+1/2 stop	CC10Y
Kodachrome 40 Type A (KPA)	+1/2 stop	CC05R
Ektachrome 64 (EPR)	+1/3 stop	CC05R
Ektachrome 100 (EPN)	+1/3 stop	CC05R
Ektachrome 200 (EPD)	+1/2 stop	CC05M
Ektachrome 100 Plus (EPP)*	+1/3 stop	CC05R
Ektachrome 400X (EPL)**	+1/3 stop	CC05R
Ektachrome P1600 (EPH)	+1/2 stop	CC05R + CC05Y

NR = Not recommended
**Pro versions are +1/2 stop with CC05B.*
***Also recommended at 10 seconds +1/2 stop with CC10R.*

Most Kodak black-and-white films suggest 1 extra stop of exposure at 1 second, 2 stops at 10 seconds, and 3 stops at 100 seconds. You can also call Kodak at 1-800-242-2424 for advice on their films' reciprocity characteristics.

Night Exposures

Night scenes contain extreme ranges of exposure contrast that film is incapable of handling fully. Thus, you need to figure out whether you are exposing for the lights or the lit objects (or something in between). A "correct" exposure cannot be dictated for any situation—the following are suggested starting points for exposure with ISO 100 film.

Remember to adjust for the film's reciprocity effects (see "Reciprocity Effects" on page 25) if the exposure is longer than 1 second. At twilight, close down 2 stops from the suggested exposure (below) if the twilight is illuminating the scene. And finally, make sure to bracket!

Night Scene	Aperture	Shutter Speed
Distant city scenes at twilight	f/2.8	2 seconds
Distant city scenes at night	f/2.8	4 seconds
Nearby city scenes	f/2.8	1/8 second
Street scenes	f/2.8	1/8
Las Vegas street scenes	f/5.6	1/8
Lit buildings	f/2	1/4
Lit window displays	f/5.6	1/30
Wet reflections	f/2	1/4
Neon lights	f/5.6	1/15
Christmas lights	f/4	2 seconds
Home interior	f/2	1/15 second
Candlelit scenes	f/2.8	1/4
Subjects at campfire	f/2	1/15
Fireworks	f/16	Bulb
Flames	meter*	1/125 or faster
Freeway (blurred lights)	f/16	40 seconds
Amusement park	f/2.8	1/8 second
Stadium sports	f/2.8	1/30
Star trails**	maximum aperture	20 minutes minimum
Full moon***†	f/11	1/125 second
Gibbous moon***	f/11	1/60
Quarter moon***	f/11	1/30
Wide crescent moon***	f/11	1/15
Thin crescent moon***	f/11	1/8
Scenes lit by full moon min‡	f/2.8	3 minutes
Scenes lit by full moon max‡	f/2.8	16 minutes
Scenes lit by quarter moon‡	f/2.8	15–30 minutes
Scenes lit by crescent moon‡	f/2.8	30–60 minutes

*Assumes flames are the subject. If subject is lit by flames, you'll need more exposure.
**You may not want to use the maximum aperture due to distortion. If that is the case, adjust your exposure accordingly. See "Star Trails" on page 29.
***Maximum exposure time to avoid an oblong moon should be 250/focal length (e.g., 1/2 second exposure with a 500mm lens).
†"Lunar 11" Rule applies to a full moon (i.e., use 1 stop more than a sunlit scene with the "Sunny 16" Rule).
‡ Don't include the moon in the shot or the moon will be severely overexposed and oblong.

Auto Lights

- With ISO 100 film, use f/8 or f/11 and a long shutter speed to record light trails of taillights and headlights.

- Use a smaller aperture, like f/16, and a long shutter speed to record oncoming headlights in heavy traffic moving at slow speeds.

- To get complete light trails, expose from 30 seconds to 2 minutes.

- Use a tripod at all times.

- Bracket! And don't forget to compensate for reciprocity effects (see page 25).

Stars and Comets

When photographing a sky with no ambient light (i.e., in the wilderness), a lens with an aperture of f/2 or faster and ISO 400 film will yield detailed pictures of the Milky Way in about 15 minutes (the exact amount varies due to the reciprocity of the film used). ISO 1600 film yields similar results in less than a minute (again, bracket to cover reciprocity). The difference is important. With a 15-minute exposure and no sky-tracking mechanism, star trails will be evident even with a wide-angle lens. With 60-second and shorter exposures, stars are recorded nearly as pinpoints with wide-angle to normal lenses (up to 60mm).

To get the best results:

- *Start each roll with a normally exposed daylight scene.* This gives you a reference for whether your exposures are correct or not, plus it gives the photofinisher a reference for where to cut the film (especially important for slides!).

- *Use a large aperture, but not the largest.* Stop down 1 or 2 stops from the maximum aperture. Lens aberrations and flare will be especially evident in the corners of the frame at the widest aperture, especially with "fast" lenses. Consider renting (or purchasing) a Nikkor 55mm Noct lens, which is probably the best-corrected Nikon lens for taking photos of pinpoint light sources such as stars.

- *Consider filtration.* Every bright star is surrounded by an unfocused halo of blue light when viewed from the Earth's surface. A pale yellow filter (Wratten 2B or 2E) reduces this halo. Comets

generally have bluish gas tails and yellow dust tails. To empha-
size the gas tail use a Wratten 47A, to emphasize the dust tail
use a Wratten 21.

• *Keep exposures short, if possible.* This reduces star trails and
 keeps reciprocity effects within predictable levels. If you must
 use long exposures, you'll need a mechanism to track the sky.
 Borrow a telescope with a tracking mechanism and mount your
 camera to it, if necessary.

• *To prevent recording star trails* (i.e., to get pinprick stars): Use the
 following formula to calculate the maximum exposure length.

Formula: 600/Focal Length = Maximum Exposure in Seconds

Example: 600/50mm = 12-second exposure

• *Don't place comet heads in the corner of the frame.* Again,
 the corners of the frame are where your lens is most prone
 to distortion.

Star Trails

• *Use a tripod and a cable release!* The bigger the tripod, the
 better, as you need to make sure the shutter is locked open for
 hours. Who knows when a wind might kick up?

• *Avoid moonlit nights.* Shoot during a new moon, if possible. If
 you can't avoid shooting on a night with a moon, make sure that
 you're shooting an area of the sky that the moon won't move
 into over the course of the exposure.

• *Avoid light pollution.* It is hard to get decent star trails in and
 around metropolitan areas due to the amount of ambient light.
 Get away from cities and streetlights, and turn off any lighting
 over which you have control (porch light, Coleman lantern, etc.).

• *Use long exposures.* Star-trail exposures are typically measured
 in hours. To get a full circular set of trails with a wide-angle lens,
 I leave the shutter open for 6 hours.

• *Use the camera's Time or Bulb setting.* Some Nikon cameras
 have a T (Time) setting that is fully mechanical and will not drain
 the camera's batteries in any way. (However some Nikon
 cameras' Time settings are battery-dependent.) The B or Bulb
 setting on all Nikons will consume some battery power over the
 duration of the exposure, in different degrees depending on if
 you are using a manual camera such as the FM2n or an automatic

camera such as the N90s/F90X. If you are using an automatic Nikon that is reliant on its batteries for operation, you should probably invest in a remote release that supports long exposures. However, using an automatic camera to time a long exposure by setting a long shutter speed in shutter-priority or manual mode (especially in cold conditions) will almost certainly drain the batteries.

- *Center your camera on the North Star.* To get concentric star trails (circles) in the Northern Hemisphere, you'll need to center your camera on the North Star (Polaris). In the Southern Hemisphere, there is no comparable star, however if you aim the camera due south (use the Southern Cross) at an angle from the horizon equivalent to the number of degrees latitude at which you are located, your star trails will be concentric. (e.g., If you are at 36° south latitude, aim your camera toward the southern horizon at an angle of 36°.)

- *Record the constellations with star trails.* Use a small aperture (f/16) for the star-trail portion of exposure (the 6-hour part). Then, for the last 5 minutes of your exposure, open up the aperture fully (to f/2.8 or faster, if possible). The end points of the trails will be slightly better exposed than the trails, and if done correctly, should show off the constellations.

Tip: If you're serious about shooting long exposures at night, get a good kitchen timer or a watch alarm. Set the camera on Bulb or Time, click to start the exposure, set and start the timer or alarm, and then go about your business until it goes off.

Lightning

To photograph lightning at ISO 100, try using f/5.6 or f/8. The first figure is the one recommended by Kodak and Nikon, but many professionals prefer to use a slightly smaller aperture so that the lightning is more distinct. The aperture is the only thing you need to control in order to get a good exposure (the strike itself is the duration!).

Look for things that you can silhouette in the foreground against the lightning flash. In this case, calculate exposure for the lightning, not for the objects lit by the lightning.

If you want to get correct exposure for the objects in the scene

and include a lightning strike, use a long shutter speed and the appropriate f/stop (see "Night Exposures" on page 26).

 Example: If you want to shoot a lightning strike in a distant city scene (f/2.8 at 4 seconds), you would instead expose the film for 8 seconds (plus any additional time required for reciprocity effects) at f/5.6, or 16 seconds at f/8. Such long exposures help ensure that at least one lightning strike is in the frame.

Time between Flash and Thunder	Distance to Lightning	Aperture
<10 seconds	Under 2 miles	f/11
10–45 seconds	2–9 miles	f/8
>45 seconds	Over 9 miles	f/5.6

 The flash-to-thunder difference works out to about 5 seconds = 1 mile, or about 3 seconds per kilometer.

SAFETY NOTE

Lightning is life-threatening! The only safe way to photograph lightning is from inside a building that has correctly installed lightning rods. Cars can be reasonably safe if you aren't touching the outside of the car or anything connected to the electrical ground. Don't take shelter under trees or any other tall object. You should be at least 20 feet (6 m) from any tree, but within the area circumscribed by the 45° line drawn from the top of the tree to the ground; this keeps you from being the tallest thing around while keeping you far enough away from the tree if it is hit. Unfortunately, not being the tallest thing in an area doesn't guarantee that you won't be hit. Finally, if you feel the hairs on your neck stand up or feel a slight shock when touching your camera or other object, you are in imminent danger of being struck! Discard all metal immediately, put your feet together, and squat, making yourself as small and low as possible. If someone in your party does get hit by lightning, administer CPR and treat them for shock immediately.

Exposure Compensation Methods

- *Exposure compensation dial.* Dial in a new exposure value. Plus (+) compensation is used to add exposure to backlit or predominantly light subjects; minus (–) compensation is used to properly render dark subjects. Be sure to cancel the compensation when you're done!

- *AE lock.* Meter on a neutral subject and hold down the auto-exposure lock button, then recompose. Most Nikon cameras have an exposure lock control. This is useful for shooting off-center or excessively bright or dark subjects.

- *Change your metering mode.* Try using center-weighted or spot metering instead of average or matrix metering in order to have more control over the area of the photo that's being metered.

- *Set an ISO value on the camera different from the nominal one for the film you're using.* Each time you double an ISO setting on the camera, you'll get half the exposure (1 stop underexposure). You'll get double the exposure (1 stop overexposure) when you halve the ISO value. Remember to reset your ISO value to its normal value when you no longer need exposure compensation! See the table on page 33.

 Note: This is **not** the same as pushing or pulling film (in which you change the ISO value and instruct the lab to process the film at the altered speed). To use this method for exposure compensation, the lab must process your film at the original ISO value, resulting in the desired amount of under- or overexposure.

Using ISO Values for Exposure Compensation

To use the following chart, first determine the number of stops you want to change the exposure by, then reading the row pertaining to your current ISO, read the new ISO value below the number of stops of exposure.

 Example: If you are shooting Kodachrome 64 and want to open up (add) 1 stop to compensate for backlight, set the ISO value on the camera to 32.

Film Speed	−2 stops	−1 stop	+1 stop	+2 stops
25	100	50	12	6
50	200	100	25	12
64	250	125	32	16
100	400	200	50	25
200	800	400	100	50
400	1600	800	200	100

ISO Values

ISO stands for the International Standardization Organization. For photography purposes, it designates their standard for film speed. Film speed used to also be referred to as DIN or ASA. DIN was the European standard for specifying film speed and has slowly been replaced by ISO. Some older light meters (and some old film you might be storing in the refrigerator) may be specified in DIN. All current Nikon cameras use ISO specifications for film speed. Some older models refer to the film speed as an ASA value; however the ISO and ASA values are identical.

The values in the chart below are listed in 1/3-stop increments. A 1-stop difference in exposure is achieved by doubling or halving the ISO value (e.g., 80 to 40), while a 1-stop difference in exposure varies by 3° in DIN (e.g., 20° to 17°).

ISO	DIN	ISO	DIN
25	15°	320	26°
32	16°	400	27°
40	17°	500	28°
50	18°	640	29°
64	19°	800	30°
80	20°	1000	31°
100	21°	1250	32°
125	22°	1600	33°
160	23°	2000	34°
200	24°	2500	35°
250	25°	3200	36°

Shutter Speeds

Each shutter speed value listed in bold type in the chart below is a
full stop apart from the one preceding it. They are the speeds that
are commonly marked on shutter speed dials and viewfinder
displays. Some of these values are rounded slightly for convenient
display on the viewfinder or LCD panel.

If a number is followed by a " symbol, seconds are indicated.
Those numbers without this symbol indicate the reciprocal of the
number in seconds (e.g., 2" = 2 seconds, 2 = 1/2 second).

Full Stops	1/3 Stops	1/2 Stops	Full Stops	1/3 Stops	1/2 Stops
30"			**15**		
	25"	23"		20	23
	20"			25	
15"			**30**		
	13"	12"		40	45
	10"			50	
8"			**60**		
	6"	6"		80	90
	5"			100	
4"			**125**		
	3"	3"		160	180
	2.5"			200	
2"			**250**		
	1.6"	1.5"		320	350
	1.3"			400	
1"			**500**		
	1.3	1.5		640	750
	1.6			800	
2			**1000**		
	2.5	3		1250	1500
	3			1600	
4			**2000**		
	5	6		2500	3000
	6			3200	
8			**4000**		
	10	12		5000	6000
	13			6400	
			8000		

F/stops

The values in bold in the following chart are full stops apart from those that precede them and are those that are commonly marked on lenses. Most Nikon lenses can be set at intermediate settings (i.e., they allow continuous "stepless" variation of the f/stop). The values shown here, some of which are rounded slightly for convenient display, are what more recent Nikon cameras display in the viewfinder.

Full Stops	1/3 Stops	1/2 Stops
1.0		
	1.1	1.2
	1.3	
1.4		
	1.6	1.7
	1.8	
2		
	2.3	2.4
	2.5	
2.8		
	3.2	3.5
	3.6	
4		
	4.5	4.8
	5	
5.6		
	6.3	6.7
	7	
8		
	9	9.5
	10	
11		
	12.7	13
	14.3	
16		
	18	19
	20	
22		
	25	27
	28	
32		

Notes

Filters

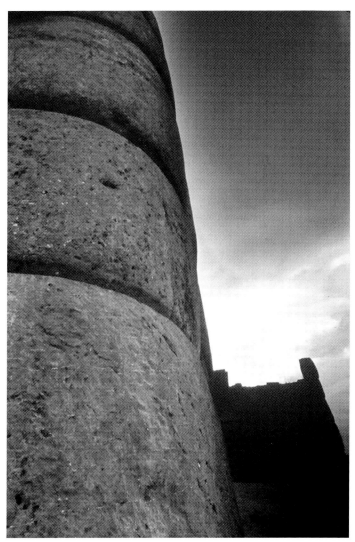

I wanted my photos to recreate the atmosphere of these Peruvian ruins. A hard-edged 2-stop graduated filter was positioned diagonally to darken the sky and the distant ruins. Fill flash, set at −1.7 stops, illuminated detail in the foreground.

Filters

Filters can be used to render lighting and other atmospheric conditions more realistically on film or add subtle or dramatic special effects to a photograph. This overview of filters covers those most likely to be required by professional photographers in the field.

Nikon Filters

Filter Name	Type	Filter Factor (Daylight Film)	Sizes (mm)
Circular Polarizing	Polarizer	Varies	52, 62, 72, 77
Soft Focus #1 & #2	Diffusion	No Loss	52, 62, 72
Neutral Color (NC)	Clear Glass	No Loss	39, 52, 58, 62, 72, 77
L37C	UV Haze (Coated)	No Loss	39, 52, 62, 72, 77, 82 95, 122, 160
L1BC	Skylight	No Loss	39, 52, 62, 72, 95*, 122*
L38	Ultraviolet	No Loss	52
Y44	Yellow	1/2-Stop Loss	52, 95*, 122*
Y48	Yellow	2/3-Stop Loss	39, 52, 62*, 72*, 77*, 95*, 122*
Y52	Yellow	1-Stop Loss	39, 52, 62*, 72*, 77*, 95*, 122*
O56	Orange	1-5/6-Stop Loss	39, 52, 62, 72, 77, 95, 122
R60	Red	3-Stop Loss	39, 52, 62, 72, 77, 95, 122
X0	Green	1-Stop Loss	52, 62*, 72*, 77*
X1	Green	2-1/3-Stop Loss	52
ND2s	Neutral Density	1-Stop Loss	39
ND4s	Neutral Density	2-Stop Loss	39, 52, 72
ND8s	Neutral Density	3-Stop Loss	39, 52
ND400	Neutral Density	8-2/3-Stop Loss	52
A2	Amber	1/3-Stop Loss	39, 52, 62, 72, 77
A12	Amber	1-Stop Loss	39, 52, 62
B2	Blue	1/3-Stop Loss	39, 52, 62, 72, 77
B8	Blue	2/3-Stop Loss	39, 52
B12	Blue	1-Stop Loss	39, 52, 62

** Indicates recently discontinued filter/size combinations. All other filters listed are current as of this writing. Filter factors are approximate.*

Filter Factors

Most filters require an exposure compensation factor to obtain proper exposure. If you use your camera's internal through-the-lens (TTL) meter to determine exposure, you don't have to worry about this. However, if you use an external hand-held meter to determine exposure, you'll need to compensate for the filter factor. Check your filter's instruction sheet for its filter factor.

To determine the amount of compensation necessary when using multiple filters, multiply the factors together and then consult the following table (e.g., a filter with a factor of 8 and another with a factor of 2 would result in a factor of 16 together, a 4-stop increase).

Filter Factor	*Exposure Increase (in stops)*
1x	0
1.25x	1/3
1.5x	2/3
2x	1
2.5x	1-1/3
3x	1-2/3
4x	2
5x	2-1/3
6x	2-2/3
8x	3
10x	3-1/3
12x	3-2/3
16x	4
20x	4-1/3
24x	4-2/3
32x	5
40x	5-1/3
50x	5-2/3
64x	6
80x	6-1/3
100x	6-2/3

Color Compensating Filters

Color compensating filters change the color balance of pictures recorded on color films, or they compensate for the deficiencies in the spectral quality of a given type of lighting. Ideal filtration varies by film emulsion, age of lights, and other factors. When in doubt, run tests. The following are general recommendations:

Correcting for Fluorescent Light

Fluorescent Type	Daylight Film	Tungsten Film
Daylight	40M + 40Y (+1 stop)	85B + 40M + 40Y (+1-1/2 stops)
White	20C + 30M (+1 stop)	60M + 50Y (+1-2/3 stops)
Warm White	40C + 40M (+1-1/3 stops)	50M + 40Y (+1 stop)
Warm White Deluxe	60C + 30M (+2 stops)	10M + 10Y (+2/3 stop)
Cool White	30M (+2/3 stop)	60M + 60Y (+1-1/3 stops)
Cool White Deluxe	20C + 10M (+2/3 stop)	20M + 40Y (+1-1/3 stops)

Note: The manufacturer's recommendation for exposure and filtration may vary slightly depending upon a particular film type, emulsion, or age of the bulb. If color correction is vital, call the film manufacturer and/or run a film test.

Adding magenta is common to every suggested correction. A useful shortcut for correcting fluorescent light when using daylight film is to use a 30M filter (+2/3 stop). This is close enough to neutral with most fluorescent lights and is the correction I use for its simplicity and minimal exposure adjustment. Correcting for mixed lighting is futile.

Correcting for Mercury Vapor Light

Mercury Vapor Type	Daylight Film	Tungsten Film
GE "Lucalox"	70B + 50C	50M + 20C
	(+3 stops)	(+1 stop)
GE "Multivapor"	30M + 10Y	60R + 20Y
	(+1 stop)	(+1-2/3 stops)
Clear Mercury	80R	90R + 40Y
	(+1-2/3 stops)	(+2 stops)
Deluxe White Mercury	40M+20Y	70R + 10Y
	(+1 stop)	(+1-2/3 stops)

Note: The manufacturer's recommendation for exposure and filtration may vary slightly for a particular film type or emulsion. If color correction is vital, call the film manufacturer and/or run a film test.

Adding red (magenta + yellow = red) is a common element in virtually every suggested correction. A useful shortcut for correcting mercury vapor light when using daylight film is simply to use a 30R or 40R filter (+2/3 stop).

Not all mercury vapor and sodium vapor lights can be corrected for. Sodium vapor lights, especially, omit only one narrow band in the yellow-green spectrum. Often, filtering to try to correct for these light types is wasted effort, as the results are anything but neutral.

Color Conversion Filters

Standard conversion filters can be used when shooting under a light source that is different than what the film was designed for. These filters adjust the color of the light source to approximate the color temperature for which the film is recommended.

Color Temperatures and Compensation

Film Color Balance	Light Source	Conversion Filter
Daylight*	<3,200° K	80A plus an 82-series
Daylight*	Auto headlights	80A or B
Daylight*	Sodium vapor	80A or B
Daylight*	Tungsten**	80A
Daylight*	Photolamp†	80B
Daylight*	>6,000° K	81
Daylight*	Mercury vapor	See chart on page 41.
Daylight*	Open shade	85C
Tungsten**	Daylight*	85B
Tungsten**	Photolamp†	81A
Photolamp†	Daylight*	85
Photolamp†	Tungsten**	82A

*5,500°K

**3,200°K

†3,400°K

Color Temperature of Various Light Sources

At sunrise the light is low in color temperature (~3,100° Kelvin) and rises to its high around noon (~5,500° K), after which it again drops. This means that light towards the extremes of the day is redder than at midday, and midday light is bluer.

To determine which filter to use to correct for color temperature and produce neutral color balance, subtract the MIRED value for the light you are shooting in (see following chart) from the MIRED value of the film you are shooting with (daylight film is 182). Find that value on the "MIRED Values for Filters" chart on page 43, and use the corresponding filter.

Source	Color Temperature	MIRED Value*
Candlelight	~1,930° K	518
75-Watt bulb	2,800° K	357
100-Watt bulb	~2,900° K	345
200-Watt bulb	3,000° K	333
Sunrise/Sunset	3,100° K	323
Tungsten light	~3,200° K	312
Photolamp	3,400° K	294

Source	Color Temperature	MIRED Value*
Dawn/Dusk	~3,600° K	278
Predawn/Predusk	~4,000° K	250
"Daylight" fluorescent	4,500° K	222
Carbon arc	5,200° K	192
Daylight	5,500° K	182
Typical flash	6,000° K	167
Overcast sky	7,000° K	143
Shade in hazy sky	10,000° K	100

Calculated by multiplying the reciprocal of the color temperature by one million (or, 1,000,000/color temperature). (See "MIRED Values for Filters.")

MIRED Values for Filters

A MIRED (MIcroREciprocal Degree) is a unit of measurement used to calculate the correct filter value for a given light. To determine filtration, simply calculate the MIRED shift (the difference between the film you're using and the MIRED value of the light you're shooting in), then use the following chart. Positive MIRED shifts make a scene warmer, negative MIRED shifts make a scene cooler. See chart below.

Example: Using daylight-balanced film (MIRED value 184) indoors in studio lighting (MIRED value 333) represents a shift of –149, therefore the closest filter value would be an 80A. Filters can be "stacked" to compound their effect, if necessary.

Filter	MIRED Shift	Filter	MIRED Shift
85B	+131	82	–10
85	+112	82A	–21
86A	+111	78C	–24
85C	+81	82B	–32
86B	+67	82C	–45
81EF	+52	80D	–56
81D	+42	78B	–67
81C	+35	80C	–81
81B	+27	78A	–111
86C	+24	80B	–112
81A	+18	80A	–131
81	+9		

Filters for Black-and-White Film

Filters used in panchromatic black-and-white photography adjust how colors appear in gray-tones. This can be used to highlight or reduce the prominence of certain picture elements. For example, darkening the gray scale value of a blue sky makes clouds stand out, or lightening green leaves makes a red rose appear rich and velvety. A general rule is that a filter lightens its own color and darkens the color that would appear opposite it (its complement) on a color wheel. The following is a quick summary of which black-and-white filter to use for a desired result:

Filter Color	Makes Blues	Makes Greens	Makes Yellows	Makes Reds
Yellow	Darker	Lighter	Lighter	Lighter
Orange	Darker	Darker	Lighter	Lighter
Red	Darker	Darker	Lighter	Lighter
Green	Darker	Lighter	Lighter	Darker
Blue	Lighter	Darker	Darker	Darker

Filters to Carry

Polarizer

A polarizing filter reduces reflections, causing colors to appear more saturated in the finished photograph or allowing a clear picture to be made through glass or water. By rotating the polarizer within its mount, the amount of polarization can be adjusted. Polarizers reach their full effect when used at a 90° angle to the light source and have almost no effect when pointed into or away from the light source. A handy rule of thumb to remember when shooting with a polarizer is to point your shoulder (either one) towards the sun. The extent of polarization can also be seen graphically by studying the effect of rotating the filter on the camera's meter, as the exposure value varies depending upon the amount of polarization.

You can create a neutral-density filter in an emergency by using two polarizing filters together and experimenting a bit with the rotation. Two polarizers set at cross angles (90°) polarize all light, resulting in a reduction of exposure. (One polarizer adjusts light only in one plane and therefore doesn't reduce exposure evenly.)

Circular polarizers (not linear ones) should be used with all Nikon autofocus SLR cameras.

Note: Polarizers don't always work as expected when shooting through airplane windows. Some window materials interact with the polarizer's function and create undesirable rainbow effects.

Neutral-Density

A neutral-density filter is used to reduce the amount of light hitting the film so that a slower shutter speed or larger aperture can be used for creative effect. An ND 2 filter has a filter factor of 2, reducing exposure by 1 stop, and an ND 4 has a filter factor of 4, reducing exposure by 2 stops.

One common use for a neutral-density filter is to obtain a slow shutter speed to create a "flowing" effect with moving water. As the name implies, they are "neutral," having no impact on color rendition. The table that follows shows the relationship between a neutral-density filter's value and the increase in exposure that must be set.

Density	Filter Factor	Exposure Compensation (in stops)
0.10	1.25x	+1/3
0.20	1.5x	+2/3
0.30	2x	+1
0.40	2.5x	+1-1/3
0.50	3x	+1-2/3
0.60	4x	+2
0.70	5x	+2-1/3
0.80	6x	+2-2/3
0.90	8x	+3
1.00	10x	+3-1/3
2.00	100x	+6-2/3
3.00	1,000x	+10
4.00	10,000x	+13-1/3

Graduated

Graduated filters are used to reduce exposure in one area (typically sky) while not influencing the rest of the scene. They come in soft (a gradual change between the filtered and non-filtered area) and hard (an abrupt transition between the filtered and non-filtered area) graduations. Use hard filters only if there is a clear "edge" on which you can hide the boundary (horizon, tree line, etc.). Most in-camera

matrix metering systems do a good job of handling exposure without requiring compensation.

As an alternative, you can spot meter on an area that you intend to filter (e.g., the sky) and one that will remain unfiltered (e.g., the foreground), apply the filter factor to the exposure value of the area you intend to filter, and then use an exposure value that bridges the difference between the two values.

Most professionals prefer graduated filters that are "neutral" in color impact (i.e., they don't alter color values) for general photography. However, tobacco-colored and blue graduated filters are also available. The former is sometimes useful for shooting sunrises or sunsets, and the latter works well to enhance fog or mist.

Tip: Graduated filters that screw onto the front of the lens like regular filters are not recommended. It is highly unlikely that you can compose your scene to adapt to the location of the gradation. Purchase a Cokin P filter holder and adapter rings for each of your lenses' thread sizes and use the drop-in graduated filters designed for that system. Singh-Ray also produces an excellent set of neutral-color graduated filters for Cokin P holders.

Warming

The most commonly used warming filters are the 81A and 81B. These filters add a warm bias to the color balance, exaggerating the reds, browns, oranges, and yellows in a scene. Warming filters are often useful in overcast scenes or other situations where there is a distinct blue tint to the light. Another common use is to "boost" a sunrise or sunset, especially if fill flash is used to provide foreground illumination. There are several slide films that have a "warm" color balance, producing an effect much like an 81A filter would provide.

Some professional photographers tape a small piece of a plastic warming filter permanently over a portion (but not all) of their flash head to add a touch of warmth to the light. (The majority of the Fresnel should be unfiltered to produce true whites.) If the flash pictures you take consistently seem to appear unnaturally lit, try this trick. But be warned that putting anything over your flash head robs your flash of some of its effective output, and you need to use a material that can withstand high temperatures without degrading.

Soft-Focus (Diffuser)

Soft-focus filters lower the apparent contrast and reduce sharpness in a scene. Note that the larger the aperture, the more pronounced the effect.

You can make your own soft-focus filter in the field by taking a clear filter (skylight or UV work fine) and gently rubbing a small amount of petroleum jelly on the front of the filter. The effect generated by this type of filter is not as repeatable as that of a commercial filter, but you can do things like keep the center area clear (and therefore sharp) while letting the edges go soft. Several filter manufacturers such as Cokin make a whole medley of various soft-focus filters, which are fun to experiment with for different effects.

Skylight and Ultraviolet (UV)

There is great controversy regarding the pros and cons of carrying skylight or UV filters. Common wisdom holds that a skylight filter protects your lens from possible damage while providing an occasional haze-reducing effect. UV filters can be useful for protecting lenses in hot, dusty climates.

Some photographers choose not to put any additional glass in front of their lenses unless it provides the enhancement they are looking for. Each additional glass surface between your subject and the film increases the risk of flare and potentially decreases the overall potential resolving power.

This issue of using a filter to protect the front element of your lens is a near-religious one. I've heard stories from some photographers about how they banged their lens against something and the only damage was the broken skylight filter. I also know someone whose broken skylight filter became wedged into the screw mount and scratched the front element of an expensive lens, requiring it to be sent in for repair. You'll have to decide for yourself which solution is right for you.

Ways to Reduce Contrast

• Use a polarizing filter.

• Use a graduated gray filter.

• Use a reflective surface to bounce light onto the subject. (Improvise: Use any light-colored fabric you happen to be carrying; I sometimes use my emergency "space blanket." Be aware that the color of the fabric, however light, will influence the color cast of the image.)

• Set a lower ISO and "pull" process the film (excluding color negative film).

- Use fill flash (typically at –1 to –2 stops).
- Use a diffuser. (Improvise by using a sheet of translucent plastic.)
- Wait for an overcast day or a passing cloud.
- Use a lower-contrast film.

Ways to Increase Contrast

- Set a higher ISO and "push" process the film (excluding color negative film).
- Take photographs at high noon (direct, bright daylight) with no fill.
- Use a higher-contrast film.

Ways to Reduce Haze

- Use a UV filter (this affects only short light frequencies).
- Use a polarizing filter.
- Shoot with the sun behind you or at your side.
- Avoid long-distance shots, especially telephoto.
- For black-and-white work, use an orange or red filter.
- Wait for clouds, smoke, fog, etc. to clear.

Ways to Reduce Flare

- Use a lens hood.
- Shield the front lens element from the sun with a piece of cardboard or your hand.
- Keep both the front and rear lens elements clean.
- Don't place the sun in or near the edge of the frame.
- Use single focal length lenses instead of zooms.
- Use a lens with an aspherical front element (they are better corrected for flare and do not focus flare spots the same way symmetrical lenses do).
- Remove all filters.

Unusual Subjects and Special Effects

Night shots are best taken at twilight, when the sky still has enough light in it to keep from reading completely black. The trick is to find that moment when the exposure is balanced for both the artificial lights and the sky.

Aerial Perspective

Aerial perspective occurs when objects farther away from you appear lighter than objects closer to you. The classic aerial perspective shot is a series of overlapping mountain ridges or peaks that grow fainter the farther they are from you; properly done, it looks like someone made cardboard cutouts of each ridge, painted them in successively lighter colors, then placed them one behind the other. To best achieve aerial perspective:

- *Shoot when mist, haze, or a storm is in the air.* Clear, haze-free skies diminish the effect.

- *Look for "overlapping" objects that are at increasing distances from you.* The classic shot is of mountain ridges, but you can achieve the same effect in a metropolitan area with large buildings or on water where there are lots of islands or coastal features (rocks, coves, etc.).

- *Shoot into the sun.* Backlighting the mist or haze increases the effect. Early morning and late afternoon work best, as the sun will be at a low angle, which also adds to the effect.

- *Use a telephoto lens to compress perspective.*

- *Use a spot meter to check values for each of the planes in your perspective;* remember, slide film captures a range of only about 5 stops. You'll want to meter on a mid-value plane.

- *Watch for glare and stray light hitting the front of the lens.* Whereas you want the distant objects to be faint and low in contrast, you want to preserve contrast in the foreground.

- *Include something that will give the scene a sense of place* (a pagoda, fire tower, person, etc.). Either place the object in silhouette, or make sure that it has a bright color or a highlight in it (midtone items tend to blend with the distant gray values).

Dew

If nature hasn't provided you with enough dew, you can create your own. Bring a small spray bottle filled with water and use it (sparingly) to enhance dew on spider webs, leaves, etc. You can always drink the water if you don't use it.

Stopping Action

The following are the "rule-of-thumb" shutter speeds that are
required to stop action using wide-angle or normal lenses:

Type of Action	Moving across Frame	Moving Head-on
People walking	1/125 second	1/30 second
People jogging	1/250	1/60
Horses trotting	1/250	1/60
Medium-paced sports	1/250	1/125
Swimmers	1/250	1/125
Slow-moving vehicles	1/250	1/125
People sprinting	1/500	1/125
Cars or bicycles in traffic	1/500	1/125
Horses galloping	1/1000	1/250
Diver	1/1000	1/250
Low-flying planes	1/1000	1/250
Skiers, skaters	1/1000	1/500
Train	1/2000	1/500
Race cars	1/2000	1/500

For more accurate results, use the following table (calculated for
a 50mm lens).

Subject's Speed in mph (kph)	Distance to Subject in feet (m)	Moving across Frame	Moving Diagonally to Camera	Moving Head-on
5 (8)	12 (4)	1/500 sec.	1/250 sec.	1/125 sec.
	25 (8)	1/250	1/125	1/60
	50 (15)	1/125	1/60	1/30
	100 (30)	1/60	1/30	1/15
10 (16)	12 (4)	1/1000	1/500	1/250
	25 (8)	1/500	1/250	1/125
	50 (15)	1/250	1/125	1/60
	100 (30)	1/125	1/60	1/30
25 (40)	12 (4)	1/2000	1/1000	1/500
	25 (8)	1/1000	1/500	1/250
	50 (15)	1/500	1/250	1/125
	100 (30)	1/250	1/125	1/60

Subject's Speed in mph (kph)	Distance to Subject in feet (m)	Moving across Frame	Moving Diagonally to Camera	Moving Head-on
50 (80)	12 (4)	1/4000	1/2000	1/1000
	25 (8)	1/2000	1/1000	1/500
	50 (15)	1/1000	1/500	1/250
	100 (30)	1/500	1/250	1/125
	200 (61)	1/250	1/125	1/60

A shutter speed twice as fast is needed for each doubling of lens focal length. For example, if you are using a 100mm lens, a subject moving 50 mph across the frame 25 feet away from you would require 1/4000 second. Likewise, a shutter speed twice as slow is required for each halving of lens focal length.

Using a flash as a primary light source can also stop action, as even at full output, Nikon flash units illuminate for 1/1000 second. At lower outputs, they illuminate for even shorter times.

To reduce the effect a subject's movement has on sharpness:

• Have the subject move towards you rather than across the frame.

• Use a wider-angle lens or make the subject smaller in the frame by moving back.

• Pan with the action (see "Panning with Action").

• Anticipate lulls in the action or shoot when the movement is minimized (e.g., shoot race cars at a corner where they have to navigate the slowest).

• Ask the subject to slow down!

Panning with Action

In general, use a shutter speed that is the inverse of the subject's speed. For example, to pan with a car moving at 30 miles per hour (50 kph), use 1/30 second.

Enhancing the Appearance of Movement (Subject Blur)

- Use a slow shutter speed (1/4 to 1/15 second) and pan with the action.

- Use slow-sync (blur in front of subject) or rear-sync (blur behind subject) flash.

- Use a slow shutter speed and zoom the lens during exposure.

- Set the camera for multiple exposure, set the ISO value to half its rated speed, and set the camera to its fastest frame advance setting. Click off two consecutive exposures. You'll get the image twice on the same frame.

Shooting Sports

The following sections include suggestions for a minimum lens kit, ideas on where to shoot from and how to follow action, plus some easy photos to take for several popular sports.

Baseball

- 400mm f/5.6, teleconverters; *take the longest lens you own!*

- The optimum shooting positions are behind first base, at the end of either dugout (or just behind them), and behind home plate.

- Follow a base runner, pre-focus on a spot for a swing or pitch, and don't try to follow the ball (you can sometimes follow a player, especially an outfielder). Anticipate action that might occur at a base (typically second base).

- Easy photos include batter swing, pitcher release, close action at first, slides into second on a steal or a double play, and congratulations offered at home plate after a score.

Basketball

- 35-70mm f/2.8 zoom, 80-200mm f/2.8 autofocus zoom; *take the fastest lenses you own!*

- ISO 1600 film is often necessary. ISO 800 is a minimum to insure reasonable shutter speeds even with the lens wide open.

- Sit at court level near a corner. The area underneath the basket is generally forbidden, as players on fast breaks often land there if

fouled. You'll be restricted to shooting somewhere around the three-point line at the ends of the court. In most arenas, the sidelines are reserved for the official's table, player benches, and VIPs. Don't block the view of the paying customers; you'll need to be seated on the floor or kneeling. Bring kneepads and wear comfortable, baggy pants.

- Anticipate! Pre-focus on the area under a basket and wait for a fast break; follow the star shooter and wait for him or her to get the ball (don't follow the ball); learn common out-of-bounds plays; learn to anticipate jump shots.

- Easy photos include free throws, timeouts, and warm-ups.

- Virtually all arenas require that photographers shoot hand-held—players are often "flying" out of bounds and can be easily injured by large metal objects in their path. And it's not just the players who get injured. I once watched a player land on a TV cameraman, pushing the camera into the cameraman's face, breaking his nose, and giving him one heck of a shiner.

- Flash is not allowed in most arenas except by pre-arrangement and then only if you have the professional equipment necessary to mount it far above the court and trigger it remotely.

Football

- 70-210mm f/4 zoom, 300mm f/4; a longer, faster lens if you have one, and possibly a short, 28-85mm zoom if you're carrying two cameras and need to shoot close action.

- ISO 400 film is typically used to get fast, action-stopping shutter speeds.

- On the sideline, stand 10 to 15 yards ahead of the action.

- Follow either the quarterback or the ball (decide before the start of play!).

- Look for opportunities when the offense is within the 30-yard line of the opponent (most touchdowns occur here, and touchdown pictures sell). Typically, you'll want to stand around the 20-yard line, which gives you the option of shooting upfield at the quarterback or downfield at receivers in the end zone.

- When the team is within five yards of a touchdown, try standing at the sideline just inside the end zone area; watch the positions of the line judges, who may get in your way.

- Shooting from the end zone is often a good choice when the team is within the 10-yard line (watch out for the back judge's position; he may cut off your view of the action). Typically you are restricted to the area from the numbers to the sideline (i.e., not in the middle). Another good position is along the sideline even with the back of the end zone.

- Photographers are generally not allowed in the team bench areas (the area between the two 30-yard lines).

- Consider using two cameras, one with a telephoto lens for distant action, and one with a 28-85mm zoom lens for close action and sideline shots.

- Most stadiums require photographers to shoot hand-held or using a monopod—no tripods! This is for the safety of the players.

Hockey

- 80-200mm f/2.8 zoom; *take the fastest long lens you own!*

- Shoot from the penalty box, if possible. Otherwise you'll be above the action and shooting through clear plastic barriers.

- Stay with one skater, you'll get some action eventually!

- Relatively easy photos include face-offs, perhaps, but nothing is very easy to capture in this sport since it moves so fast.

Soccer

- 70-210mm f/4 zoom for close action, 300mm f/4 or longer telephoto; *take the longest lens you own!*

- Corner shots and goalie shots are the only natural shots of field action; you have to work hard to follow the action otherwise. One alternative is to follow a single player and be ready to start shooting as the ball comes to him or her.

- Concentrate on the goalie during breakaways; watch the center area in front of the net on corner kicks; look for headers on long downfield kicks.

- Easy photos include after-score celebrations and penalty kicks.

Volleyball

- 28-70mm zoom, 70-210mm zoom; f/stop varies with location (indoors or out).

- Shoot on the sideline—near the net, but behind the referee.
- Watch where the set is going and be ready to shoot the action. Follow one player.
- Serves are the easiest photos to get, but since this is a reasonably predictable sport, it is not difficult to anticipate when and where the spike, hit, or block is going to occur.

What to Get Right

Depending on the subject you are shooting, each has one or more aspects critical to ensuring the picture's success. For example:

Subject: Architecture
What to Get Right: Small aperture, level camera
A small aperture is required to increase depth of field, the camera needs to be upright (parallel to the building's surface) and level (perpendicular to the building's surface) to avoid tilted subjects and converging lines.

Subject: Candid Photos of Children
What to Get Right: Fast shutter speed
Children move fast! You want to capture an expression or activity.

Subject: Close-ups
What to Get Right: Small aperture, focus
Depth of field is extremely shallow in macro photography, making focus critical. To maximize depth of field, use a small aperture. However, remember, the greater the magnification ratio, the shallower the depth of field, no matter how small the aperture is!

Subject: Interiors
What to Get Right: Small aperture, lighting, level camera
A small aperture is required to increase depth of field, the camera needs to be level and upright to prevent converging lines. Lighting can be tricky; watch out for shadows.

Subject: Landscape
What to Get Right: Small aperture; level horizon, preferably not placed in the center of the frame.
A small aperture is required to increase depth of field; tilted and centered horizons can look distorted or unreal.

Subject: Night Shots
What to Get Right: Exposure
Be aware of reciprocity effects and the effect of various light sources on color balance and exposure.

Subject: Pets
What to Get Right: Fast shutter speed
Same as children, only more so!

Subject: Portrait
What to Get Right: Large aperture, long focal length, low-contrast lighting
Use a large aperture to keep the subject isolated from the background. Longer focal lengths are more flattering (80 to 135mm), and soft light reduces blemishes and wrinkles.

Subject: Sports
What to Get Right: Fast shutter speed, typically long focal lengths
A fast shutter speed is required to stop action, a long lens is required to isolate the subject.

Subject: Sunsets
What to Get Right: Small aperture, exposure
A small aperture is required to increase depth of field. You can expose for a silhouette or use fill light to illuminate the foreground subject.

Subject: Water
What to Get Right: Very slow shutter speed, or very fast shutter
 speed
Shutter speeds slower than 1/2 second produce blurred, fluid water,
while a shutter speed of at least 1/250 "freezes" water's action.

Subject: Wildlife
What to Get Right: Very long lens, large aperture
Both of these things help isolate the animal from the background.
With a long lens, the subject will fill the frame while you remain at
a safe distance.

Photographing TVs or Computer Monitors

Adjust the TV's contrast lower than you would normally view it, and
turn off all the lights in the room. Use daylight-balanced film for
color TVs or monitors. Due to the scanning method used by
cathode ray tubes, a shutter speed of 1/8 second or slower is
necessary. Shutter speeds up to 1/30 second may work, but they do
not always result in clear images (typically a diagonal band may
appear between 1/8 and 1/30 second). At 1/30 second and shorter
exposures, the exposure will end before the image is scanned onto
the screen completely. A portion of the screen will be dark. Expo-
sure varies with the tube's age and brightness setting, but f/4 or
f/5.6 at 1/8 second is a good starting place for bracketing using
ISO 100 film.

Soft-Focus

To achieve a "painterly" effect, take a multiple exposure with the
first exposure in focus and the second slightly out of focus (use a
large aperture to limit the impact that depth of field might have on
the out-of-focus image). This technique works well with still-life
subjects, producing sharp edges with a slight halo effect.

In-Camera Soft-Focus

Set the camera for multiple exposures. The camera should be
mounted on a tripod. Each exposure should be underexposed by
1 stop (i.e., if the meter says to use f/8 at 1/500 second, use f/8 at
1/1000 instead). You can create different softening effects by varying
how you balance the two exposures. For example, to achieve a

slight softening, you might give the in-focus image 2/3 its normal exposure and the out-of-focus image 1/3 its normal exposure.

Out-of-Camera Slide Sandwich (Orton Imagery)

The camera should be mounted on a tripod. Shoot the scene in focus, but overexpose by 1 or 2 stops. Shoot the scene again, this time out of focus, using your largest aperture and overexpose by 1 stop. When you get the slides back from the developer, mount both together in a single mount.

Note: Both techniques involve defocusing a lens, which often has a slight impact on image size. You may need to zoom your lens slightly to compensate if you want to keep elements in the scene closely aligned. For more on soft-focus effects, see page 46.

Cross-Processing

With standard processing techniques, slide film uses Process E-6 and print film uses Process C-41. With cross-processing, however, slide film is processed in negative film chemicals or negative film is processed in slide film chemicals. This can result in more saturated colors and higher-than-normal contrast. But the results vary considerably depending upon the film choice and exposure.

• For most slide films, add 1 stop of exposure. When you use Process C-41, you'll get negatives that produce prints with very high contrast and high color saturation. Fuji Velvia and Provia tend to produce a yellow cast, especially in skin tones. Kodak films tend to be neutral to green.

• For most print films, add 2 or 3 stops of exposure. When you use Process E-6, you'll increase contrast and color saturation. Blacks will be more dense.

Despite what a lab might tell you, Kodak states that cross-processing does not result in contaminated chemicals and causes no problems to processors as long as it is done in small batches.

Note: Don't try cross-processing Kodachrome or older, non-Process E-6 infrared film.

Infrared

Infrared film is sensitive to a different spectrum of light than regular film or our eyes, and because of this, colors are rendered somewhat differently on infrared film than normal. Furthermore, by cross-processing Kodak's latest Process E-6 based infrared emulsion (EIR) or using different filters, you can modify the color response even further.

In "Sunny 16" light (see page 20), try an ISO of 250 (for Process E-6 film); in overcast situations, try ISO 160 instead. Bracket 1/2 stop in each direction.

Normal Color	Infrared with Yellow Filter	Infrared with Orange Filter	Infrared with Red Filter	Infrared Cross-Proc.
Blue	Magenta	Deep Blue	Cyan/Green	Near Black
Green (grass)	Magenta	Magenta/Red	Orange	Red
Red	Varies*	Varies*	Varies*	Varies*

Typically yellow, orange, or even white depending upon the amount of infrared in the subject.

Note: Kodak recommends a yellow (Wratten 12) filter with the current Process E-6 version of their infrared film.

Photographing Outdoors

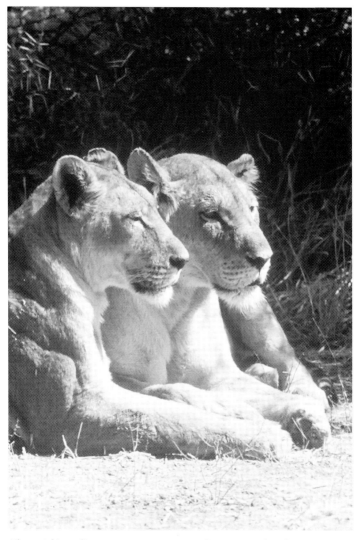

These African lions were so accustomed to tourists that they remained calm and unconcerned while our safari photographed them. Shooting from the safety of a vehicle, I was close enough to use an 80-200mm lens.

Tips on Photographing Animals

Attracting Subjects

- To attract birds or small animals to a particular branch or location, try putting a dab of peanut butter on the spot (add nuts, seeds, or bread crumbs, if necessary). Remember to keep the amount small so it doesn't show in the picture, and don't do this repeatedly at a site! There's a difference between habituating an animal and attracting one.

- Different types of food attract different birds and animals. Sunflower seeds, for instance, tend to attract the largest number of bird species.

- To attract birds, try saying "pssh, pssh, pssh" in short tones, quietly, while sitting still. Yes, it seems to work, though no one knows why!

- If the bird you're trying to attract is a ground feeder, be sure to have a small perch near where your food is (try sticking a small branch into a cleared area). Ground feeders almost always land on a perch and survey the area prior to feeding.

- To attract insects to a particular flower, try mixing up a small batch of sugar water, and put several drops on the flower's pistil. Other water additives you might try besides plain sugar include honey (doesn't drip), beer or liquor, and fermented or overripe fruit.

- Moths are attracted to light, but blacklight is an especially effective attractant.

Birds

- Birds flying in still air can turn and fly in any direction at any time; you need to stay on your toes.

- Birds soaring in a thermal or along cliffs move more slowly upwind, making it easier to frame and focus on them.

- Most large birds turn into the wind prior to taking off.

- Most large birds land into the wind as well.

You are too close to a bird if any of the following is true:

- The bird is skittish and flushes repeatedly.

- The bird raises its head and watches you carefully.

- The bird sounds an alarm call.
- The bird performs distraction displays such as feigning a broken wing.
- The bird preens excessively. This includes excessive pecking at dirt or its feet, or repeatedly wiping its bill.

Stalking

When stalking animals:

- Keep downwind (the wind should be in your face as you're facing the animal).
- Keep out of sight.
- Watch your shadow; animals do!
- Do not become a silhouette on the horizon.
- Make a slow, silent approach.
- Approach animals at an oblique angle, not directly.
- Wear clothes that don't rustle or make noise.
- Wear natural colors that blend with the environment (light in snow, dark in the forest, etc.).
- Stay still; let the animal come to you.

You are too close to an animal if any of the following is true:

- The animal is skittish. Skittish behavior includes jumping at sounds or movement, paying excessive attention to you, or any attempt by the animal to increase the distance between you and it.
- The animal displays any aggressive or nervous behavior. Indeed, almost any change in behavior by a mammal indicates that you've approached closer than they are comfortable with. Typically, mammals will simply move away from you if you approach more closely than they can tolerate.
- The animal's head posture changes. Changes to look for include lowering or raising the head, ears pointed in your direction, ears pinned back, and raised hair on the neck and shoulders. It's normal for a mammal to take note of you when it first detects you, but it will go back to its prior behavior very quickly if it is comfortable with your presence.

Blinds (or Hides)

- If possible, erect blinds a day or two prior to using them. If you march in, set up a blind, then go inside immediately, the animals associate you (a human) with the blind, and will not be as comfortable with your presence. If you set it up and leave, they will become more accustomed to the blind and more comfortable with its presence.

- When setting up blinds, make sure you account for where the sun's position will be later in the day (or the time you'll be using it). The sun moves, but your blind doesn't!

- In general, blinds should be downwind of the scene you're trying to photograph.

- Bring plenty of water (and food, if necessary). Bring clothes appropriate for changing weather conditions. A small folding stool will make your life in the blind more comfortable. If you have to have entertainment, bring a small, portable stereo with headphones.

- If you're using a blind to photograph a nest, set your camera (with a remote release) up on a tripod, and trigger the camera from afar (use binoculars or a spotting scope to figure out when). Human presence near a nest can often result in parents abandoning their infants, something no responsible photographer wants to be accountable for. For this reason, some countries require permits to photograph nesting birds.

Caution

In general, use long lenses and blinds to photograph animals in the wild. While there are places—like the Galapagos—where you can stick your lens virtually in the animal's face, such situations are rare. In most cases, wild animals perceive any close approach as a threat and will defend themselves. If an animal approaches you, stay calm, don't make sudden movements, and regard it as a rare treat, especially if you also manage to take a few pictures.

Warning: *Wild animals are unpredictable. Although these suggestions will help increase your margin of safety, they are by no means guaranteed.*

- *Don't wear perfume or fragrance* (insect repellant, suntan lotion, lip balm, and many other outdoor products often have a scent).

- *Never approach a predator* (bear, cat, wolf, etc.). Slowly back away from the animal.

- *Let the animal know you're there.* In bear country, wear a bear bell, talk out loud while hiking, approach from upwind, etc. You don't want to surprise an animal. Learn how to recognize fresh animal tracks and scat. Always give animals a chance to move away before making a closer approach.

- *Be aware of an animal's comfort zones.* Each animal has a different comfort zone, and it will change with every situation. Move slowly and indirectly towards an animal, and avoid eye contact. If the animal backs away from you, you're too close. If the animal shows other nervous behavior (elephants flap ears, some mammals fold their ears back, others begin looking nervously from side to side, show teeth, stomp, or thrash at nearby brush), move away. Observe the animal's behavior before moving closer, and stop when it changes behavior.

- *If you see a young animal or baby, the mother is nearby.* Leave immediately! Even otherwise non-aggressive animals are protective of their newborn.

- *Know the animal's escape route.* For example, hippos always head for water when spooked, so don't get between a hippo and water! Mountain goats always try to climb uphill away from danger, so don't approach them from above. Likewise, know what the animal's food supply is. Don't get between the animal and its meal.

- *If you are charged by a bear or elephant, the general consensus is to hold your ground.* Most brown bear charges are faux (there is some disagreement about grizzly charges). Lower your head slightly, don't look directly into the animal's eye, but don't turn around and don't run (you can't outrun most animals, anyway). Don't hit grizzlies, but hitting a brown bear sometimes works. Use pepper spray only if you are physically attacked. Spray the bear's face and/or hit the ground facedown, protecting your head and neck. Don't allow the bear to roll you face up (continue the roll so that you're facedown).

- *If confronted by a cat, make yourself look as big as possible* (spread your jacket, put your hands above your head, etc.). If you are actually attacked, be aware that a cat will likely jump and go for your throat, so protect it, and brace yourself for being hit high and knocked down. Hit the attacking cat's head as often

and as hard as you can (use your camera or tripod if necessary—put up a struggle).

- *Check with local authorities.* They can tell you about any local laws or rules, any recent problems, and helpful guidelines. If the local ranger or park official believes that you're trying to take pictures without having a significant impact on the animal, they will generally be very helpful and may even decide to go out with you and show you some "secret" spots.

- *Do not approach snakes or try to pick them up.* The majority of snakebites are on the hands and face, and guess how that happens? Most snakes have a limited strike range—much smaller than you'd expect; at most two-thirds the snake's length, often only a couple of feet. Snakes are often reluctant to expend energy to strike unless they absolutely feel threatened. Rattle-snakes give plenty of warning. If in snake country, wear ankle-high boots and take care where you step (especially when stepping on rocks off the trail or when backing up). Never put your hand in a crevice without checking it first; indeed, never put your hand where you can't see, if possible. Remember that snakes are cold-blooded, so they retreat to cool, shady crevices during the hottest part of the day.

- *You will encounter insects, so you'd best be prepared for them.* Loose-fitting long pants tucked into your boots or socks, and long-sleeved shirts are a must (white or light-colored to show off ticks and to discourage mosquitoes). Lightweight gloves should be considered (a thin silk liner works fine). Consider spraying the outside of your clothing with permethrin. Use a DEET-based repellant on exposed skin (but avoid concentrations above 50%). Wear a hat, and consider getting one with built-in mosquito netting. Avoid sitting directly on the ground, stay away from stagnant water, avoid standing around in the shade, and don't wave your hands around trying to convince the insects to go away. The greatest danger of encountering malaria-carrying mosquitoes occurs during the hours prior to and after sunset.

NANPA Principles of Ethical Field Practices

NANPA (North American Nature Photography Association) believes that following these practices promotes the well-being of the location, subject, and photographer. Every place, plant, and animal, whether above or below water, is unique, and cumulative impacts occur over time. Therefore, one must always exercise good individual judgement. It is NANPA's belief that these principles will encourage all who participate in the enjoyment of nature to do so in a way that best promotes good stewardship of the resource.

Environmental: Knowledge of Subject and Place

- Learn patterns of animal behavior.
 Know when not to interfere with animals' life cycles.

- Respect the routine needs of animals.
 Remember that others will attempt to photograph them, too.

- Use appropriate lenses to photograph wild animals.
 If an animal shows stress, move back and use a longer lens.

- Acquaint yourself with the fragility of the ecosystem.
 Stay on trails that are intended to lessen impact.

Social: Knowledge of Rules and Laws

- When appropriate, inform park managers or other authorities of your presence and purpose.
 Help minimize cumulative impacts and maintain safety.

- Learn the rules and laws of the location.
 If minimum distances exist for approaching wildlife, follow them.

- In the absence of management authority, use good judgement.
 Treat the wildlife, plants, and places as if you were their guest.

- Prepare yourself and your equipment for unexpected events.
 Avoid exposing yourself and others to preventable mishaps.

Individual: Expertise and Responsibilities

- Treat others courteously.
 Ask before joining others already shooting in an area.

- Tactfully inform others if you observe them engaging in inappropriate or harmful behavior.
 Many people unknowingly endanger themselves and animals.

- Report inappropriate behavior to proper authorities.
 Don't argue with those who don't care; report them.

- Be a good role model, both as a photographer and a citizen.
 Educate others by your actions; enhance their understanding.

Reprinted from North American Nature Photography Association, by permission.

NANPA
10200 West 44th Avenue #304
Wheat Ridge, CO 80033
(303) 422-8527

Outdoor Survival

When shooting in the wilderness or away from well-traveled areas, you should always take a survival kit with you. At a minimum, this includes:

• Flashlight
• First-aid kit
• Swiss Army knife
• Matches or lighter for starting a fire
• Compass
• Water bottle (filled!)
• Extra clothing (for changing weather conditions—typically a waterproof jacket, possibly gloves, hat, and a fleece vest)

In addition, you may want to carry:

• Insect repellant, sunscreen, lip balm
• A whistle (helps others find you in emergencies)
• Emergency "space blanket" (preserves heat loss, can be used as tarp on wet ground, can provide some shelter from rain by making it into an A-frame tent)
• Rope
• An umbrella (yes, this is still the most effective protection for most rainstorms)
• A GPS (Global Positioning System) receiver (useful for relocating remote locations, plus can be used to establish a track of your route, which you can use to navigate home if you become lost)

Surviving outdoors when lost, trapped by weather, or injured is not difficult if you're prepared.

• *Let someone else know your plans before you head out.* Make sure they know where you're headed, when you plan to be back, and whom they should call if you're not back within a prescribed period. You should also register with the local park or BLM (Bureau of Land Management) authorities, even if a permit is not required for the area you're entering.

• *Know where you're going.* Look at maps of the area you're traveling in, memorize key landmarks. Locate the easiest escape routes, and make note of how to find them and navigate them. Carry a compass. Take notes and carry them with you. Draw a

map of your route as you go, taking periodic compass or GPS readings.

- *Don't wear cotton in cold weather!* You're at greater risk of hypothermia if your clothes get wet and lose their heat-retention abilities (and even sweat can soak your clothes, so don't think it has to rain to be a problem). Wet cotton doesn't provide any protection and wicks the warmth right away from your body. Polypropylene, fleece, and even wool are better choices.

- *Bring a hat.* In cold weather, the greatest amount of heat is lost through your head. In summer, heat becomes your head's biggest danger, and a hat can help prevent heat stroke.

- *Dress in layers.* While wearing a hat and gloves can help conserve heat, adding an extra layer of clothing around your torso is also effective. I tend to dress in polypropylene long-underwear, with wind and water-resistant pants, a fleece vest, and a Columbia water-resistant jacket that has a liner and outer down parka that can be separated, if necessary (I also keep a waterproof Gore-Tex shell in my pack). If I get hot, I take off the long underwear bottoms and wear just the top and the pants. As weather conditions get cooler or stormy, I start adding layers.

- *Dress in long sleeves and long pants, preferably in light colors* (except for winter conditions, when you should wear dark, heat-absorbing colors). Ticks and mosquitoes will be less of a problem with long pants and long sleeves, and the light colors don't attract them as readily as darker colors do. You'll be better protected if you fall or have to move through thick brush. You won't have to worry as much about sun exposure. And if you're using one of the newer polyester-based fabrics that wick sweat from your body, you'll often be cooler than you would in a cotton T-shirt and shorts.

- *Don't try to carry more than 20% of your body weight.* For a 200-pound man, that means a pack of 40 pounds, maximum. Carrying additional weight impairs your performance. If you keep your pack weight to less than 20% of your body weight, you should be able to go as far and as fast as you're able to without carrying a pack. Remember to weigh the water you'll be carrying (a pint of water weighs a little over a pound, a liter weighs a kilo)!

Weather Rules of Thumb

How to Calculate the Temperature

- *Count cricket chirps:* Count the number of chirps per minute, subtract 40, divide by 4, and then add 50. That's the approximate temperature in °F. This formula is reliable in North America; foreign crickets may vary.

- *Check your breath:* Breath first becomes visible at about 45° F (7° C).

- *Look at the flowers:* Dandelions close up when the temperature drops below 51° F (10° C).

How to Calculate the Wind Force

- *Calm* (<1 knot, <1 mph, <1 kph)—Smoke rises vertically, no waves.

- *Light Air* (1–3 knots, 1–3 mph, 1–5 kph)—Smoke shows the wind's direction, small ripples appear on large bodies of water.

- *Light Breeze* (4–6 knots, 4–7 mph, 6–11 kph)—Wind is felt on the face, leaves rustle, weather vanes move with the wind, small wavelets appear on large bodies of water.

- *Gentle Breeze* (7–10 knots, 8–12 mph, 12–19 kph)—Leaves and twigs are in constant motion, light flags begin to extend, crests appear on large wavelets in large bodies of water.

- *Moderate Breeze* (11–16 knots, 13–18 mph, 20–28 kph)—Dust is raised, loose paper blows, small branches move, small waves appear on large bodies of water.

- *Fresh Breeze* (17–21 knots, 19–24 mph, 29–38 kph)—Small trees sway, moderate waves appear on the sea, crested waves appear on small inland bodies of water.

- *Strong Breeze* (22–27 knots, 25–31 mph, 39–49 kph)—Large branches move, wires begin to whistle, umbrellas become difficult to handle, large waves appear with white foam crests.

- *Near Gale/Moderate Gale* (28–33 knots, 32–38 mph, 50–61 kph)—Trees are in motion, it takes effort to walk against the wind, breaking waves spray inland.

- *Gale/Fresh Gale* (34–40 knots, 39–46 mph, 62–74 kph)—Twigs break from trees, it is difficult to walk against the wind,

moderately high waves of greater length appear, crests break off
in spindrift.

- *Strong Gale* (41–47 knots, 47–54 mph, 75–88 kph)—Structural
 damage may occur, high waves, dense streams of foam, crests
 tumble and fall over.

- *Storm/Whole Gale* (48–55 knots, 55–63 mph, 89–100 kph)—
 Trees are uprooted, considerable damage occurs, very high
 waves appear with overhanging crests.

Ways to Find North

- *Position your watch so that the hour hand points toward the sun.*
 True south is halfway between the hour hand and the 12-o'clock
 position (in North America). Subtract an hour from the watch's
 position if daylight saving time is in effect.

- *Check the sunrise or sunset.* In most of the continental United
 States, the sun rises a little north of true east, stands due south at
 noon, and sets a little north of due west. In the winter, the sun
 travels farther south, so the sun rises south of east, and sets south
 of west.

- *Push a stick vertically into the ground.* Mark the end of its
 shadow. Wait 15 minutes and mark the end of the shadow
 again. The line between the two marks runs west to east (first
 mark to second).

- *At night, locate the Big Dipper.* Follow the line from the two
 stars at the end of the cup to Polaris (the North Star). Polaris is
 due north. In the Southern Hemisphere, the long axis of the
 Southern Cross points toward a starless region, which lies
 due south.

- *The constellation Orion can help you anywhere in the world.*
 The uppermost of the three stars in the belt rises due east and
 sets due west.

Using a Camera in Cold Temperatures

- *Extend battery life.* Use an external power pack or lithium batteries. Keep a spare set of batteries in a warm inside pocket. Some pros use chemical warmers available at sporting goods or camping stores. However, note that these warmers generate enormous heat (up to 156° F!), and that heat can damage film and camera surfaces if applied directly.

- *Don't stick to your camera!* Wear gloves. Consider wearing thin glove liners if you need to take your gloves off to set or use the camera.

- *Avoid condensation.* Avoid breathing or blowing on the camera. Use a camel's hair brush or lens tissue to get snow off the lens, use a chamois cloth on the eyepiece and top plate. Keep the camera cold or warm it slowly (i.e., don't take it from cold outdoors to warm indoors directly). Instead, seal the camera in a plastic bag void of air before going inside (the more air, the easier it is for condensation to form).

- *Protect the camera from direct exposure, when possible.* If you're not shooting, put the camera into a carrying case or equipment bag. Alternatively, put it into an outside pocket of your jacket. This will keep the batteries slightly warmer, make it less likely you'll damage film, and make the camera a little easier to handle. However, note that warming the camera is likely to induce condensation—you're not trying to warm up the camera; rather, you're trying to keep it from getting too cold.

- *Use zoom lenses.* Changing lenses can freeze your hands and expose your camera's innards to the elements (blowing snow, for example). Choose a zoom lens that covers a wide range of focal lengths you're likely to need (the 24-120mm zoom for scenics, or the 180-600mm zoom for wildlife, for example).

Preventing Static Electricity Sparks

In cold or dry conditions, static electricity discharge can produce jagged lines resembling lightning on your negatives.

- Work in 45% relative humidity or higher, if possible.

- Avoid any fast film winding, loading, or rewinding (i.e., use slow, deliberate manual advance or the slowest possible auto advance or rewind speed). On an F4, use the silent film advance

setting and rewind the film by hand, slowly. (However, be aware that silent film advance uses a great deal of battery power, which can be a problem in colder temperatures.)

• Wipe the pressure plate with an anti-static cloth prior to loading a roll of film.

• Mix a few drops of liquid fabric softener with a quart of water, then rub a small amount of this solution onto the film pressure plate. However, water can damage a camera. Apply only a minute amount of fluid to the pressure plate and wipe it dry. This is often enough anti-static protection for most static-prone situations.

Wind Chill Factors

Hypothermia is possible at **all** the temperatures in these charts. Consider any temperature less than 50° F (10° C) as potentially life-threatening, and act accordingly.

Wind Chill in °F

Wind Speed	40°	30°	20°	10°	0°	–10°	–20°
4 mph	40	30	20	10	0	–10	–20
6 mph	35	24	13	2	–9	–20	–31
8 mph	31	20	8	–4	–16	–27	–39
10 mph	28	16	4	–9	–21	–33	–46
20 mph	18	4	–10	–25	–39	–53	–67
30 mph	13	–2	–18	–33	–48	–64	–79
40 mph	10	–6	–22	–37	–53	–69	–85

Wind chill for °F is calculated as follows:

Wind Chill = 0.0817 (3.71 x wind speed$^{0.5}$ + 5.81 – 0.25 x wind speed) (temp. – 91.4) + 91.4

Wind Chill in °C

Wind Speed	0°	−5°	−10°	−15°	−20°	−25°	−30°
10 kph	−2	−7	−12	−17	−22	−27	−32
20 kph	−7	−13	−19	−25	−31	−37	−43
30 kph	−11	−17	−24	−31	−37	−44	−50
40 kph	−13	−20	−27	−34	−41	−48	−55
50 kph	−15	−22	−29	−36	−44	−51	−58
60 kph	−16	−23	−31	−38	−45	−53	−60

Wind chill for °C is calculated as follows:

Wind Chill = 0.045 (5.27 x wind speed$^{0.5}$ + 10.45 – 0.28 x wind speed) (temp. – 33) + 33

Treating Hypothermia

Hypothermia can occur at temperatures as warm as 50° F (10° C), especially if the body is wet or exposed to the wind (a wet body can lose heat 200 times faster than a dry one). Shivering is a danger signal; your body is warning you of impending hypothermia. Here's what to do, in order of importance:

1. *Reduce exposure.* Get out of the wind and the wetness. Find or build a shelter that reduces your exposure. Beware of radiant heat loss. Heat is easily transferred from your body to colder objects, such as a rock or snowpack; use insulation between your body and any colder object.

2. *Keep the body dry or dry it off, if possible.* Get out of wet cotton clothes! Cotton provides no insulating capability when wet. Most synthetics and wool provide insulating capabilities, but you should still dry off, if possible.

3. *Put on extra layers of dry clothing, if possible.* Put on a hat, and use the hood on your jacket or parka.

4. *Put a vapor barrier around your body.* Put on a jacket made of Gore-Tex or other similar material, or cut a head hole in a plastic trash bag and wear it around your torso.

5. *Heat water and drink warm liquids.* Even if you can't warm the liquid, you should continue drinking water to prevent dehydration and decreased blood volume.

6. *Utilize any heat source to improve your body temperature.*
 Make a fire, snuggle up with a dry, warm friend, make a hot
 water bottle and put it under your vapor barrier, etc.

7. *Exercise produces internal heat* (that's what shivering is all
 about—muscles trying to produce extra heat). So stay active.
 Do not become totally inactive.

8. *Continue eating, even if only small snacks.* Fatigue and
 diminished energy stores can contribute to hypothermia.

9. *Stay awake!*

10. *Stay clothed.* If at some point you suddenly feel warm and are
 tempted to take off your extra clothing, don't! One of the
 body's final compensation efforts gives you a false sense of
 warmth—many hypothermia victims are found naked because
 they suddenly felt hot.

Treating Frostbite

Frostbite is a very dangerous condition, but survivable if you keep
your senses about you:

- *Learn to recognize the warning signs: sensations of cold or pain,
 and pallor of the affected skin.* As freezing progresses, all pain
 and sensation go away and the skin becomes white. Eventually,
 frostbitten tissue becomes quite hard, and extensive frostbite
 produces a dull purple color.

- *If there is a chance that an area will be re-frostbitten prior to
 reaching a care facility, do not attempt to warm the area.*
 Refrozen areas do not respond to treatment as well as areas that
 have been frozen only once. It is better to hike out on a frostbit-
 ten foot than it is to warm it, then have it freeze again while
 hiking out.

- *Do not rub an area to warm it.* Rubbing irritates the already
 sensitive skin. High temperatures further damage the tissues, so
 don't try to heat an area over an open flame!

- *The best warming is done by immersing the area in water* (only
 100° to 108° F! [38° to 42° C]). Prior to immersion, remove all
 clothing and other restrictive objects (Band-Aids, etc.) from the
 area. Remember, a frostbitten hand is essentially a block of ice
 and thus will lower the temperature of the water. You'll need to
 monitor and keep the water bath at the proper temperature to

be fully effective. As an alternative, sticking a frostbitten hand under a warm armpit may be attempted in an emergency (no rubbing!). Typically, it takes at least 30 minutes and often 60 minutes of immersion to re-warm the tissue.

- *Do not stop or interrupt treatment because of pain.* Give the patient aspirin or other pain medication, if necessary.

- *Once the area is re-warmed, you must keep the patient warm, and the injured area must be protected from all trauma and irritation.* Put no pressure on the injured area, and don't allow it to rub against anything. If blisters appear, do not rupture them or you will risk infection (clear blisters are a good sign—you can expect the underlying tissue to recover; bloody blisters indicate dead tissue).

- *Keep the area clean and disinfected.*

- *Get the victim to a treatment center immediately.* Frostbite takes weeks to heal completely, and infection is a distinct possibility. If the victim is a smoker, he or she must stop smoking until recovery is complete (smoking affects the blood supply to extremities).

Using a Camera in Hot Temperatures

- *Keep film cool.* Film will surely color shift at temperatures above 120° F (49° C). Use a food cooler to keep film cool. Unload film in batches rather than individually to maintain a low temperature in the cooler.

- *Use slide film.* Slide film holds up to heat better than negative film.

- *Protect your camera from direct sun.* Don't leave any camera out in the sun (that includes when it's hung around your neck!). Cover it with light-colored or reflective material if you need to leave it out for awhile. Use light-colored cases.

- *Beware of humidity.* Silica gel or other absorption devices belong in all your cases. Make sure you pack enough as one tiny bag is not nearly enough to absorb all the humidity in a camera case. Seal your equipment with a pack of desiccant in plastic bags void of air.

- *Beware of dust.* This is another reason to seal your equipment in plastic bags. Use lens caps when the equipment is not in use. Use double cases or put your case in a large garbage sack. Use a clear filter (UV) on all lenses.

Heat Factor

Heat exhaustion becomes a danger when the Heat Factor is 105° F (41° C) or greater (see entries in bold).

Heat Factor (Humidity vs. °F)

	40%	50%	60%	70%	80%	90%	100%
70° F	68	69	70	70	71	71	72
75°	74	75	76	77	78	79	80
80°	79	81	82	85	86	88	91
85°	86	88	90	93	97	102	**108**
90°	93	96	100	**106**	**113**	**122**	
95°	101	**107**	**114**	**124**	**136**		
100°	**110**	**120**	**132**	**144**			
105°	**123**	**135**	**149**				
110°	**137**	**150**					
115°	**151**						

Heat Factor (Humidity vs. °C)

	40%	50%	60%	70%	80%	90%	100%
21° C	20	20.5	21	21	21.5	21.5	22
24°	23	24	24.5	25	25.5	26	26.5
27°	26	27	28	29	30	31	33
29°	30	31	32	34	36	39	**42**
32°	34	35.5	38	**41**	**45**	**50**	
35°	38	**42**	**45.5**	**51**	**58**		
38°	**43**	**49**	**55.5**	**62**			
41°	**50.5**	**57**	**65**				
43°	**58**	**65.5**					
46°	**66**						

Treating Heatstroke (Hyperthermia)

Learn to recognize the symptoms of heat exhaustion and heat stroke—faintness, dizziness, headache, confusion, irrational behavior, possible nausea, vomiting, convulsions, and loss of consciousness. ***Heat stroke is a medical emergency and must be treated immediately.*** Perform the following steps, listed in order of importance:

1. *If the victim is unconscious, keep the airway open.*

2. *Treat for shock.* Raise the victim's feet. Do not put a blanket on the victim.

3. *Move the victim to a cooler spot.* The victim should be positioned out of direct sun. Improvise; create your own shade if necessary.

4. *Remove victim's clothing and fan the body.* You need to increase air circulation and evaporation.

5. *Place cool, wet towels or clothing on the victim's extremities and torso.* Immersion in cool (not icy) water is helpful. Avoid icepacks or ice, which constrict the blood vessels and delay the body's natural cooling effect. In short, use any reasonable method for cooling the victim's body.

6. *Massage the victim's extremities to increase circulation.*

7. *Administer oxygen, if available.* ***Do not*** administer aspirin or other drugs.

8. *Evacuate the victim to a care facility as soon as possible.* If the victim has lost consciousness at any point, this is absolutely necessary.

9. *Beware of the rebound effect.* The victim may seem to recover, but symptoms often begin to appear again after three or four hours, especially if treatment is terminated due to apparent recovery, or the victim is re-exposed to the conditions that caused the problem in the first place.

Notes

Macro Photography

This marine iguana's spiny profile against the dark background made for an interesting portrait. The short minimum focus distance of the 60mm Micro Nikkor lens (and the cooperation of the iguana) allowed me to get in close and crop out distracting elements.

Magnification and Subject Size

Magnification	Ratio	Subject Size (in inches)	Subject Size (in mm)
0.25x	1:4	3-3/4 x 5-5/8	96 x 144
0.5x	1:2	1-7/8 x 2-13/16	48 x 72
1x (life size)	1:1	15/16 x 1-7/16	24 x 36
2x	2:1	7/16 x 11/16	12 x 18
3x	3:1	5/16 x 1/2	8 x 12
4x	4:1	1/4 x 3/8	6 x 9
5x	5:1	3/16 x 9/32	4.8 x 7.2
6x	6:1	5/32 x 1/4	4 x 6
7x	7:1	1/8 x 7/32	3.4 x 5.1

- A 1.4x extender has the same effect on magnification as it does on focal length. In other words, if your lens goes to 1:1 (life size), adding a 1.4x extender will take it to 1.4x (1.4:1) and a 2x extender will double its magnification (twice life size, or 2:1).

- As a rule of thumb, a lens generally needs extension equal to its focal length to get to a 1:1 (life-size) ratio. To figure out how much extension is needed for a given magnification, multiply the magnification by the focal length of the lens.

- If you don't have a TTL meter, you can generally figure exposure compensation for close-up work by opening up 1 stop for every 0.5x increase in magnification (see "Exposure Compensation at Specific Magnifications" on page 84).

- Don't automatically assume that you should set the smallest aperture because you think you need more depth of field. At high magnification levels, diffraction will begin to have an impact on the overall sharpness (see "Depth of Field and Diffraction" on page 86). Rules of thumb:

 Use f/8 or larger at 2x or greater.
 Use f/11 or larger at 1.4x.
 Use f/16 or larger at 1x.

 Exception: If magnification comes from a close-up lens, not an extension, always stop down to a mid-range aperture (typically f/5.6 to f/11).

Extension Tubes

Extension tubes (extension rings) can be mounted between the camera and lens to vary the lens' reproduction ratio. Extension tubes PK-11A, PK-12, and PK-13 add 8mm, 14mm, and 27.5mm of extension respectively. There is some loss of light when an extension tube is used, depending upon the length of the tube. In-camera metering will compensate exposure.

Matrix metering, autofocus, and program modes will not work with an extension tube attached. Only manual (M) and aperture-priority (A) exposure modes with center-weighted or spot metering and manual focus can be used.

Note: The PK-11 (8mm) should not be used with Nikon AF lenses. Use the PK-11A instead.

Reproduction Ratios of Nikkor AF Lenses with Extension Tubes

Lens	PK-11A	PK-12	PK-13
20mm	1:2.6 to 1:2.1	1:1.5 to 1:1.3	1.4:1 to 1.4:1
24mm	1:3 to 1:2.3	1:1.7 to 1:1.5	1.1:1 to 1.2:1
28mm	1:3.6 to 1:2.4	1:2.1 to 1:1.6	1:1 to 1.1:1
35mm	1:4.5 to 1:2.5	1:2.6 to 1:1.8	1:1.3 to 1:1.1
50mm	1:6.4 to 1:3.3	1:3.7 to 1:2.4	1:1.9 to 1:1.5
55mm Micro	1:6.9 to 1.15:1	1:3.9 to 1:1.3	1:2 to 1:1
85mm	1:10.6 to 1:4.6	1:6.1 to 1:3.5	1:3.1 to 1:2.2
105mm Micro	1:13.1 to 1:1.7	1:7.5 to 1:1.6	1:3.8 to 1:1.3
135mm	1:16.9 to 1:5.2	1:9.6 to 1:4.2	1:4.9 to 1:3
180mm	1:22.5 to 1:6	1:12.9 to 1:5	1:6.5 to 1:3.6
300mm	1:37.5 to 1:8.1	1:21.4 to 1:7	1:10.9 to 1:5.3

To figure out the amount of extension necessary for any given magnification, simply multiply the desired magnification by the focal length of the lens.

Extreme wide-angle lenses designed to be used at infinity focus are not recommended to be used with extension tubes, due to distortion.

Exposure Compensation at Specific Magnifications

Magnification Power	Magnification Ratio	Additional Exposure
0.25x	1:4	1/2 stop
0.3x	1:3	2/3 stop
0.4x	2:5	1 stop
0.5x	1:2	1-1/3 stops
0.7x	2:3	1-2/3 stops
1x	1:1	2 stops
1.5x	1.5:1	2-2/3 stops
2x	2:1	3-1/3 stops
3x	3:1	4 stops
4x	4:1	4-2/3 stops

For example, if you have added enough extension to shoot life size (1:1), you need to open up your lens 2 stops. If you are using the camera's built-in meter, it will be accurate **if and only if** you meter at the same focus distance you're going to shoot at.

Extension Tubes and Effective Aperture

Unlike close-up lenses, extension tubes cause some light loss, making the aperture indicated on the lens inaccurate. If you have a camera that has through-the-lens metering, it will automatically compensate for this effect. However those with cameras that lack this feature will need to calculate the "effective aperture" in order to produce correct exposure. For most lenses, you can use the following formula to calculate the effective aperture that should be set:

Effective Aperture = (Magnification + 1) x Aperture Indicated on Lens

Note: This formula does not work for specialized Nikon macro lenses.

Close-up Lenses

Magnification can be achieved by attaching a close-up lens (also called a diopter or close-up filter) to your lens. These accessories do not affect exposure or TTL meter readings. Nikon makes close-up lenses 0, 1, and 2 for normal lenses and 3T, 4T, 5T, and 6T for telephoto and zoom lenses.

Nikon Close-up Lenses

Lens Name	Filter Size	Diopter Value
0	52mm	+0.7
1	52mm	+1.5
2	52mm	+3.0
3T	52mm	+1.5
4T	52mm	+2.9 (use +3 value)
5T	62mm	+1.5
6T	62mm	+2.9 (use +3 value)

Tip: If you need a close-up lens that is a 77mm or has a thread size other than Nikon's 52mm or 62mm, try Canon's 250D (+4) or Canon 500D (+2).

Magnification achieved by attaching a close-up lens to your lens can be obtained by using the following formula:

Magnification = (Diopter Value x Lens Focal Length [in meters]) + Lens Magnification

While I do not recommend using multiple close-up lenses (because of vignetting, flare, and reduction in sharpness), if you do, always put the most powerful one closest to the lens.

Adding a close-up lens will change the distance at which the lens focuses. The following chart gives the focus distance when a close-up lens is added to a lens focused at infinity.

Diopter Value	Focus Distance (in inches)	Focus Distance (in cm)
+1	39.4	100
+1.5	26.3	67
+2	19.7	50
+3	13.1	33
+4	9.8	25
+5	7.9	20

Reproduction Ratios with Close-up Lenses

Lens	Close-up Lens +0	Close-up Lens +1	Close-up Lens +2
24mm	1:58 to 1:7.8	1:28 to 1:6.9	1:14 to 1:5.6
28mm	1:49 to 1:3.7	1:24 to 1:3.4	1:12 to 1:3.1
35mm	1:39 to 1:4.9	1:19 to 1:4.4	1:9.4 to 1:3.7
50mm	1:27 to 1:5.3	1:13 to 1:4.7	1:6.6 to 1:3.3

Always stop down to a mid-range aperture (typically f/5.6 to f/11) when using close-up lenses. There is no exposure change (i.e., no filter factor).

Depth of Field and Diffraction in Macro Photography

In macro photography, two standard rules of thumb need to be reconsidered:

- Normally, depth of field is about twice as deep behind the focus point as it is in front, but in macro photography this rule does not apply. Depth of field stretches equally on either side of the focus point as you get to high magnification levels (see page 98).

- Lens-induced diffraction isn't generally a problem with landscape photography, thus photographers often stop their lenses down to the smallest aperture to get the largest possible depth of field. In macro photography, however, diffraction becomes a big problem, especially if you're using extension tubes or bellows, which change the effective aperture to something even smaller than normal. At 2x magnification, diffraction will be easily visible at f/16 or smaller. At magnification levels up to 2x, I recommend a minimum effective aperture of f/11. (Remember, that's not the *marked* f/stop, but the *effective* f/stop. See page 84.)

Lenses

Getting very close with a wide-angle lens exaggerated the length of this Galapagos tortoise's neck. Shallow depth of field was used effectively to isolate his beatific expression.

Camera-Lens Compatibility

Body	Pre-AI	AI , AI-S, E	F3AF	AF	AI-P	AF-D	AF-I
F100	No*	MF[1,2]	No*	AF	MF	AF	AF
F5	No[†]	MF[1,2]	MF[1,2]	AF	MF	AF	AF
F4	MF[1,2]	MF[1]	AF[1]	AF	MF	AF[3]	AF[3]
F3	MF	MF	MF	MF	MF	MF[3]	MF[3]
N90s/F90X	No*	MF[1,2]	MF[1,2]	AF	MF	AF	AF
N70/F70	No*	MF[1,2]	MF[1,2]	AF	MF	AF	AF
N60/F60	No*	MF[4]	No*	AF	MF	AF	MF[3]
N8008s/F-801s	No*	MF[1,2]	MF[1,2]	AF	MF	MF[3]	MF[3]
FM2n	No*	MF	MF	MF	MF	MF[3]	MF[3]

* *Damages the AI mechanism on the camera body and voids the camera's warranty unless the lens has been modified to be AI.*

† *Camera body can be modified by Nikon to accept pre-AI lenses in A or M modes with no matrix metering.*

MF = Manual focus AF = Autofocus
1 = No P or S exposure mode 2 = No matrix metering
3 = No distance information 4 = Manual exposure mode only

Nikkor Lens Types

Manual Focus

A The original bayonet lens mount introduced in 1959 for the Nikon F and Nikkormat cameras. Easily distinguished by a chrome filter ring. Refer to the "Pre-AI" column in the compatibility chart above.

C Has "Nikon Integrated Coating" and a black filter ring. Distinguishable by a "C" after the lens designation. Produced from 1967 to 1970. Refer to the "Pre-AI" column in the compatibility chart above.

K Focus ring has rubber coating. Only a few lenses were produced with this design. Refer to the "Pre-AI" column in the compatibility chart above.

N The first of the AI (Automatic Maximum Aperture Indexing) lenses. ADR (Aperture Direct Readout) was added, and most lenses were significantly redesigned. Production started in 1977 and phase-out began in 1982. Refer to the "AI, AI-S, E" column in the compatibility chart above.

AI-S Distinguished by the smallest aperture being printed in orange on both the ADR and main aperture scales. These also have a small scoop carved out of the bayonet flange, which transmits information regarding the lens' aperture mechanism to the camera. This facilitates aperture control in the P and S modes. Introduced in 1982, some AI-S lenses are still being produced. Refer to the "AI, AI-S, E" column in the compatibility chart.

E Low-cost version of several AI and AI-S lenses introduced for use with the Nikon EM. Distinguished by a plastic focusing ring and relative light weight. Clearly says "Nikon Series E" on the lens. Refer to the "AI, AI-S, E" column in the compatibility chart.

P Introduced with the 500mm f/4 ED-IF lens in 1988, P lenses are AI-S lenses with built-in CPUs that relay lens information to the camera. Refer to the "AI-P" column in the compatibility chart.

Autofocus

AF Introduced with the first autofocus cameras in 1986. Basically correspond to AI-S lens versions, but with the addition of autofocus and a CPU built into lens. Refer to the "AF" column in the compatibility chart.

AF-I A coreless, integrated (what the "I" stands for) motor was added to high-end telephoto lenses (300mm f/2.8, 400mm f/2.8, 500mm f/4, and 600mm f/4) for faster autofocus. Otherwise identical to D lenses. Also introduced in 1992. Refer to the "AF-I" column in the compatibility chart.

AF-S Introduced with the Nikon F5 in 1996, has a silent-wave (what the "S" stands for) ultrasonic motor for even faster autofocusing with high-end telephoto lenses. Refer to the "AF-I" column in the compatibility chart.

D Distance information from the lens was added to the CPU's capabilities. Introduced prior to the launch of the N90/F90 in 1992 and is the primary lens type currently being produced. Noted by a "D" after the aperture designation on the lens. Refer to the "AF-D" column in the compatibility chart.

IX Lenses designed for Advanced Photo System format cameras. Not intended for use with 35mm cameras.

Optical Designations

ED Extra-low Dispersion glass is used in the elements. ED glass ensures that the focal points of every wavelength of light converge to ensure optimal sharpness and contrast at every aperture (which is of particular importance in long lenses. This feature does not affect camera compatibility.

IF Internal Focusing. Nikon's telephoto lenses are designed with elements that focus internally rather than by extending the optical system forward. Focus is achieved without changing the lens' center of gravity, which assists in hand-held shooting. This feature does not affect camera compatibility.

Lens Hood Designations

HB Bayonet mount

HE Extension hood for long lenses with built-in hood

HK Slips onto lens and locks via a knurled knob

HN Screw mount

HR Rubber

HS Snaps onto lens similarly to lens cap

AF Nikkor Lenses (Fixed Focal Length)

Note: Many Nikon lenses have gone through several iterations during the course of their production. The minimum focusing distances listed in this and the following lens charts are for the most recent version of the lenses (as of the date of publication); older versions may have different minimum focus distances. Also, some modest rounding has been done to some focus distances to make the tables more readable.

Lens	Aperture Range	Filter	Hood	Min. Focus Distance	Angle of View
16mm D	2.8–22	included	built-in	10″ (25 cm)	180°
18mm D	2.8–22	77mm	HB-8	10″ (25 cm)	100°
20mm D	2.8–22	62mm	HB-4	10″ (25 cm)	94°
24mm D	2.8–22	52mm	HN-1	1′ (30 cm)	84°
28mm D	1.4–16	72mm	HK-7	1.15′ (35 cm)	74°
28mm D	2.8–22	52mm	HN-2	1′ (30 cm)	74°
35mm D	2–22	52mm	HN-3	10″ (25 cm)	62°
50mm D	1.4–16	52mm	HR-2	1.5′ (45 cm)	46°
50mm	1.8–22	52mm	HR-2	1.5′ (45 cm)	46°
85mm D	1.8–16	62mm	HN-23	3′ (85 cm)	28°30′
85mm D	1.4–16	77mm	HN-31	3′ (85 cm)	28°30′
180mm D ED-IF	2.8–22	72mm	built-in	5′ (1.5 m)	13°14′
300mm ED-IF	2.8–22	39mm, drop-in	built-in	10′ (3 m)	8°10′
300mm D ED-IF AF-I	2.8–22	39mm, drop-in	HK-19	8.5′ (2.5 m)	8°10′
300mm D ED-IF AF-S	2.8–22	52mm, drop-in	HK-22	8.5′ (2.5 m)	8°10′
300mm ED-IF	4–32	39mm, drop-in	built-in	8.5′ (2.5 m)	8°10′
400mm D ED-IF AF-I	2.8–22	52mm, drop-in	HK-20	11′ (3.3 m)	6°10′
500mm D ED-IF AF-I	4–22	39mm, drop-in	HK-21	16′ (4.9 m)	5°
500mm D ED-IF AF-S	4–22	52mm, drop-in	HK-24	16.5′ (5 m)	5°
600mm D ED-IF AF-I	4–22	39mm, drop-in	HK-18-1, 2	20′ (6 m)	4°10′
600mm D ED-IF AF-S	4–22	52mm, drop-in	HK-23	19.5′ (5.9 m)	4°10′

AF Nikkor Lenses (Special-Purpose)

Lens	Aperture Range	Filter	Hood	Min. Focus Distance	Angle of View
Micro 60mm D	2.8–32*	62mm	HN-22	8.75″ (22 cm)	39°40′
Micro 105mm D	2.8–32*	52mm	HS-7	1′ (30 cm)	23°20′
DC 105mm D	2–16	72mm	built-in	3′ (90 cm)	23°20′
DC 135mm D	2–16	72mm	built-in	4′ (1.2 m)	18°
Micro 70-180mm D ED	4.5–5.6	62mm	HB-14	1.25′ (0.37 m)	13°40′– 34°20′
Micro 200mm D ED-IF	4–32*	62mm	HN-30	1.7′ (50 cm)	12°20′

True at infinity

AF Nikkor Lenses (Zoom)

Lens	Aperture Range*	Filter	Hood	Min. Focus Distance**	Angle of View
20-35mm D IF	2.8–22	77mm	HB-8	1.7′ (50 cm)	62–94°
24-50mm D	3.3/4.5–22	62mm	HB-3	1.6/2.0′ (50/60 cm)	46–84°
24-120mm D IF	3.5/5.6–22	72mm	HB-11	2′ (60 cm)	20°30′–84°
28-70mm D	3.5/4.5–22	52mm	HB-6	1.3/1.6′ (39/50 cm)	34°20′–74°
28-70mm D ED-IF AF-S	2.8–22	77mm		1.5′ (45 cm)	34°20′–74°
28-80mm D	3.5/5.6–22	58mm	HB-10	1.7′ (50 cm)	30°10′–74°
28-85mm	3.5/4.5–22	62mm	HB-1	0.8/2.6′ (23/80 cm)	28°30′–74°
28-105mm D IF	3.5/4.5–22	62mm	HB-18	0.8′ (15 cm)	23°20′–74°
28-200mm D IF	3.5/5.6–22	72mm	HB-12	7′ (2.1 m)	12°20′–74°
35-70mm D	2.8–22	52mm	HB-1	0.9/2′ (28/60 cm)	34°20′–62°
35-80mm D	4/5.6–22	52mm	HN-3	1.2′ (35 cm)	30°10′–62°
35-105mm D IF	3.5/4.5–22	52mm	HB-5	2.8′ (85 cm)	23°20′–62°
35-135mm	3.5/4.5–22	62mm	HB-1	1/5′ (30 cm/1.5 m)	18–62°
70-210mm D	4.5/5.6–32	62mm	HN-24	4/5′ (1.2/1.5 m)	11°50′–34°20′
70-300mm D ED	4/5.6–32	62mm	HB-15	5′ (1.5 m)	8°10′–34°20′
75-300mm	4.5/5.6–32	62mm	HN-24	5/10′ (1.5/3 m)	8°10′–31°40′
80-200mm D	4.5/5.6–32	52mm	HR-1	5′ (1.5 m)	12°20′–30°10′
80-200mm D ED	2.8–22	77mm	HB-7	5/6′ (1.5/1.8 m)	12°20′–30°10′
80-200mm D ED-IF AF-S	2.8–22	77mm		5′ (1.5 m)	12°20′–30°10′

Some maximum apertures vary with focal length.

**When two distances are listed, the first number is the macro focusing distance, the second is the normal minimum focusing distance.*

Manual Nikkor Lenses (Fixed Focal Length)

Lens	Aperture Range	Filter	Hood	Min. Focus Distance	Angle of View
6mm	2.8–22	built-in	none	0.9′ (25 cm)	220°
8mm	2.8–22	built-in	none	1′ (30 cm)	180°
13mm	5.6–22	built-in	built-in	1′ (30 cm)	118°
15mm	3.5–22	rear-mount	built-in	1′ (30 cm)	110°
24mm	2–22	52mm	HK-2	1′ (30 cm)	84°
28mm	2–22	52mm	HN-1	0.9′ (25 cm)	74°
35mm	1.4–16	52mm	HN-3	1′ (30 cm)	62°
50mm	1.2–16	52mm	HR-2, HS-12	1.7′ (50 cm)	46°
85mm	1.4–16	72mm	HN-20	3′ (85 cm)	28°30′
105mm	2.5–22	52mm	built-in	3.5′ (1.1 m)	23°20′
135mm	2.8–32	52mm	built-in	4.5′ (1.3 m)	18°
200mm ED-IF	2–22	gelatin	HE-4, built-in	8.2′ (2.5 m)	12°20′
300mm ED-IF	2.8–22	39mm, drop-in	HE-4, built-in	10′ (3 m)	8°10′
400mm ED-IF	2.8–22	52mm, drop-in	HE-3, built-in	13′ (4 m)	6°10′
400mm ED-IF	3.5–22	39mm, drop-in	built-in	15′ (4.5 m)	6°10′
400mm ED-IF	5.6–32	72mm	built-in	13′ (4 m)	6°10′
500mm ED-IF	4–22	39mm, drop-in	HK-17	16′ (5 m)	5°
600mm ED-IF	4–22	39mm, drop-in	HE-5, built-in	21′ (6.5 m)	4°10′
600mm ED-IF	5.6–32	39mm, drop-in	HE-4, built-in	16′ (5 m)	4°10′
800mm ED-IF	5.6–32	52mm, drop-in	HE-3, built-in	26′ (8 m)	3°

Manual Nikkor Lenses (Special-Purpose)

Lens	Aperture Range	Filter	Hood	Min. Focus Distance	Angle of View
500mm Reflex	8	82/39mm	HN-27	5' (1.5 m)	5°
1000mm Reflex	11	39mm	built-in	26' (8 m)	2°30'
2000mm Reflex	11	built-in	built-in	60' (18 m)	1°10'
PC 28mm	3.5–22	72mm	HN-9	1' (30 cm)	74°
PC 35mm	2.8–32	52mm	HN-1	1' (30 cm)	62°
58mmNoct	1.2–16	52mm	HR-2, HS-7	1.7' (50 cm)	40°50'
Medical 120 IF	4–32*	49mm	none	1.1' (35 cm)	18°50'
Micro 200mm IF	4–32	52mm	built-in	2.3' (71 cm)	12°20'
UV 105mm	4.5–32	52mm	none	1.57' (48 cm)	23°20'

Range varies with film speed.

Manual Nikkor Lenses (Zoom)

Lens	Aperture Range	Filter	Hood	Min. Focus Distance	Angle of View
35-200mm	3.5/4.5–22	62mm	HK-15	1–5.5' (0.3–1.6 m)	12°20'–62°
50-300mm ED	4.5–32	95mm	HK-5	8.5' (2.5 m)	8°10'–46°
180-600mm ED	8–32	95mm	HN-16	8.5' (2.5 m)	4°10'–13°40'
1200-1700mm P ED-IF	5.6/8–22	52mm	built-in	35' (10 m)	1°30'–2°

Using a Teleconverter

Mounting a teleconverter between the camera and lens increases the lens' effective focal length. This increases subject magnification without affecting the lens' minimum focusing distance. Magnification increases by the power of the teleconverter being used. Nikon makes them in 1.4x and 2x powers.

Be aware that teleconverters decrease the effective aperture, resulting in some loss of light—the 1.4x by 1 stop and the 2x by 2 stops. Angle of view and depth of field are also reduced. The following chart reveals the effects that teleconverters have on focal length and aperture when used with certain lenses.

Original Lens	With 1.4x Converter	With 2x Converter
300mm f/4	420mm f/5.6	600mm f/8*
300mm f/2.8	420mm f/4	600mm f/5.6
400mm f/4	560mm f/5.6	800mm f/8*
500mm f/4	700mm f/5.6	1000mm f/8*
600mm f/5.6	840mm f/8*	1200mm f/11*

Autofocus may not work, even with an autofocus-capable converter, due to the reduction in the effective aperture. (Nikon's AF system requires an aperture of f/5.6 or faster in order to operate.)

Tip: Galen Rowell and other professional Nikon users have discovered that it is possible to use two converters (a 1.4x and 2x) at once with the high-speed long lenses that focus past infinity. They must be connected by putting an extension tube between the two converters. With a 500mm f/4, for example, this gives you a 1400mm ~f/11 lens that has reasonable resolving quality.

Nikon Teleconverters

TC-201: 2x. Compatible with AF and AIS lenses. Does not support autofocus. Two stops of light are lost. Use with lenses whose rear element protrudes.

TC-301: 2x. Compatible with AF and AIS lenses. Does not support autofocus. Two stops of light are lost. Use with lenses whose rear element is inset.

TC-14A: 1.4x. Compatible with AF and AIS lenses. Does not support autofocus. One stop of light is lost. Use with lenses whose rear element is flush.

TC-14B: 1.4x. Compatible with AF and AIS lenses. Does not support autofocus. One stop of light is lost. Use with lenses whose rear element is inset.

TC-14E: 1.4x. Compatible with AF-I and AF-S lenses. One stop of light is lost.

TC-20E: 2x. Compatible with AF-I and AF-S lenses. Two stops of light are lost.

AF Lens Teleconverter Compatibility

Lens	TC-201	TC-301	TC-14A	TC-14B	TC-14E	TC-20E
16mm D	MF	—	MF	—	—	—
18mm D	MF	—	MF	—	—	—
20mm D	MF	—	MF	—	—	—
24mm D	MF	—	MF	—	—	—
28mm f/1.4 D and f/2.8 D	MF	—	MF	—	—	—
35mm D	MF	—	MF	—	—	—
50mm D	<f/11, MF	—	<f/11, MF	—	—	—
50mm	MF	—	MF	—	—	—
85mm f/1.8 D	<f/11, MF	—	Vg, MF	—	—	—
85mm f/1.4 D	MF	—	MF	—	—	—
180mm D ED-IF	Vg	—	Vg	—	—	—
300mm N ED-IF	Vg	MF	Vg	MF	—	—
300mm D I ED-IF	—	MF	—	—	✓	✓
300mm D S ED-IF	—	MF	—	—	✓	✓
300mm f/4 ED-IF	Vg	MF	—	MF	Mod.	Mod.
400mm D I ED-IF	—	MF	—	MF	MF	MF
500mm D I or S ED-IF	—	MF	—	MF	✓	MF
600mm D I or S ED-IF	—	MF	—	MF	✓	MF
Micro 60mm D	<f/11, MF	—	<f/11, MF	—	—	—
Micro 105mm D	Vg	—	—	—	—	—
Micro 200mm D	Vg	—	—	—	—	—
DC 135mm	—	—	—	MF	—	—
20-35mm D	MF	—	MF	—	—	—
24-50mm D	MF	—	MF	—	—	—
24-120mm D	MF	—	MF	—	—	—
28-70mm D	MF	—	MF	—	—	—
28-85mm	<f/11, MF	—	<f/11, MF	—	—	—
35-70mm D	MF	—	MF	—	—	—
35-80mm D	MF	—	MF	—	—	—
35-105mm D	MF	—	MF	—	—	—
35-135mm	MF	—	MF	—	—	—
70-210mm D	MF	—	MF	—	—	—
75-300mm	Vg	—	Vg	—	—	—
80-200mm D	Vg	—	Vg	MF	—	—
80-200mm D ED	Vg	—	Vg	MF	—	—

✓ = *Fully compatible*
MF = *Manual focus only*
Vg = *Manual focus only, vignetting may occur.*
<f/11 = *Uneven exposure results at small apertures (f/11, f/16, f/22).*
Mod. = *Compatible, with modification*

Manual Lens Teleconverter Compatibility

Lens	*TC-201*	*TC-301*	*TC-14A*	*TC-14B*
6mm	MF	—	MF	—
8mm	MF	—	MF	—
13mm	MF	—	MF	—
15mm	MF	—	MF	—
24mm	MF	—	MF	—
28mm f/2	MF	—	<f/11, MF	—
35mm	<f/11, MF	—	MF	—
50mm	MF	—	Vg	—
85mm	<f/11, MF	—	<f/11, MF	—
105mm f/1.8	MF	—	MF	—
105mm f/2.5	MF	—	Vg	—
135mm	Vg	—	MF	MF
200mm f/2 ED-IF	<f/11, MF	—	Vg	MF
300mm f/2.8 ED-IF	Vg	MF	Vg	MF
400mm f/2.8 ED-IF	Vg	<f/11, MF	MF	<f/11, MF
400mm f/3.5 ED-IF	—	MF	Vg	MF
400mm f/5.6 ED-IF	—	MF	—	MF
500mm f/4 ED-IF	—	MF	—	MF
600mm f/4 N ED-IF	—	MF	—	MF
600mm f/5.6 ED-IF	—	MF	—	MF
800mm f/5.6 ED-IF	—	<f/11, MF	—	<f/11, MF
500mm Reflex	Vg	—	Vg	✓*, MF
1000mm Reflex	—	✓*	—	✓*
2000mm Reflex	—	✓*	—	✓*
58mm Noct	<f/11, MF	—	<f/11, MF	—
Medical 120mm IF	—	—	—	—
Micro 200mm IF	—	MF	Vg	MF
UV 105mm	—	—	—	—
35-200mm	Vg	—	—	—
50-300mm	MF	—	MF	—
180-600mm ED	—	MF	—	MF
1200-1700mm P ED-IF	—	—	—	—

MF = Manual focus only

Vg = Manual focus only, vignetting may occur.

<f/11 = Uneven exposure results with small apertures (f/11, f/16, f/22).

✓ = Manual focus; teleconverter usable if rear filter is removed.*

Depth of Field

Depth of field extends roughly 2/3 behind the point of focus and 1/3 in front of it. However with macro lenses, depth of field is greatly reduced, and the depth of field extends roughly equally in front of and behind the point of focus (see page 86).

Determining Hyperfocal Distance

Hyperfocal distance is the closest point at which one can focus to include infinity within the depth of field.

To determine the hyperfocal distance when using a lens with depth-of-field marks:

1. Set the desired aperture.

2. Each aperture is listed twice on the depth-of-field scale. Turn the focusing ring so that the infinity symbol aligns with one of the aperture numbers corresponding to the aperture you have set.

3. Read the distance opposite the central index on the depth-of-field scale. This is the hyperfocal distance. The distance opposite the other corresponding aperture number on the depth-of-field scale is the near depth-of-field limit.

Hyperfocal Distances in Feet*

f/stop	16mm	20mm	24mm	28mm	35mm	50mm	100mm	200mm	300mm
1.4	24'	38'	54'	74'	115'	235'	938'	3750'	8437'
2	19'	29'	42'	57'	89'	182'	729'	2917'	6563'
2.8	12'	19'	27'	37'	58'	117'	469'	1875'	4219'
4	8'6"	13'	19'	26'	40'	82'	328'	1313'	2954'
5.6	6'	9'5"	14'	18'	29'	59'	235'	938'	2110'
8	4'3"	6'8"	9'6"	13'	20'	41'	164'	657'	1477'
11	3'2"	4'10"	7'	9'6"	15'	30'	120'	478'	1075'
16	2'2"	3'4"	4'10"	6'6"	10'	21'	82'	329'	739'
22	1'6"	2'6"	3'6"	4'9"	7'5"	15'	60'	239'	538'
32	1'1"	1'9"	2'5"	3'4"	5'2"	10'	41'	165'	370'

Hyperfocal distances in this chart were calculated using a circle of confusion diameter of .025mm (Zeiss standard). All distances were rounded to the nearest foot above 10 feet, to the nearest inch below 10 feet.

Hyperfocal Distances in Meters*

f/stop	16mm	20mm	24mm	28mm	35mm	50mm	100mm	200mm	300mm
1.4	7.3	11.4	16.5	22.4	35	71	286	1143	2571
2	5.7	8.9	12.8	17.4	27.2	56	222	889	2000
2.8	3.66	5.7	8.2	11.2	17.5	36	143	571	1286
4	2.56	4	5.8	7.8	12.3	25	100	400	900
5.6	1.83	2.86	4.11	5.6	8.8	17.9	71	286	643
8	1.28	2	2.88	3.92	6.1	12.5	50	200	450
11	0.93	1.46	2.10	2.85	4.46	9.1	36	145	328
16	0.64	1	1.44	1.96	3.06	6.3	25	100	228
22	0.47	0.73	1.05	1.43	2.23	4.55	18.2	73	164
32	0.32	0.5	0.72	0.98	1.53	3.13	12.5	50	113

Hyperfocal distances in this chart were calculated using a circle of confusion diameter of .025mm (Zeiss standard). All distances were rounded to the nearest meter above 25 meters, to .1 meter from 5 to 25 meters, and to .01 meter below 5 meters.

Determining Light Falloff Performance

To roughly estimate the aperture at which a particular lens will experience no light falloff:

1. Mount the lens on your camera and aim it at a small, bright light—a distant street light at night is ideal.

2. Place the light in the center of the viewfinder.

3. Refocus the lens to its closest focus distance so the light becomes a round blur.

 Note: You may not be able to use the closest focus distance with some lenses because at their closest focus distance they produce a general blur of the entire scene rather than a point blur. If that is the case, just move the focus point towards you and away from the light until you can see a round blur, not a distinct object.

4. Now reposition the blur into one corner of the viewfinder. If the previously blurred circle becomes a pointed ellipse, then mechanical vignetting is taking place (i.e., you are experiencing light falloff typical of most lenses).

5. Select smaller apertures one at a time until the vignetting disappears (i.e., the ellipse becomes a circular blur again). Typically, you'll need to close down the aperture between 1 and 3 stops to eliminate falloff entirely.

Using a Wide-Angle Lens

One of the benefits of wide-angle lenses is that they allow you to include a broad expanse of information in the photograph. However because of their wide angle of view (and depending upon the level of optical correction), they can produce some image distortion.

Wide-angle shots are often made more interesting if you include a foreground subject, giving the scene a visual focal point and a size reference.

1. Compose the frame to include a foreground subject, if possible.

2. Move in close to the foreground subject.

3. Be aware of distortion of the objects at the edges of the frame (or use it for creative effect).

4. Use a bubble level to reduce the keystone effect (or tilt the lens to exaggerate the effect).

Focal Length and Perspective

Perspective is the rendition of three-dimensional objects in two dimensions. A common misconception is that perspective is determined by the lens' focal length. This is not the case. Perspective is controlled by changing the camera-to-subject distance.

In other words, if you take three photographs of a subject from a single location with three different focal length lenses, perspective is unchanged. In other words, the size relationship between objects remains the same. However, if you take three photographs with the same lens but change the camera-to-subject distance, perspective (the size relationship between subjects) does change.

Basic Flash Information

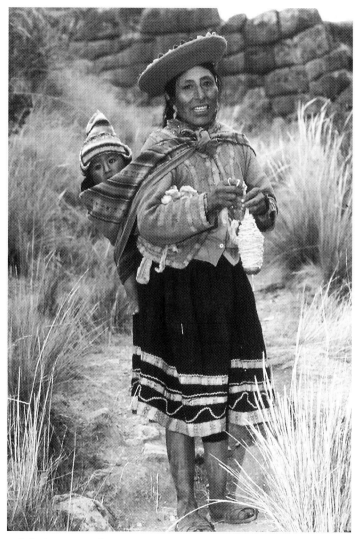

Fill flash was used to evenly illuminate this Peruvian woman's face, add small catchlights to enliven the subjects' eyes, and soften harsh shadows caused by the bright sun.

Electronic Flash

Electronic flash is essentially a portable sun that is available no matter what the weather or lighting conditions. Flash can render subjects either super-sharp or blurred, with either high or low contrast. Edges and textures can be enhanced, and backgrounds emphasized or de-emphasized by using simple flash techniques. In most cases, the use of electronic flash is most impressive when it is subtle and hardly noticeable.

Flash Exposure Principles

The quanity of light emitted by an electronic flash is determined by the power of the flash unit and the duration of the burst of light. The light from the flash is subject to the following limitation:

Brightness Decreases with Distance. Light is subject to the Inverse Square Law—brightness decreases in proportion to the square of the distance it travels. Thus, the distance of the flash unit from the subject determines the amount of light that actually reaches the subject.

Flash Synchronization

For exposure of the complete film frame, the flash must be fired when the focal-plane shutter is completely open across the entire width of the image. If the flash is fired before the shutter is completely opened, partially exposed or even completely unexposed pictures will result. As a rule, this problem does not occur with most current Nikon cameras in automatic modes because the camera will not select a shutter speed faster than the maximum available sync speed.

Guide Number (GN)

Guide number (GN) is a numerical value assigned to measure a flash unit's maximum light output. Guide numbers are generally calculated with ISO 100 film as the standard. The higher the GN, the greater the flash output. GN can be used to calculate exposure settings using the following formula:

GN ÷ Distance = Aperture

Note: Since distance is part of the guide number formula, guide numbers can be calculated in meters or feet. In the United States,

guide numbers are calculated in feet and are consequently 3.3 times larger than the corresponding metric guide number.

To calculate a guide number for an ISO value other than 100, use the following adjustments:

Film Speed	Multiply GN By	Film Speed	Multiply GN By
40	0.63	320	1.8
50	0.7	400	2
64	0.8	500	2.25
80	0.9	640	2.5
100	1	800	2.8
125	1.12	1000	3.15
160	1.25	1250	3.55
200	1.4	1600	3.95
250	1.6		

Guide Numbers and Side-Lighting

For lighting with flash coming from angles greater than 30° to the camera-subject axis, a general rule is to open the aperture by:

- 1/2 f/stop at 45 °
- 1 f/stop at 60°
- 2 f/stops at 70°

Guide Numbers and Zoom Flash Heads

Adjusting a flash unit's zoom head changes the angle of illumination and the effective distance range of the flash unit. For GN ratings for specific Nikon Speedlights at various zoom head settings, see the corresponding instruction sections that follow.

Using Guide Numbers in Outdoor Photography

Guide numbers are formulated for typical indoor situations. In outdoor shooting situations, the effective output of a flash unit is usually about 70% of the rated guide number. If in doubt, bracket the exposures or test in advance.

Speedlight Flash Modes

Manual Flash Mode (M)

With manual flash, the photographer computes the correct aperture for the subject distance and film speed, or takes a flash meter reading and adjusts the aperture accordingly. With full manual, the flash unit has only one output, which is rated by its GN.

When to Use Manual Mode: Many photographers who are well versed in flash use manual mode in unusual conditions (with subjects exhibiting high or unusual reflectance) or when they want full control for producing creative effects. It is best to make a series of bracketed exposures, in fixed increments over and under the calculated exposure when using manual flash.

Power Output Control in Manual Mode: Some Nikon Speedlights allow you to reduce the power output so that aperture and distance can be varied within a wide range of choices.

Automatic "Sensor" (Non-TTL) Flash Mode (A)

With automatic (A) flash mode, a sensor on the front of the flash determines when the exposure is correct. This was the first type of automatic flash technology available and, while it was welcomed with enthusiasm when it was first introduced, it is rarely used today as it is far inferior to more sophisticated through-the-lens (TTL) flash.

Standard TTL Flash Mode (TTL)

"TTL" means through-the-lens. In this mode, the light from the flash passes through the lens and is reflected off the film to a flash metering cell inside the camera body. The camera's computer then adjusts the flash for proper exposure.

Using this mode is relatively simple: The photographer preselects an aperture appropriate for the distance range.

Automatic TTL Flash Modes (A-TTL)

In the automatic TTL flash modes, the camera's computer takes the ambient light exposure into consideration before determining the actual flash exposure. This generally renders the scene with a mixture of flash and ambient light to produce a correct and pleasing exposure.

A-TTL with Center-Weighted Metering

In this mode ambient light is measured using center-weighted metering. The flash is adjusted based on the TTL flash measurement.

When to Use A-TTL with Center-Weighted Metering: This mode makes it possible to use A-TTL flash when non-AF lenses are used on recent Nikon cameras. It is sometimes an appropriate choice though, even with an AF lens. If the central portion is the primary subject of the photograph, and the background is totally unimportant, select this method to concentrate on the exposure of the central area. You can also do this with spot metering if a highly selective area is desired.

A-TTL with Spot Metering

Principally, the same applies here as for center-weighted A-TTL flash mode (above).

When to Use A-TTL with Spot Metering: The time to use this mode is when targeting exposure for a specific area by using AE-L. However, it is important to select an area to meter that is of middle value (18% gray).

A-TTL with Matrix Metering

When used with cameras that offer matrix metering, this mode automatically evaluates the ambient light (and in the case of backlit subjects, the contrast relationship between the subject and background brightness) using matrix metering. This is done before the actual flash exposure is calculated. The TTL sensor then controls the flash during the exposure.

When to Use A-TTL with Matrix Metering: For general photography, matrix metering with automatic exposure will produce very reliable exposures. However, subjects with unusual reflectance or lack of reflectance (black on black or white on white) or subjects that are off-center could pose problems.

A-TTL Multi-Sensor with Matrix Metering

This mode is available with the F100, F5, N90/F90, N90s/F90X, N70/F70, and N60/F60 cameras only when used with AF Nikkor type D lenses. As in matrix-balanced TTL flash, the aperture, shutter speed, and duration of the flash are adjusted before the shutter release is pressed. During the actual flash exposure, the exposure process is similar to A-TTL with matrix metering, however the TTL flash exposure is determined by a sophisticated five-segment multisensor flash metering system.

> ***When to Use A-TTL Multi-Sensor with Matrix Metering:*** With an appropriate camera and lens, this mode is ideal for all subjects and situations. This method handles extremes in subject reflectance and unusual subject placement particularly well.

Monitor Preflash

When the shutter release is pressed all the way, the flash unit (SB-26, SB-27, and SB-28) emits a series of invisible preflashes, which are evaluated by the flash multi-sensor in appropriate cameras (see above). Spatial distribution and the reflectance of the main subject and the background are evaluated and the flash exposure is fine-tuned based on these preflash readings.

> ***When to Use Monitor Preflash:*** Use preflash for all subjects and situations, because this additional information cwwan only result in an improved exposure.

Exposure Considerations

It is important to note these exposure principles when working with flash:

1. The camera metering method affects only the ambient light exposure, even with TTL flash modes.

2. Matrix metering gives optimal consideration to both ambient light and subject contrast. When A-TTL flash mode is used, this is the recommended camera metering method for best exposure of ambient light. However, it is available only with AF, AI-P, and AF-D Nikkor lenses (except the F4, which can also use AI/AI-S lenses).

Advanced Flash Techniques

Bounce Flash

Bounce flash is a valuable technique for achieving natural-looking flash photos of people and groups. Because the light from the flash is reflected off a surface such as a ceiling, it is softened and falls on the subject from a more pleasing direction than straight, harsh, on-camera flash.

To begin, the Speedlight flash should be set to one of the A-TTL modes and the flash head tilted to 60°. The flash should be test-fired. If the ready light blinks, the picture may be underexposed. In this case, move closer, check the angle of the flash head, or open the lens aperture. However, upon further test-firings, if the ready light continues to blink, try a faster film (higher ISO number).

Tips for Shooting with Bounce Flash: Because the light travels a much greater distance than with direct flash, the effective flash-to-subject range is reduced. Make sure the flash and the settings you have chosen are sufficient to travel the extra distance. Also, remember that you are working with reflected light. Bounced light will reflect the color of the surface it is bouncing off.

Sometimes when flash is bounced from a ceiling, shadows fall in the subject's eye sockets. To minimize this effect, use the diffuser card available with the SB-25, SB-26, SB-27, and SB-28. This usually also produces a "catchlight"—the bright spot of light that gives life to the subject's eyes—which is quite pleasing in a portrait.

Tools for Controlling Light

These devices modify or control flash for soft or creative effects:

- *Reflector*—Bounces light into shadow areas
- *Diffuser*—Softens light
- *Flag or Gobo*—Black or opaque object that blocks light from an area
- *Umbrella*—Softens and scatters light
- *Snoot*—Narrows light beam by blocking it
- *Fresnel lens*—Narrows light beam by focusing it
- *Cookie (Cukaluris)*—Patterned template that gives shape to shadows

Slow-Sync Flash

Slow-sync flash is usually used to improve the exposure of excessively dark backgrounds. Slow-sync provides a shutter speed long enough to expose the dark background, while the light from the flash exposes the subject.

• With the F100, F5, F4, N90s/F90X, and N70/F70 manual or shutter-priority mode can be used to set the desired slow shutter speed.

• With the F100, F5, N90s/F90X, N70/F70, and N60/F60 program and aperture-priority mode will automatically set an appropriately slow shutter speed for background exposure if SLOW mode has been set on the camera.

Motion Blurs with Rear-Sync Flash

This mode alters the time at which the flash fires in relation to the shutter sequence so that motion blurs are rendered realistically behind a moving subject.

• *Set the camera to rear-sync flash mode if you want moving objects to have streaks following behind them.*

• *Set the camera to shutter-priority (S) mode.* This allows you to set a shutter speed slow enough to insure motion blur in the foreground (or if you are panning with the subject, background blur).

• *Set your shutter speed between 1/30 and 1/4 second and check the available aperture.* Longer shutter speeds tend to introduce too much blur, while shorter shutter speeds reduce the possibility of blur.

High-Speed Synchronization (FP)

Currently this feature is available with the F100, F5, N90/F90, and N90s/F90X combined with the SB-25, SB-26, or SB-28. High-speed sync combines extremely fast shutter speeds with flash to record a daylight subject frozen in mid-action. High-speed sync can also be used with fill flash in daylight to give emphasis to the foreground subject while blurring the background. This would not be possible in normal automatic fill-flash mode because the longer shutter speed would expose the background accurately, but far too bright for the effect you desire. This technique is also used to superimpose several images on a single frame for a stroboscopic flash effect.

How to Use High-Speed Flash: In FP mode, the opening of the first shutter curtain causes the Speedlight to trigger an uninterrupted sequence of short high-frequency flash bursts. These many bursts contribute to the total image exposure as the open slit of the shutter curtains travels across the film. This technique decreases the effective flash output, causing the guide number to drop significantly. TTL flash is not possible with FP, so the camera and flash must be adjusted manually.

Red-Eye and How to Prevent It

Red-eye is caused by the light from the flash reflecting off the back of the retina. While there is never a guarantee when it comes to red-eye, here are a few ways you can prevent or reduce its effect.

• *Use the red-eye reduction feature, if available, on your Speed-light or built-in flash.* This may however only reduce, not eliminate, red-eye, and it is sometimes distracting to the subject.

• *Don't let the subject look directly at the camera.* If the subject is looking more than about 15° to the side, red-eye usually doesn't occur.

• *Move the flash away from the lens axis.* Use an SC-17 cord and take the flash off the camera body or use a flash bracket such as a Stroboframe® flash bracket.

• *Use bounce flash.* Bounce flash will not cause red-eye, however it does reduce the flash range considerably.

Basic Flash Troubleshooting Checklist

If your flash isn't working, or you suspect it isn't working properly, here are some things to check:

• *Check the power switch!* Nikon flash units need to be set either to ON or STBY (Standby).

• *Check to make sure the batteries are installed correctly.*

• *Check battery life.* If the power switch is on but the LCD does not illuminate, the zoom motor races, or if the flash is slow to recharge, the batteries may be weak, cold, old, or infrequently used. Such batteries may show up as "okay" according to the battery indicator, but may be borderline instead. Replace them.

• *Check battery contacts.* Use a pencil eraser (clean up the "crumbs" afterward) to clean the contacts on the batteries and

inside the flash unit's battery chamber. A moistened cotton swab should be used to wipe up any battery fluid or other grime on the contacts first. Make sure that the battery contacts haven't lost their "spring," which keeps them from making good contact with the battery.

- *Test-fire the flash.* Make sure that the flash is recycling and capable of flashing by pressing the test-flash button. Try removing the flash from the camera and test-firing it. If a non-firing flash test-fires, the problem is usually with the camera.

- *Make sure that the camera is set for flash.* On Nikon equipment, the main thing to check is that your camera's shutter speed is set within the allowable sync range (for example, 1/30 to 1/250 second for a N90s/F90X; slow sync extends the lower range to 30 seconds). In automatic settings, the camera will not allow the setting of a sync speed faster than the maximum, however, in manual mode it is possible to make a mistake, so check your settings!

- *Make sure the ready light comes on.* Confirm that the ready light illuminates on both the flash unit's LCD and in the camera's viewfinder. If it comes on in one, but not the other, you may have isolated the problem.

- *Check the flash unit's LCD for error messages.* Any message that is flashing on the LCD indicates one of two things:

 1. The previous exposure was out of flash range. Check settings or test-fire the flash to doublecheck the distance. Adjust your aperture and/or flash settings to achieve proper exposure.
 2. You are currently in a mode in which you are supposed to be setting the flash, not using it. Finish setting the flash, or press the SEL button until it is in the correct mode for operation.

- *Check the flash unit's contacts with the camera.* As with the battery contacts, clean these contacts with a pencil eraser and possibly a cotton swab. With Nikon flash units, make sure that they are fully locked to the camera by tightening the knurled locking wheel on the flash shoe.

- *Check the underexposure indicator (if available).* If the underexposure indicator is lit and a number (e.g., –2.0) appears after firing the flash, you may need to open the aperture by that number of stops in order to get a correct exposure.

Hint: If the flash unit's underexposure data on the LCD has disappeared, you can recall the information for the last shot fired by pressing the LCD illuminator button.

Nikon Flash Unit Comparison

Flash Unit	Flash Coverage	Recycle Time*	Maximum Duration	Minimum Duration	Guide Number**
SB-11	35mm	8	1/800 second	NA	118
SB-14	28mm	8	1/800	NA	105
SB-140†	28mm	8	1/800	NA	105
SB-16a/b	28–85mm‡	1	1/1,250	1/8,000 second	105
SB-17	35mm‡	8	1/1,400	1/10,000	82
SB-20	28, 35, 85mm	7	1/1,200	1/15,000	98
SB-21a/b	NA	8	1/1,600	1/25,000	~43
SB-22	35mm‡	4	1/1,700	1/8,000	82
SB-23	35mm	2	1/2,000	NA	65
SB-24	24–85mm	7	1/1,000	1/20,000	118
SB-25	20, 24–85mm	7	1/1,000	1/23,000	118
SB-26	18, 20, 24–85mm	7	1/1,000	1/23,000	118
SB-27	24, 35–70mm	5	1/1,000	1/6,700	98
SB-28	18, 20, 24–85mm	6.5	1/830	1/8,700	118

Minimum time, in seconds, with fresh AA alkaline batteries

**In feet, at 35mm setting, for ISO 100 film*

†*For UV or IR use*

‡*Goes wider with diffuser in place*

NA: Information not available

Speedlight SB-28 Instructions

The Speedlight SB-28 is very similar to the SB-26 in its capabilities, however, the SB-28 is more compact and cannot be triggered remotely. Because it does not have a normal/rear flash sync control, rear-curtain sync is possible only with cameras that offer that option.

Changing the Distance Display to Feet or Meters

1. If the distance display on the LCD panel reads either feet or meters and you would like to change it to the opposite unit of measurement, press the ON/OFF button to turn the unit off.

2. Hold down the LCD illuminator button while pressing the ON/OFF button.

To reverse the setting, repeat the procedure.

Setting the ISO Film Speed Manually*

1. Push the SEL button until the film speed value blinks on the LCD panel.

2. Use the + or – adjustment buttons to enter the desired film speed.

3. Press the SEL button again to set the speed.

For cameras such as the F3 and FM2n, which do not supply the film speed to the flash unit automatically.

Setting the Aperture Value Manually

1. With manual cameras, set either M or A (non-TTL) mode on the flash unit. With electronic cameras set the flash unit to A (non-TTL) mode. This is done by pressing the mode button until the corresponding symbol (M or A) appears on the LCD panel.

2. Push the SEL button until the aperture value blinks in the LCD.

3. Use the + or – adjustment buttons to enter the desired aperture.

4. Press the SEL button again to set the aperture value.

Setting the Zoom Head Position Manually

1. If your camera cannot transmit the lens' focal length automatically to the flash unit's LCD panel, press the zoom button until the zoom value appears. An M appears above the word zoom.

2. Press the zoom button to set the zoom value.

3. To resume automatic zoom setting, press the zoom button until the M disappears above the word zoom on the LCD.

Or,

1. If your camera transmits the lens' focal length automatically to the flash unit's LCD and you want to override the focal length displayed, press the zoom and + buttons at the same time until the M starts blinking above the word zoom on the LCD.

2. Press the zoom button to set the zoom value.

3. To re-instate automatic zoom head setting, press the zoom and + buttons again until the M disappears above the word zoom.

In either case, when the Fresnel lens is pulled out over the flash head, 20mm is set automatically. 18mm can also be set by pressing the zoom button when the Fresnel lens is pulled out. Push the Fresnel lens back into its compartment to cancel these settings.

Setting TTL Auto Flash Mode

The TTL flash modes are possible only with cameras that have TTL technology.

1. On the camera, set the aperture and the flash sync mode to normal or rear, as desired.

2. Set the camera's metering mode (3D multi-sensor, multi-sensor, center-weighted, or spot).

3. For standard TTL, press the mode button until ⎚ appears on the LCD panel. (With the F100 or F5 set to spot, this is the mode you must use.)

4. For 3D multi-sensor or multi-sensor fill, press the flash unit's mode button until ⎚ or ⎚ appears next to the ⎚ symbol (this depends upon the camera in use—if your camera does not offer matrix metering, the ⎚ symbol appears).

4. For center-weighted or spot, press the flash unit's mode button until the ⎚ symbol appears next to the ⎚ symbol (F4, F5, F100 excluded).

5. Confirm the zoom position, distance, and ISO film speed.

3D multi-sensor metering is automatically selected if the camera offers it and a D-type lens is used; with non D-type lenses, the multi-sensor pattern is set. If the camera offers neither of these metering patterns, the one set on the camera is used.

Setting Non-TTL Auto Flash (A) Mode

1. Press the mode button until A appears on the LCD panel.

2. Set the desired aperture on both the flash (see "Setting the Aperture Value Manually" on page 112) and the camera.

3. If the camera has a flash sync control, set it to normal or rear, as desired.

4. Set the exposure mode and shutter speed on the camera.

5. Confirm the ISO and zoom settings.

6. Check that your subject falls within the distance range displayed on the flash unit's shooting distance scale.

7. After the ready light illuminates, you can take the picture.

8. If the ready light blinks after the exposure has been made, the flash may have been insufficient for proper exposure. In that case, set a wider aperture or move closer to your subject.

Setting Manual Flash (M) Mode

1. Press the mode button until M appears on the LCD panel.

2. If the camera has a flash sync control, set it to normal or rear, as desired.

3. Set the ISO film speed (see "Setting the ISO Film Speed Manually" on page 112) and the zoom head position (see "Setting the Zoom Head Position Manually" on page 112).

4. To adjust the power output control, press the + or – button to choose the desired light output. The output changes in 1/3-stop increments in a sequence that combines both flash output and flash exposure compensation. The selected power setting appears in the upper right-hand corner of the LCD panel. Press the SEL button to enter your selection.

5. Check that the distance range indicated on the LCD panel corresponds with the flash-to-subject distance. Adjust flash output if necessary.

6. Set the aperture (and shutter speed, if necessary) on the camera.

7. If the aperture value on the flash unit has not been set automatically by the camera to match the lens' aperture, set it manually (see "Setting the Aperture Value Manually" on page 112).

8. When the ready light illuminates, you can take the picture.

Setting Repeating Flash

1. Set the camera to manual mode and select an appropriate shutter speed. (Shutter speeds should be as slow as possible for the lighting conditions; B [bulb] can be used in total darkness.)

Formula: **Shutter Speed = Number of Flashes per Frame**
Flash Speed (in Hz)

Example: 1 second = 8 flashes per frame/8 Hz

2. Set the aperture (see "Setting the Aperture Value Manually" on page 112).

3. If the camera has a flash sync switch, set it to normal.

4. If the zoom head position has not been set automatically to match the lens' focal length, set the zoom head position (see "Setting the Zoom Head Position Manually" on page 112).

5. Press the mode button until M and the repeating flash symbol (three lightning bolts) appear at the top of the LCD panel.

6. Press the SEL button until the flash output value blinks. Press the + or – button to set the flash output. When the number stops blinking or the SEL button is pressed, the number is set.

7. Press the SEL button until the number of flash bursts per second (Hz) blinks. Press the + or – button to set the flash frequency (number of flashes fired per second). When the number stops blinking or the SEL button is pressed, the number is set.

8. Press the SEL button until the number of flashes per frame blinks (the number farthest to the left on the LCD panel). Press the + or – button to set the desired number.

SB-28 Maximum Repeating Flashes

Hz	1/8	1/16	1/32	1/64
1–2	14	30	60	90
3	12	30	60	90
4	10	20	50	80
5	8	20	40	70
6	6	20	32	56
7	6	20	28	44
8	5	10	24	36
9	5	10	22	32
10	4	8	20	28
20–50	4	8	12	24

9. If the aperture value on the flash unit has not been set automatically by the camera to match the camera's aperture, set it manually (see "Setting the Aperture Value Manually" on page 112).

10. If necessary, press the + or – adjustment button to make the distance on the flash unit's LCD match the subject distance.

11. If necessary, reset the aperture on the camera to match that on the flash unit's LCD panel.

12. Reduce the aperture by 1 or 2 stops to compensate for subject overlap.

13. When the ready light illuminates, you can take the picture.

Setting High-Speed Sync Flash

For the F100, F5 and N90s/F90X only

1. Press the flash unit's mode button until M appears at the top of the LCD panel.

2. Set the camera's flash sync mode to normal.

3. Confirm the ISO and zoom setting.

 Note: You cannot use the 18mm or 20mm zoom setting.

4. Choose a shutter speed from 1/250 to 1/4000 second on the camera.

5. Press the flash unit's + or – button until FP appears on the LCD panel.

6. Set the aperture indicated by the camera on the flash (for non-AF lenses).

7. Focus on the subject.

8. Confirm that the flash-to-subject distance corresponds to that shown on the flash unit's shooting distance scale. If not, move your or the subject's position, or choose a different zoom head setting.

9. When the ready light illuminates, you can take the picture.

SB-28 High-Speed Guide Numbers
(in feet, at ISO 100)

Shutter Speed	24mm	28mm	35mm	50mm	70mm	85mm
1/250	46	50	56	65	74	77
1/500	33	36	39	46	52	56
1/1000	23	25	28	33	36	39
1/2000	16	17	20	23	26	28
1/4000	11	12	14	16	18	20

(in meters, at ISO 100)

Shutter Speed	24mm	28mm	35mm	50mm	70mm	85mm
1/250	14	15	17	20	23	24
1/500	10	11	12	14	16	17
1/1000	7	7.5	8.5	10	11	12
1/2000	5	5.3	6	7	8	8.5
1/4000	3.5	3.7	4.2	5	5.6	6

Rear-Curtain Sync

Rear-curtain sync flash can be performed with the SB-28 only when used with cameras that have a rear-curtain sync control (such as the N90s/F90X, N70/F70, F5, and F100). However, it cannot be used in the following cases:

- When using a vari-program or red-eye reduction (N90s/F90X, N70/F70)

- When using the SB-28 as a secondary unit in a multiple-flash setup (N90s/F90X, N70/F70, F5, F100)

- When the shutter speed is set at T (time exposure) (F4, F5)

- In FP or repeating flash mode

Flash Exposure Compensation

Exposure adjustments made on the camera affect the entire expo-sure. By changing the ISO setting or the exposure compensation dial on the camera body, the aperture, shutter speed, and flash duration will be affected in all auto TTL flash modes. This will change the exposure of the image's foreground **and** background. However care must be taken, since a change in the film speed also results in a change of the guide number, and hence, the shooting range.

Adjustments made to the flash exposure affect only the subject. Flash exposure adjustments, also called "flash compensation," are made on the LCD of the flash or with the MF-26 Multi-Control Back on the N90s/F90X. These changes cause a variation of the duration of the flash that is independent of the camera's selection of aperture and shutter speed. The resulting change in foreground brightness (affected by flash compensation) is different from that of the background.

Set flash exposure compensation by following these steps:

1. Press the mode button until 🞖 appears on the LCD panel.

2. Press the SEL button until the 🞖 indicator appears and a compensation value blinks in the top right-hand corner of the LCD panel.

3. Press the + or – adjustment button to change the compensation value in 1/3-stop increments.

4. Press the SEL button again to set desired compensation value.

To cancel, set the value to **0.0**.

Flash Exposure Bracketing

The N90s/F90X can be used with the Multi-Control Back MF-26 to bracket flash exposure. A series of exposures can be made in increments determined by the photographer (from 0.3 to 2.0 stops) by using the flash exposure bracketing mode of the Multi-Control Back MF-26. This type of exposure compensation affects only the flash exposure.

Test-Firing the Flash

1. Turn the flash on.

2. Press the red flash button. If the ready light blinks, there may not be enough flash for correct exposure at the set aperture.

Using the Flash at Close Distances (<2 ft. or <0.6 m)

1. Press the mode button until ▦ appears on the LCD panel.
2. Pull out the wide-angle diffuser and place it in front of the flash head.
3. Set the zoom setting to 20mm or 18mm on the LCD panel, regardless of the focal length of the lens in use.
4. Set the camera's exposure mode to aperture-priority, manual, or close-up mode.
5. Set the aperture. Determine the aperture to use as follows:

Formula: **Aperture = Value* / Flash-to-Subject Distance**

*Where Value Is: 14 feet or 4.3 meters for ISO 100 or lower
26 feet or 8 meters for ISO 125 to 400
36 feet or 11 meters for ISO 500 and above

Example: ~f/16 = 14 /1 foot, at ISO 50

SB-28 Guide Numbers

(in feet, at ISO 100)

Output	18mm	20mm	24mm	28mm	35mm	50mm	70mm	85mm
full	59	66	98	105	118	138	157	164
1/2	42	46	69	74	84	98	112	118
1/4	30	33	49	53	59	69	79	82
1/8	21	23	35	37	42	49	56	59
1/16	15	16	25	26	30	35	39	42
1/32	10	11	17	19	21	25	28	30
1/64	8	8	12.5	13	15	17	20	21

(in meters, at ISO 100)

Output	18mm	20mm	24mm	28mm	35mm	50mm	70mm	85mm
full	18	20	30	32	36	42	48	50
1/2	12.7	14	21	22.5	25.5	30	34	36
1/4	9	10	15	16	18	21	24	25
1/8	6.4	7	10.5	11.3	12.7	15	17	18
1/16	4.5	5	7.5	8	9	10.5	12	12.7
1/32	3.2	3.5	5.3	5.7	6.4	7.5	8.5	9
1/64	2.3	2.5	3.8	4	4.5	5.3	6	6.3

SB-28 Flash Range

(in feet, at ISO 100)

f/stop	20mm	24mm	28mm	35mm	50mm	70mm	85mm
1.4	4.1–46	6.2–60	6.6–60	7.4–60	8.6–60	9.8–60	10–60
2	2.8–32	4.4–49	4.7–52	5.2–58	6.1–60	7.0–60	7.2–60
2.8	2.1–23	3.1–34	3.3–37	3.7–41	4.3–48	4.9–55	5.1–58
4	2.0–16	2.2–24	2.4–26	2.6–29	3.0–34	3.5–39	3.6–41
5.6	2.0–11	2.0–17	2.0–18	2.0–20	2.2–24	2.5–27	2.6–29
8	2.0–8.2	2.0–12	2.9–13	2.0–14	2.0–17	2.0–19	2.0–20
11	2.0–5.7	2.0–8.6	2.0–9.2	2.0–10	2.0–12	2.0–13	2.0–14
16	2.0–4.1	2.0–6.1	2.0–6.5	2.0–7.3	2.0–8.6	2.0–9.8	2.0–10

(in meters, at ISO 100)

f/stop	20mm	24mm	28mm	35mm	50mm	70mm	85mm
1.4	1.3–14	1.9–20	2–20	2.3–20	2.6–20	3.0–20	3.2–20
2	0.9–10	1.4–15	1.5–16	1.6–18	1.9–20	2.2–20	2.2–20
2.8	0.7–7	1.0–10	1.0–11	1.1–13	1.4–14	1.5–16	1.6–17
4	0.6–5	0.7–7.5	0.7–8	0.8–9	1–10	1.1–12	1.1–12
5.6	0.6–3.5	0.6–5.3	0.6–5.6	0.6–6.3	0.7–7.4	0.8–8.4	0.8–8.8
8	0.6–2.5	0.6–3.7	0.6–4	0.6–4.5	0.6–5.2	0.6–6	0.6–6.2
11	0.6–1.7	0.6–2.6	0.6–2.8	0.6–3.2	0.6–3.7	0.6–4.2	0.6–4.4
16	0.6–1.2	0.6–1.8	0.6–2	0.6–2.3	0.6–2.6	0.6–3	0.6–3.1

Each doubling of ISO shifts the f/stop up one row (e.g., if you are using ISO 200 film and f/2, read the f/1.4 row); with each halving of the ISO, shift down one row.

SB-28 Maximum Recycling Speed

In manual (M) flash mode, at 1/8 power or lower, the SB-28 can recycle as fast as 6 frames per second (assuming fresh batteries) when shooting with a motor drive. The number of continuous flashes varies with light output:

Output	*Maximum Continuous Flashes (at 6 fps)*
1/8	4
1/16	8
1/32	16
1/64	30

An external power source, NiCad, or lithium batteries may increase these numbers slightly.

Shooting fewer frames per second gives the flash more time to recycle and does not tax the flash unit's capabilities as heavily. This increases the number of continuous flashes possible or allows you to use greater flash output. In manual mode at full or 1/2 power or in TTL, A, or repeating flash mode, 15 continuous flashes are the maximum number you should attempt. When using manual flash mode with 1/4 output or lower, 40 continuous flashes are the maximum.

Caution: Continuous flash firing generates heat that could shorten the life of your Speedlight. Nikon recommends that you allow the flash to rest at least 10 minutes after continuous firing.

Speedlight SB-27 Instructions

Changing the Distance Display to Feet or Meters

1. Turn the SB-27 off.
2. Hold down the F button and turn the SB-27's power switch to M or Auto (whichever mode is desired). This changes the setting from meters to feet or from feet to meters. The "m" or "ft" scale can be read in the LCD panel.

Note: The SB-27 comes from the factory set to read in meters.

Setting the Standby (STBY) Function

Inside the battery compartment is the camera setting switch. With it you can select a plain camera silhouette icon or an icon that says "TTL STBY."

Setting the switch to the TTL STBY icon conserves battery power by automatically shutting off the flash unit approximately 80 seconds after the flash is last used. This can be used only with cameras that have TTL auto (A-TTL) mode.

The standby function cannot be utilized with cameras that do not have A-TTL flash (e.g., F3, FM2n), therefore the switch should be set to the plain camera silhouette. This setting should also be used to deactivate the standby function and enable forced TTL when using the flash as a slave unit with any camera (see page 127).

Setting the ISO Film Speed Manually*

1. Press the M button once to display the currently set ISO on the LCD panel.
2. Press the M button until the desired ISO number is displayed. Each tap on the M button moves the ISO number up 1/3 stop.

*For cameras that do not supply film speed information to the flash unit automatically. If no ISO value appears on the LCD panel, film speed has been set automatically and cannot be set manually.

Setting the Aperture Value Manually

If your camera does not send the aperture setting to the flash unit automatically, it must be set on the flash manually.

1. Set the flash mode selector to M.
2. Push the F button once to show the aperture setting.

3. Press the F button until the desired aperture is displayed. Each tap on the F button moves the aperture up one stop. Note that the distance scale indicator changes as you vary the aperture; subjects beyond this distance will be underexposed, while subjects closer than this distance will be overexposed.

Setting the Zoom Head Position Manually

If your camera cannot transmit the lens' focal length automatically to the flash unit's LCD, or if it does and you want to override the focal length displayed, you can input the zoom head setting manually.

Look in the LCD panel. If an M appears above the word zoom, the zoom head position can be set manually.

1. Press the zoom button until the desired zoom setting appears on the LCD panel.

If an M does not appear above the word zoom, the zoom position has been set automatically. To override this setting:

1. Press the zoom and M buttons simultaneously for 2 seconds until an M appears above the word zoom on the LCD panel.

2. Press the zoom button until the desired zoom setting is shown on the LCD display.

3. To resume automatic zoom head setting, press the zoom and M buttons simultaneously for 2 seconds until the M above the word zoom disappears.

Setting TTL Auto (A-TTL) or TTL Auto Fill-Flash Mode

TTL auto and TTL auto fill-flash modes are possible only with cameras that have TTL technology.

1. Set the flash mode selector to Auto.

2. If using a lens with a built-in CPU and the camera in P or S exposure mode, select the smallest aperture on the camera, and press the shutter release halfway to check the focusing distance and confirm that the subject is within the flash range displayed on the flash unit's LCD panel.

3. If using a lens with a built-in CPU and the camera in A or M mode, press the shutter release halfway to check the focusing distance and confirm that the subject is within the flash range displayed on the flash unit's LCD panel. Change the aperture on the camera to change the flash range.

4. For lenses without a built-in CPU, you must use A or M mode on the camera and set the aperture manually on the flash unit (see "Setting the Aperture Value Manually" on page 122). Once you've found an aperture that fits your subject range, set that aperture on the camera as well.

 Note: The 3D multi-sensor pattern is selected automatically if using an F100, F5, N90s/F90X, N70/F70, or N60/F60 with a D-type lens.

5. The type of flash operation—such as matrix-balanced fill, center-weighted or spot fill flash, or standard TTL flash—is selected by pressing the SB-27's M button.

Setting Non-TTL Auto Flash (A) Mode

Non-TTL auto flash mode is used with cameras that do not have TTL technology.

1. Set the flash unit's camera setting switch (inside the battery chamber) to the plain silhouette of a camera icon.

2. Set the flash mode selector to Auto.

3. Set the camera's exposure mode to aperture-priority (A) or manual (M).

4. Set the ISO film speed on the flash unit (see "Setting the ISO Film Speed Manually" on page 122).

5. Set the aperture on the flash unit (see "Setting the Aperture Value Manually" on page 122), and confirm the shooting distance on the lens.

6. Set the matching aperture on the camera lens.

Setting Manual Flash (M) Mode

Manual flash mode can be used to control flash output with any camera.

1. Move the flash mode selector to M.

2. Set the camera to aperture-priority (A) or manual (M) exposure mode.

3. Set the ISO film speed on the SB-27 (see "Setting the ISO Film Speed Manually" on page 122).

4. Press the M button until the desired light output appears in the LCD panel: 1/1 (full), 1/2 , 1/4, 1/8, or 1/16 power.

5. If the lens has a built-in CPU (AF or AI-P), set the aperture on the lens and check the distance indicator on the flash unit's LCD (the aperture displayed on the flash unit's LCD will automatically correspond with the lens' aperture setting). Make sure the subject is within flash range.

For other lenses, set the aperture on the flash so that the shooting distance is accurate, then set the camera's aperture to correspond.

Setting Flash Exposure Compensation

1. Set the flash mode selector to Auto (see "Setting TTL Auto or TTL Auto Fill-Flash Mode" on page 123).

2. Simultaneously press the F and M buttons until the ⚡± symbol appears and 0.0 blinks in the LCD panel.

3. Press the F (up) or M (down) adjustment buttons to change compensation in 1/3-stop increments.

4. Setting automatically locks in approximately 4 seconds after you have last pressed the button.

To cancel, reset to a value of 0.0.

In TTL auto mode, flash exposure compensation must be employed to affect flash exposure. You can set flash exposure compensation from −3.0 to +1.0 EV in 1/3-stop increments with the SB-27. To affect the ambient light exposure as well, set the camera's exposure compensation in combination with flash exposure compensation.

Tip: Galen Rowell suggests that you use a value of −1.7 stops for standard TTL fill flash, a value which I find provides excellent foreground fill in most situations.

In manual flash mode, you can use the camera's exposure compensation control or change the ISO value on the camera or flash unit to affect the overall exposure.

Test-Firing the Flash

1. Set the flash mode selector to M or Auto.

2. When the ready light (above the flash mode selector) is on, press the red test-flash button (also called the open-flash button) on the back of the flash unit below the pivot point.

3. If the ready light blinks, flash may have been insufficient to provide adequate exposure at the set aperture. Open up the aperture or move closer to the subject.

Using Flash at Close Distances (<2 ft. or <0.6 m)

The SB-27 should be used only with AF lenses from 24mm to 105mm in length, otherwise, flare will occur. When using bounce flash with a 24-35mm lens, extend both portions of the bounce card; with longer lenses, use only the main portion of the bounce card.

1. Set the flash mode selector to TTL auto mode (see "Setting TTL Auto or TTL Auto Fill-Flash Mode" on page 123).

2. Set the camera to aperture-priority, Close-Up, or manual exposure mode.

3. Pull the built-in bounce diffuser out at a 45° angle. The diffuser card is not effective for shooting subjects closer than 1 foot (0.3 m).

4. Unfold the diffuser card and tilt it until it is perpendicular (90°) to the main bounce card.

5. Determine the aperture to use as follows:

Formula: Aperture = Value* / Flash-to-Subject Distance

*Where Value Is: 3.3 feet (1 m) for ISO 100 or less

6.6 feet (2 m) for ISO 125 to 400

9.2 feet (2.8 m) for ISO 500 and above

Note: If using the flash directly, without a diffuser, these numbers become 14 (4), 26 (8), and 36 (11), respectively.

Example: ~f/3.5 ≥ 3.3 / 1 foot, at ISO 50

Setting the SB-27 to Be Used as a Remote Slave Unit (Forced TTL, Forced A mode)

Forced TTL mode is useful when the SB-27 is used as a photo slave in a multiple-flash setup. This disables its standby function, allowing the flash unit to fire simultaneously with the main flash unit.

Forced A mode can be used to easily compensate exposure when the SB-27 is used with any camera that has matrix metering.

Set aperture-priority exposure mode. To overexpose, enter a smaller aperture setting on the SB-27 than on the lens; to underexpose, enter a larger aperture setting on the SB-27 than on the lens.

1. Select TTL or A mode.

2. Open the battery compartment and slide the camera setting switch to the plain camera silhouette icon.

3. Hold the zoom button down while turning the SB-27's flash mode selector from Off to Auto. The TTL or A symbol should blink, indicating that the SB-27 is now in forced TTL or A mode.

 To cancel, repeat step 3. The TTL or A symbol stops blinking.

SB-27 Guide Numbers

(in feet, at ISO 100)

Output	Duration (in seconds)	24mm	28mm	35mm	50mm
full	1/1,000	82	89	98	112
1/2	1/1,100	58	62	69	79
1/4	1/2,500	41	44	49	56
1/8	1/4,200	29	31	34	39
1/16	1/6,700	20	22	24	28

(in meters, at ISO 100)

Output	Duration (in seconds)	24mm	28mm	35mm	50mm
full	1/1,000	25	27	30	34
1/2	1/1,100	17.7	19	21.2	24
1/4	1/2,500	12.5	13.5	15	17
1/8	1/4,200	8.8	9.5	10.5	12
1/16	1/6,700	6.2	6.7	7.4	8.5

SB-27 Maximum Recycling Speed

In manual (M) flash mode, at 1/8 or 1/16 power, the SB-27 can recycle as fast as 6 frames per second (assuming fresh batteries) when shooting with a motor drive. The number of continuous flashes varies with light output:

Output	Maximum Continuous Flashes (at 6 fps)
1/8	4
1/16	8

An external power source, NiCad, or lithium batteries may increase these numbers slightly.

Shooting fewer frames per second gives the flash more time to recycle and does not tax the flash unit's capabilities as heavily. This allows you to increase the number of continuous flashes possible or to use greater flash output. In manual mode at full or 1/2 power or in auto flash mode, 15 continuous flashes are the maximum number you should attempt. When using manual flash mode with 1/4 output or lower, 40 continuous flashes are the maximum.

Caution: *Continuous flash firing generates heat that could shorten the life of your Speedlight. Nikon recommends that you allow the flash to rest at least 10 minutes after continuous firing.*

Speedlight SB-25 and SB-26 Instructions

The SB-25 and SB-26 flash units are very similar in operation and capability. However the SB-26 has the ability to be triggered remotely, whereas the SB-25 does not. Unless otherwise noted, the following instructions apply to both the Speedlight SB-25 and SB-26.

Changing the Distance Display to Feet or Meters

1. Open the battery chamber.
2. Slide the meter/feet lever to "m" for meters or "ft" for feet.

Setting the ISO Film Speed Manually*

1. Push the SEL button until the film speed value blinks on the LCD panel.
2. Use the up and down adjustment arrows to enter the desired film speed.
3. Press the SEL button again to set the speed.

For cameras such as the F3 and FM2n, which do not supply the ISO speed to the flash unit automatically.

Setting the Aperture Value Manually

1. With manual cameras, set the flash unit either to M or A (non-TTL) mode. With electronic cameras, set the flash unit to A (non-TTL) mode.
2. Push the SEL button until the aperture value blinks in the LCD panel.
3. Use the up and down adjustment arrows to enter the desired aperture.
4. Press the SEL button again to set the aperture value.

Setting the Zoom Head Position Manually

1. If your camera cannot transmit the lens' focal length automatically to the flash unit's LCD, or if you want to override the focal length displayed, press the zoom button until the zoom value appears. An M appears above the word zoom on the LCD.
2. Press the zoom button to set the zoom value.

3. To resume automatic zoom setting, press the zoom button until the M above the word zoom disappears from the LCD panel.

When the Fresnel lens is pulled out over the flash head, 20mm is set automatically. On the SB-26, 18mm can also be set by pressing the zoom button. Push the Fresnel lens back into its compartment to cancel the setting.

Setting Standard TTL Auto Flash Mode

Standard TTL flash mode is possible only with cameras that have TTL technology.

1. Set the flash mode selector to TTL.

2. Press the M button until the ▥ symbol appears on the LCD.

3. Move the flash sync switch to normal or rear, as desired.

4. Confirm the aperture, zoom position, and ISO film speed.

5. When the ready light illuminates, take the picture.

6. If the ready light blinks after the flash has fired at full strength, light was insufficient for proper exposure. Move closer to the subject or set a wider aperture.

3D multi-sensor metering is automatically selected if the camera offers it and a D-type lens is used; with non-D-type lenses, the multi-sensor pattern is set. If the camera offers neither of these metering patterns, the one set on the camera is used.

Setting Auto TTL Flash (A-TTL) Mode

Auto TTL flash mode is possible only with cameras that have TTL technology.

1. Set the flash mode selector to TTL.

2. Set the camera's metering mode (3D multi-sensor, multi-sensor, center-weighted, spot).

3. For 3D multi-sensor or multi-sensor fill, press the flash unit's M button until the ▣ or ▣ symbol appears (depending upon the camera in use—if your camera does not offer matrix metering, the ▣ symbol appears).

4. For center-weighted or spot, press the flash unit's M button until the ▣ symbol appears. (Spot fill flash is not possible with the F4 or F5.)

5. Move the flash sync switch to normal or rear, as desired.

6. When the ready light illuminates, take the picture.

7. If the ready light blinks after the flash has been fired at full strength, flash output was insufficient for proper exposure. Move closer to the subject or set a wider aperture.

3D multi-sensor metering is automatically selected if the camera offers it and a D-type lens is used; with non D-type lenses, the multi-sensor pattern is set. If the camera offers neither metering pattern, the one set on the camera is used.

Setting Non-TTL Auto Flash (A) Mode

1. Set the flash mode selector to A.

2. Move the flash sync switch to normal or rear, as desired.

3. Confirm the ISO and the zoom setting.

4. Set the desired aperture on both the flash (see "Setting the Aperture Value Manually" on page 129) and the camera.

5. Check that your subject falls within the distance range displayed on the flash unit's shooting distance scale.

6. When the ready light illuminates, take the picture.

7. If the ready light blinks after the flash has been fired at full strength, flash output was insufficient for proper exposure. Move closer to the subject or set a wider aperture.

Setting Manual Flash (M) Mode

1. Set the flash mode selector to M.

2. Move the flash sync switch to normal or rear, as desired.

3. Set the ISO film speed (see "Setting the ISO Film Speed Manually" on page 129) and the zoom head position (see "Setting the Zoom Head Position Manually" on page 129).

4. For power output control, press the M button to choose the desired light output in 1-stop increments, which appears in the LCD's lower right-hand corner. Further fine adjustment between 1/2 and 1/64 power can be made in 1/3-stop increments by pressing the SEL button and then pressing the up or down arrows. The selected power setting appears in the top right-hand corner of the flash unit's LCD panel.

5. Set the aperture (and shutter speed, if necessary) on the camera.

6. If the aperture value on the flash unit has not been set

automatically by the camera to match the lens' aperture, set it manually (see "Setting the Aperture Value Manually" on page 129).

7. Press the up or down adjustment arrows so the distance indicator on the flash unit's distance scale matches the subject distance indicated on the lens' distance scale.

8. If the aperture changed on the flash unit's LCD, set the lens' aperture to match it.

Setting Repeating Flash

1. Set the camera to manual mode and select an appropriate shutter speed. (Shutter speeds should be as slow as possible for the lighting conditions; B [bulb] can be used in total darkness.)

Formula: **Shutter Speed = <u>Number of Flashes per Frame</u>**
Flash Speed (in Hz)

Example: 1 second = 8 flashes per frame/8 Hz

2. Set the flash mode selector to the repeating flash symbol (three lightning bolts).

3. Set the flash sync switch to normal.

4. If the zoom head position has not been set automatically to match the lens' focal length, set the zoom head position (see "Setting the Zoom Head Position Manually" on page 129).

5. Press the SEL button until the number of flash bursts per second (Hz) blinks. (It is the number closest to "Hz.") Press the up or down arrows to set the flash firing speed (number of flashes fired per second). When the number stops blinking or the SEL button is pressed, the number is set.

6. Press the SEL button again until the number of flashes per frame (the number on the left) blinks. Press the up or down arrows to set the number of flashes per frame. When the number stops blinking or the SEL button is pressed, the number is set.

SB-26 Maximum Repeating Flashes

The following flash rates can be achieved by using an SD-7 or SD-8 external battery pack.

Hz	*1/8*	*1/16*	*1/32*	*1/64*
1–7	20	40	80	160
8–10	10	20	40	80
20–50	8	16	20	40

7. If the aperture value on the flash unit has not been set automatically by the camera to match the lens' aperture, set it manually (see "Setting the Aperture Value Manually" on page 129).

8. If necessary, press the up or down adjustment arrows to make the distance on the flash's LCD match the subject distance.

9. If necessary, reset the aperture on the camera to match that on the flash unit's LCD.

Hint: Reduce the aperture by 1 or 2 stops to compensate for subject overlap.

Setting High-Speed Sync Flash

For the F100, F5, and N90s/F90X only

1. Move the flash mode selector to M.

2. Move the flash sync mode switch to normal.

3. Confirm the ISO, zoom setting, and aperture.

 Note: You cannot use the 18mm or 20mm zoom setting.

4. Press the M button until FP appears in the LCD panel; choose the 1 or 2 setting that appears in the lower right-hand corner.

5. Choose a shutter speed from 1/250 to 1/4000 second on the camera.

6. Focus on your subject.

7. Set the aperture indicated by the camera on the flash (for non-AF lenses).

8. Confirm that the subject is at or slightly closer than the distance indicated on the flash unit's shooting distance scale. Use the M button to change to FP1 or FP2, move the subject's position, or choose a different zoom head position, if necessary.

SB-26 High-Speed Guide Numbers
(in feet, at ISO 100; FP1/FP2)

Shutter Speed	*24mm*	*28mm*	*35mm*	*50mm*	*70mm*	*85mm*
1/250	46/33	50/36	56/39	65/46	74/52	77/56
1/500	33/23	36/25	39/28	46/33	52/36	56/39
1/1000	23/16	25/17	28/20	33/23	36/26	39/28
1/2000	16/11	17/12	20/14	23/16	26/18	28/20
1/4000	11/8	12/8	14/10	16/11	18/13	20/14

(in meters, at ISO 100; FP1/FP2)

Shutter Speed	*24mm*	*28mm*	*35mm*	*50mm*	*70mm*	*85mm*
1/250	14/10	15/11	17/12	20/14	23/16	24/17
1/500	10/7	11/7.5	12/8.5	14/10	16/11	17/12
1/1000	7/5	7.5/5.3	8.5/6	10/7	11/8	12/8.5
1/2000	5/3.5	5.3/3.7	6/4.2	7/5	8/5.6	8.5/6
1/4000	3.5/2.5	3.7/2.6	4.2/3	5/3.5	5.6/4	6/4.2

Rear-Curtain Sync

Rear-curtain sync is used to record streams of light following a moving subject.

1. Set shutter-priority or manual exposure mode on the camera, and select a shutter speed no slower than 30 seconds. (A relatively slow speed is recommended, however, for best results.)

2. Set any TTL mode, non-TTL Auto, or Manual flash mode.

3. Set the flash sync mode selector to rear.

 Rear-curtain sync flash cannot be performed:

 • When using a vari-program or red-eye reduction (N90s/F90X, N70/F70)

 • When used as a slaved flash unit (N90s/F90X, N70/F70, F4, F5, F100)

 • When the shutter speed is set at T (time exposure) (F4, F5)

Flash Exposure Compensation

Exposure adjustments made on the camera affect the entire expo-sure. By changing the ISO setting or the exposure compensation dial on the camera body, the aperture, shutter speed, and flash duration are affected in all auto TTL flash modes. This changes the exposure of the image's foreground **and** background. However take care, since a change in the film speed also results in a change of the guide number, and hence, the shooting range.

 Adjustments made to the flash exposure affect only the subject. Flash exposure adjustments, also called "flash compensation," can be made on the flash unit or with the MF-26 Multi-Control Back on the N90s/F90X. These changes cause a change in the duration of the flash that is independent of the camera's selection of aperture and shutter speed. The resulting change in foreground brightness (affected by flash compensation) is different from that of the background.

 Set flash exposure compensation by following these steps:

1. Set the flash mode selector to TTL.

2. Press the SEL button until the ▣⁺□ indicator appears and **0.0** blinks in the flash unit's LCD.

3. Press the up or down adjustment arrows to change compensa-tion in 1/3-stop increments.

4. Press the SEL button again once compensation is set as desired.

To cancel, reset the value to **0.0**.

Flash Exposure Bracketing

The N90s/F90X can be used with the Multi-Control Back MF-26 to bracket flash exposure. A series of exposures can be made in increments determined by the photographer (from 0.3 to 2.0 stops) by using the flash exposure bracketing mode of the MF-26. This type of exposure compensation affects only the flash exposure.

Test-Firing the Flash

1. Set the flash to non-TTL auto flash mode (see "Setting Non-TTL Auto Flash Mode" on page 131).

2. Press the flash button. If the ready light blinks, there may not be enough light for correct exposure at the set aperture. Use a wider aperture or move closer to the subject.

Locking the Zoom Head Position

1. Press the zoom and M buttons simultaneously until the M symbol blinks.

2. Press the zoom button to set the desired zoom head position.

To cancel, press the zoom and M buttons until the M symbol stops blinking.

Using the Flash at Close Distances (<2 ft. or <0.6 m)

1. Set the flash for TTL auto flash (see "Setting Standard TTL Auto Flash Mode" on page 130).

2. Set the zoom head position at the widest angle by using the wide-angle diffuser.

3. Determine the aperture to use as follows:

 Formula: **Aperture = Value* / Flash-to-Subject Distance**

 *Where Value Is: 14 feet or 4.3 meters for ISO 100 or lower
 26 feet or 8 meters for ISO 125 to 400
 36 feet or 11 meters for ISO 500 and above

 Example: f/4 = 36 / 9 feet, at ISO 500

Wireless Remote Flash (SB-26)

When used in multiple-flash setups, the SB-26 can be triggered remotely without the use of connecting cables. The wireless slave flash selector switch is on the front of the flash unit. When set to D (delay), the flash unit fires an instant after the main flash fires, so as not to affect the main flash unit's exposure output. When set to S (simultaneous), the slaved flash unit fires the same instant as the main flash, however it may affect the output of the main flash, and the subject may be underexposed. Refer to the owner's manual for more information on multiple-flash photography.

SB-24*, -25, and -26 Guide Numbers

(in feet, at ISO 100)

Output (in seconds)	Length	20mm	24mm	28mm	35mm	50mm	70mm	85mm
full	1/1,000	66	**98**	**105**	**118**	**138**	**157**	**164**
1/2	1/1,100	46	**69**	**75**	**85**	**98**	**112**	**118**
1/4	1/2,500	33	**49**	**52**	**59**	**69**	**79**	**82**
1/8	1/5,000	23	**33**	**36**	**43**	**49**	**56**	**59**
1/16	1/8,700	16	**25**	**26**	**30**	**33**	**39**	**43**
1/32	1/12,000	11	17	19	21	25	28	30
1/64	1/23,000	8	12.5	13	15	17	20	21

(in meters, at ISO 100)

Output (in seconds)	Length	20mm	24mm	28mm	35mm	50mm	70mm	85mm
full	1/1,000	20	**30**	**32**	**36**	**42**	**48**	**50**
1/2	1/1,100	14	**21**	**23**	**26**	**30**	**34**	**36**
1/4	1/2,500	10	**15**	**16**	**18**	**21**	**24**	**25**
1/8	1/5,000	7	**10**	**11**	**13**	**15**	**17**	**18**
1/16	1/8,700	5	**7.5**	**8**	**9**	**10**	**12**	**13**
1/32	1/12,000	3.5	5.3	5.7	6.4	7.5	8.5	9
1/64	1/23,000	2.5	3.8	4	4.5	5.3	6	6.3

Guide numbers for the SB-24 are limited to those in bold.

SB-26 Flash Range
(in feet, at ISO 100)

f/stop	20mm	24mm	28mm	35mm	50mm	70mm	85mm
1.4	4.1–46	6.2–60	6.6–60	7.4–60	8.6–60	9.8–60	10–60
2	2.8–32	4.4–49	4.7–52	5.2–58	6.1–60	7.0–60	7.2–60
2.8	2.1–23	3.1–34	3.3–37	3.7–41	4.3–48	4.9–55	5.1–58
4	2.0–16	2.2–24	2.4–26	2.6–29	3.0–34	3.5–39	3.6–41
5.6	2.0–11	2.0–17	2.0–18	2.0–20	2.2–24	2.5–27	2.6–29
8	2.0–8.2	2.0–12	2.9–13	2.0–14	2.0–17	2.0–19	2.0–20
11	2.0–5.7	2.0–8.6	2.0–9.2	2.0–10	2.0–12	2.0–13	2.0–14
16	2.0–4.1	2.0–6.1	2.0–6.5	2.0–7.3	2.0–8.6	2.0–9.8	2.0–10

(in meters, at ISO 100)

f/stop	20mm	24mm	28mm	35mm	50mm	70mm	85mm
1.4	1.3–14	1.9–20	2–20	2.3–20	2.6–20	3.0–20	3.2–20
2	0.9–10	1.4–15	1.5–16	1.6–18	1.9–20	2.2–20	2.2–20
2.8	0.7–7	1.0–10	1.0–11	1.1–13	1.4–14	1.5–16	1.6–17
4	0.6–5	0.7–7.5	0.7–8	0.8–9	1–10	1.1–12	1.1–12
5.6	0.6–3.5	0.6–5.3	0.6–5.6	0.6–6.3	0.7–7.4	0.8–8.4	0.8–8.8
8	0.6–2.5	0.6–3.7	0.6–4	0.6–4.5	0.6–5.2	0.6–6	0.6–6.2
11	0.6–1.7	0.6–2.6	0.6–2.8	0.6–3.2	0.6–3.7	0.6–4.2	0.6–4.4
16	0.6–1.2	0.6–1.8	0.6–2	0.6–2.3	0.6–2.6	0.6–3	0.6–3.1

Each doubling of ISO shifts the f/stop up one row (e.g., if you are using ISO 200 film and f/2, read the f/1.4 row); with each halving of the ISO, shift down one row.

SB-26 Maximum Recycling Speed

In manual (M) flash mode, at 1/8 power or lower, the SB-26 can recycle as fast as 6 frames per second (assuming fresh batteries) when shooting with a motor drive. The number of continuous flashes varies with light output:

Output	*Maximum Continuous Flashes (at 6 fps)*
1/8	4
1/16	8
1/32	16
1/64	30

An external power source, NiCad, or lithium batteries may increase these numbers slightly.

Shooting fewer frames per second gives the flash more time to recycle and does not tax the flash unit's capabilities as heavily. This allows you to increase the number of continuous flashes possible or to use greater flash output. In manual mode at full or 1/2 power or in TTL or A flash modes, 15 continuous flashes are the maximum number you should attempt. When using manual flash mode with 1/4 output or lower, 40 continuous flashes are the maximum.

Caution: Continuous flash firing generates heat that could shorten the life of your Speedlight. Nikon recommends that you allow the flash to rest at least 10 minutes after continuous firing.

Notes

Basic Camera Information

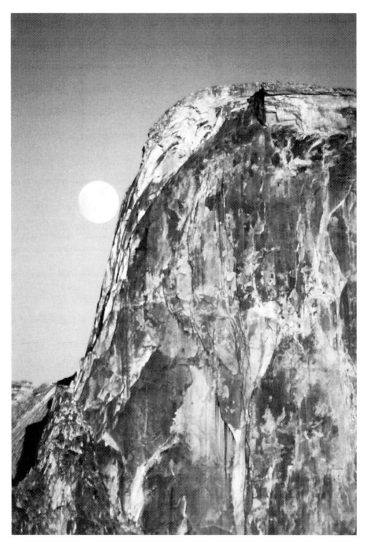

To determine the range of brightness in this scene, I spot metered on both the rock face and the moon. I would not have been able to capture detail in both areas without having used a soft-edged, 2-stop graduated filter held on the diagonal.

Nikon Designations

Nikon uses different camera designations for the U.S. and international models of some of their equipment. Thus, the N90s sold in the U.S. is identical to the F90X sold in Canada, Japan, Europe, and other areas of the world. In this book, I use both designations when referring to equipment, e.g., N90s/F90X.

Further, some Nikon models have newer versions (typically designated by an "s" in the U.S., and either an "s" or "X" elsewhere). I always refer to such models by their latest designation. Where a previous model differs from its newer "s" or "X" version, it is specifically noted. In general, if you have an N90 or F90, the information presented here for the N90s and F90X applies unless otherwise stated.

EV Ranges and Shutter Speeds

(at ISO 100, f/1.4 lens)

Camera	Metering Sensitivity	Shutter Speed Range
F100	0 to 21 EV	30 seconds to 1/8000 second
F5	0 to 20 EV	30 seconds* to 1/8000 second
F4s	0 to 21 EV	30 seconds to 1/8000 second
N90s/F90X	–1 to 21 EV	30 seconds** to 1/8000 second
N70/F70	–1 to 20 EV	30 seconds to 1/4000 second
N60/F60	1 to 20 EV	30 seconds to 1/2000 second
N50/F50	1 to 20 EV	30 seconds to 1/2000 second
N8008s/F-801s	0 to 21 EV	30 seconds** to 1/8000 second
N6006/F-601	0 to 19 EV	30 seconds to 1/2000 second
F3HP	1 to 18 EV	8 seconds to 1/2000 second
FM2n	1 to 18 EV	1 second to 1/4000 second

May be set for up to 30 minutes via custom setting, however this is not recommended due to battery consumption.
**Can perform longer shutter speeds with corresponding multi-control back. B and T exposures are possible with other cameras.*

These numbers indicate the maximum metering range possible using matrix or center-weighted metering. At ISO 100, a Nikon N90s/F90X meters from –1 EV to 17 EV at f/1.4. Typically, the usable low exposure value rises when you use film faster than ISO 100, and the usable high exposure value decreases when you use larger apertures. Spot metering generally starts at EV2 or EV3 with modern Nikon bodies.

Metering Methods

Matrix Metering

The camera's meter splits the scene into various zones (eight on the N90s/F90X, ten on the F100, for example) and uses differences in the readings in each of the zones to make more informed decisions about exposure. For example, if the upper zones are bright and the lower zones are darker, the camera may guess that the upper zones are looking at sky and reduce their influence on the calculation of the final exposure.

The F5 uses a 1005-element CCD (charge-coupled device) to add color-temperature information to the calculation, making it easier for the F5 to detect sky and other areas that may have a direct impact on exposure if not compensated for.

Tip: Matrix metering works particularly well **except** in situations where there is an extreme range of contrast, when it tends to give too much weight to bright objects.

Center-Weighted Metering

The camera concentrates the exposure calculation on the central 12mm of the frame (usually indicated by the outermost circle in the viewfinder). Typically, 60 to 75% of the exposure calculation is based upon the reading within this circle, the remainder on the rest of the frame.

Note: The F5's custom settings allow you to change the diameter of the center-weighted area to 8mm, 15mm, or 20mm. Unfortunately, the viewfinder doesn't display these areas.

Spot Metering

With spot metering, the exposure calculation is made from a very narrow area (3mm to 5mm) at the very center of the frame.

Note: Spot metering with the F5 and F100 does not always occur at the center of the frame. Instead, it follows the autofocus sensor (one of five) being used. If you use a focusing screen other than the standard EC-B, the size of the spot area changes to 6mm diameter.

The Nikon Field Guide _____

Exposure Modes

Program (P)

In program mode, the camera chooses both the aperture and shutter speed based upon a program that has been entered into the camera's computer by the manufacturer for "ideal" exposure. When longer lenses are used, these values are typically adjusted to faster shutter speeds in order to minimize camera shake. (The F100 and F5 are exceptions.) The F4 has a PH mode, which is biased toward faster shutter speeds to stop action. The N90s/F90X, N70/F70, and N60/F60 have additional, special program modes, which, though useful for some photographers, often don't do what you might want them to do. A knowledgable photographer can more quickly override the basic program to achieve similar effects with more control.

Nikon cameras typically require that you use lenses that have a built-in CPU (AF and AI-P lenses) in order to use program mode.

Unfortunately, Nikon has not been entirely consistent about how their various program modes work, how they are named (auto multi-program, automatic program, programmed auto, etc.), or how they are overridden. If you own more than one Nikon body that has a program mode, make sure you understand how each one differs.

Shutter-Priority (S)

In this mode, you set the shutter speed, and the camera calculates the correct aperture, setting it automatically. Shutter-priority mode is useful for taking images that require a specific shutter speed to achieve a certain artistic effect, such as stopping action or blurring motion.

Watch the viewfinder indicators carefully, as it is possible for you to set a shutter speed for which a correct aperture is unavailable, creating over- or underexposure.

Most autofocus Nikons require lenses that have a built-in CPU (AF and AI-P lenses) to use this mode, however the F4 does not.

Aperture-Priority (A)

With aperture-priority mode, you set the aperture, and the camera calculates the correct shutter speed and sets it automatically. This mode is useful for controlling depth of field.

Again, watch the viewfinder indicators carefully, as the camera may not be able to set an appropriate shutter speed for the selected aperture or may set a shutter speed that is too slow to be "hand-holdable."

Manual Exposure (M)

In this mode you have the most control: You set both the aperture and shutter speed; the camera provides only an exposure recommendation (i.e., the meter indicates whether you've set a proper exposure or are under- or overexposing the scene).

Basic Camera Field Repair Checklist

If your camera isn't working properly, or simply isn't working, here are some things to check:

- *Check the power switch!* More than once I've tried to take a picture without the camera switched on. Hints include the lack of LCD (liquid crystal display) panel or viewfinder readout, no exposure metering, or no autofocusing possible when the shutter release is partially depressed.

- *Turn the camera off and then on again.* Some error conditions can be corrected by cycling the camera through its startup phase.

 Note: On the N90s/F90X and the N8008s/F-801s, sometimes the shutter will lock and an Ɛ ⌐ ⌐ message will appear on the LCD display. If turning the camera off and on doesn't fix this, try setting the ISO value manually (i.e., cancel the DX setting). If this still doesn't work, rewind the film, remove and replace the batteries, and try turning the camera on and off again.

- *Turn the camera off before changing lenses.* There is anecdotal evidence that changing AF lenses on some newer Nikon cameras while the camera is on can cause "unintended" data to be transferred to the camera's CPU (central processing unit). As a precaution, it probably is prudent to turn the camera off when changing lenses.

- *Check batteries.* Weak, cold, old, or infrequently used batteries may show up as "okay" on the battery indicator, but may only be borderline. Replace any suspect batteries. Indeed, try replacing even non-suspect batteries to make sure they aren't the problem. Check to make sure the batteries are seated correctly (correct polarity—i.e., the plus terminal aligns with + indicators, the minus terminal aligns with – indicators).

Note: Some off-brand batteries have high internal resistance, producing voltage lower than is required by the camera. An **ε-ᴛ** message could occur.

• *Check battery contacts.* A moistened cotton swab should be used to wipe up any battery fluid or other grime on the contacts first. Then use a pencil eraser to clean the contacts (clean up the "crumbs" afterward). Make sure that the battery contacts haven't lost their "spring," which would keep them from making good contact with the battery.

 If it appears that a battery has leaked in your camera, have the camera looked at by a professional when you return home. Battery "gunk" is corrosive and can damage your camera.

• *Check the LCD or viewfinder for error messages.* Some Nikon cameras have some error conditions that are reported through readouts (see the camera instructions that follow for full descriptions).

• *Check the film advance.* On cameras with manual rewind (e.g., FM2, F3, F4, etc.), the rewind knob should turn when the film is advanced. Use the rewind crank to check for and take up slack (when advancing film, watch to make sure the rewind knob is moving!). Make sure you're not at the end of the roll. It sounds funny, but on some cameras (such as the F5, F4, and N90s/F90X), rewind is not automatic, so it is possible to be surprised by this if you're not paying attention to the film counter.

• *Check the self-timer.* If you press the shutter release button but the shutter doesn't release immediately, it could be that the self-timer was accidentally enabled.

• *Check the mode and lens settings.* When AF or AI-P lenses are used with cameras in program (P) or shutter-priority (S) exposure mode, the minimum possible aperture must be set on the lens (there's usually a small locking tab to help keep it there). You can return some cameras to their automatic default settings by pressing their "reset" button.

• *Check the autofocus setting.* With the autofocus switch set to single (S), the camera will not fire unless focus is actually achieved. In continuous (C) autofocus mode, the camera can be fired at any time unless custom settings are used to override it (F5, N90s/F90X).

Camera Control Locations

All references made to the location of camera controls (left, right, etc.) in the following camera instructions refer to the camera when held in the shooting position.

Nikon F5

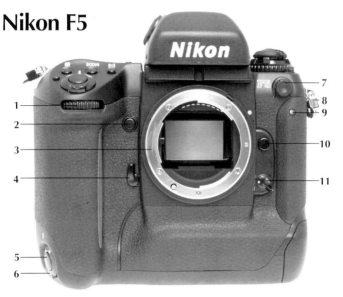

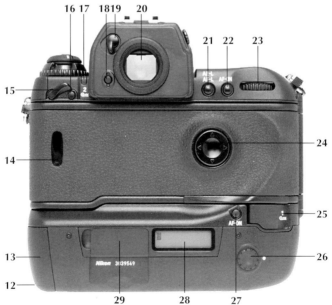

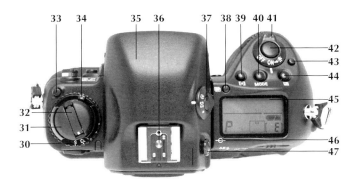

1 Front command dial
2 Depth-of-field preview button
3 Lens mount
4 Mirror lock-up lever
5 Vertical-format shutter release
6 Vertical-format shutter release lock
7 Sync terminal
8 Camera strap eyelet
9 Self-timer indicator
10 Lens release button
11 Focus mode selector
12 Battery holder release
13 Battery holder
14 Film cassette window
15 Film rewind lever 2
16 Film rewind lever 2 release
17 Warning LED
18 Finder release button
19 Eyepiece shutter lever
20 Viewfinder eyepiece
21 AE/AF-lock button
22 AF activation button
23 Rear command dial
24 Focus area selector
25 Film rewind button 1
26 Remote control terminal

27 AF activation button for vertical format
28 Rear LCD panel
29 Rear control panel (covered)
30 Film advance mode/self-timer selector
31 Film rewind knob
32 Film rewind crank
33 Film advance mode selector release
34 Camera back lock release
35 Prism
36 Accessory shoe
37 Metering mode selector
38 Multiple exposure button
39 AF area mode button
40 Exposure mode button
41 Power/LCD illumination switch
42 Shutter release button
43 Power switch lock release
44 Exposure compensation button
45 Top LCD panel
46 Film plane indicator
47 Diopter adjustment knob

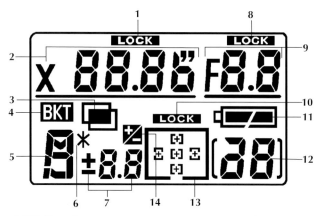

Top LCD Panel

1 Shutter speed lock
2 Shutter speed
3 Multiple exposure
4 Autoexposure/Flash bracketing
5 Exposure mode
6 Flexible program
7 Exposure compensation value

8 Aperture lock
9 Aperture
10 Focus area lock
11 Battery level indicator
12 Frame counter
13 Focus area/AF area mode
14 Exposure compensation icon

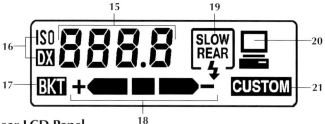

Rear LCD Panel

15 Film speed/Bracketing information/Custom setting
16 Film speed setting mode
17 Autoexposure/Flash bracketing

18 Bracketing indicators
19 Flash sync mode
20 PC link
21 Custom setting active

F5 LCD Messages

Hi ... Current settings will overexpose shot.

Lo ... Current settings will underexpose shot.

FEE blinks AF or AI-P lens not set to smallest aperture in P or S mode.

End blinks End of roll has been reached; rewind film.

⊏▬ symbol blinks Batteries are low; replace them.

E ... No film is loaded in camera.

E appears and Err blinks Film not loaded correctly; reload film.

F - - ... In A exposure mode, AF or AI-P lens isn't set to smallest aperture or manual lens is in use; in P or S modes, lens has no CPU to support autoexposure.

P or S blinks Lens has no CPU to support P or S exposure mode; camera defaults to A mode automatically.

Err blinks Camera detects a shutter or film transport problem; turn camera off and on—if problem persists, take camera to repair center.

bulb blinks Cannot set bulb shutter speed in S exposure mode; set camera to M mode or select another shutter speed.

Err, ISO, and DX blink Non-DX coded film or invalid DX code detected; set ISO manually.

Shutter speed blinks Shutter speed is faster than flash sync speed (1/250 second unless modified by custom setting).

BKT ... Camera is set for exposure or flash bracketing.

⬛ symbol blinks Camera's film data storage is full (80 rolls normally, 160 rolls with memory upgrade); download data to computer.

LCD all black:.... Camera is too hot (but still likely to operate).

LCD slow to update Camera is too cold (but still likely to operate).

F5 Alert Light

On .. End of roll has been reached; rewind film.

Blinks One of the following conditions has occurred:

1. Film didn't load correctly; reload film.
2. Second rewind lever was accidentally pressed; pull second rewind lever to normal position.
3. Shutter error detected; turn camera off and on again. If problem persists, take camera to repair center.

F5 Viewfinder Error Messages

▶◀ symbols blink Autofocus not possible; focus manually.

◀ symbol Subject not in focus or located closer than the lens' minimum focusing distance.

▶ symbol Subject not in focus or lens not set on infinity when TC-16A is used.

▨ ┆ ... Current settings will overexpose shot.

Ŀ◦ ... Current settings will underexpose shot.

FEE blinks Lens not set to smallest aperture.

F - - .. In A exposure mode, AF or AI-P
 lens is not set to smallest aperture
 or a manual lens is in use; in P or S
 modes, lens has no CPU to support
 autoexposure.

E appears in the frame counter

and E-- blinks Film not loaded correctly; reload
 film.

E-- blinks One of the following conditions
 has occurred:

 1. Non-DX coded film was
 detected or DX code not
 interpreted; set ISO manually.
 2. Camera has detected a shutter
 or film transport problem; turn
 camera off and on again—if the
 problem persists, take the
 camera to a repair center.

bulb blinks Bulb cannot be set in S exposure
 mode; set camera to M mode or
 select another shutter speed.

A appears (when P or S mode

is set) Lens has no CPU to support P or S
 exposure mode; camera automati-
 cally defaults to A mode.

⊡ symbol appears (in matrix

mode) Lens has no CPU to support matrix
 metering; camera automatically
 defaults to center-weighted
 metering.

End blinks End of roll has been reached;
 rewind film.

⚡ symbol blinks Flash may not have been sufficient
 to provide correct exposure. (See
 Flash chapter.)

153

F5 Instructions

Turning the Camera On and Off

To turn the power on, simultaneously press the button adjacent to the shutter release and rotate the power switch surrounding the shutter release to the On position.

Note: When the camera is on, pressing the shutter release halfway turns on the exposure meter, viewfinder illumination, and, when appropriate, autofocus. The meter remains active for 16 seconds unless modified by custom setting #15.

To turn power off, repeat the instructions above, but rotate the switch to Off.

Resetting the Camera to Its Default Settings

Simultaneously press the green **BKT** and **CSM** buttons on the rear control panel (next to the rear LCD) for more than 2 seconds. Resetting the F5 causes the camera to revert to the following:

- Multi-program (P) exposure mode
- Flexible program adjustments cancelled
- Single sensor focus area using the center sensor (i.e., not dynamic autofocus)
- Front-curtain flash sync, unless overridden by an SB-24, SB-25, or SB-26 Speedlight
- No exposure compensation
- No exposure and flash bracketing active (though 3 frames in 1/3-stop increments set)
- No multiple exposure
- No custom settings except custom settings **0-8** and **0-5**, which retain their settings
- No shutter speed, aperture, or focus area lock
- MF-28 Multi-Control Back: all functions are cancelled, but the set values are retained in memory.

Setting the Film Advance Mode

Hold down the film advance mode selector lock release button on the top left of the camera while rotating the dial surrounding the rewind knob (film advance mode selector) to the desired setting:

S Single Frame—Press the shutter release once for each exposure.

Cs Continuous Silent—About 1 frame per second while the shutter release is held down.

Cl Continuous Low Speed—About 3 frames per second while the shutter release is held down.

Ch Continuous High Speed—About 7.4 frames per second with AA batteries, 8 frames per second with NiMH batteries, while the shutter release is held down.

The stated frame rates are for shutter speeds of 1/250 second or faster in manual exposure and manual focus mode. Two F5s can be synchronized via the optional PC software to provide alternating shots, resulting in a total of 16 frames per second. By using custom setting #9, the Ch speed can be changed to 6 frames per second, and using custom setting #10, the Cl speed can be changed to 4 or 5 frames per second.

Note: When imprinting data on film with the MF-28 Multi-Control Back, do not set film advance to Ch because it moves too fast to imprint.

Setting the ISO Manually

Hold down the **ISO** button on the rear control panel and rotate the rear command dial to set the film speed, displayed on the rear LCD panel.

Setting the ISO Automatically with DX Encoding

Hold down the **ISO** button on the rear control panel and rotate the rear command dial until the rear LCD displays the **DX** indicator (if film is in the camera, the film's ISO value is also shown).

Loading Film

1. Set the ISO manually or set DX encoding.

2. Push the release lever in front of the rewind crank in the direction of the arrow and lift the crank to open the camera back.

3. Insert the film cartridge from the bottom (slide the top of the cartridge into the bracket at the top of the chamber).

4. Pull the film leader to the right, across to the red index mark in the take-up area.

5. Using the rewind crank, remove any slack from the film so that it lies flat.

6. Close the camera back.

7. Press the shutter release; the camera advances the film to the first frame. Check that the correct ISO value appears in the rear LCD.

 Note: Custom setting #8 can be used to automatically advance the film to the first frame when you close the camera's back, in which case step 7 is no longer necessary.

Rewinding Film

1. Lift the cover over rewind button 1 (lower right of the camera back) and press the button that's revealed.

2. Press the rewind lever lock release (upper left side of the camera back) and flip up the film rewind lever 2.

 Or,

1. Lift the cover over rewind button 1 (lower right of the camera back) and press the button that's revealed.

2. Lift the rewind crank handle and turn it in the direction of the arrow until the film is rewound into the cartridge (you'll feel a release of the tension on the handle).

 Caution: Never press the shutter release while rewinding film on the F5; doing so may damage the shutter curtain.

Setting the Metering Method

Hold in the metering system selector lock release while turning the metering system selector on the right side of the prism to the desired setting:

⊡ Matrix
 Multi-segment evaluative metering is used with additional information from a 1005-pixel CCD sensor. Requires AF or AI-P type lenses. With D-type lenses, the focus distance is also taken into account.

(•) Center-Weighted
 75% of the meter's sensitivity is concentrated in the central 12mm circle in the viewfinder. The size of the center-weighted area may be changed via custom setting #14.

● Spot
 100% of the meter's sensitivity is concentrated on a 4mm area in the viewfinder corresponding to the selected autofocus area (with EC-B screen; 6mm with other screens).

The F5's matrix metering system has a top limit of EV 16.3 (f/11 at 1/500 second in P mode).

Filtration can fool the CCD. For example, if you put a Wratten 12 filter on the lens to shoot infrared transparency film, the meter sees more yellow than normal and adjusts the exposure (generally towards overexposure in this case).

Setting the Focus Mode

Move the focus mode selector on the front of the camera body to:

S Single Servo AF—Uses focus priority (shutter cannot be released until focus is achieved).

Viewfinder symbols for a stationary subject:

▶ Lens is rotating right to achieve focus.
◀ Lens is rotating left to achieve focus.
● Focus is achieved; you must refocus if the subject moves.
▶◀ (Blinking) Camera cannot autofocus.

Viewfinder symbols for a moving subject:

▶ Focus is tracking a subject moving away from the camera.
◀ Focus is tracking a subject moving towards the camera.

A moving subject can be tracked with the F5's autofocus system only if it is moving while you are focusing. It cannot be tracked if a stationary subject starts moving after focus has been achieved.

● Focus is locked; you must refocus if the subject moves.
▶◀ (Blinking) Camera cannot autofocus.

C Continuous Servo AF—Uses release priority (shutter can be released even if the subject is not in focus); focus is continuously updated while the shutter release is pressed halfway or the AF-ON button is pressed. To lock focus, press the AF-L button.

Viewfinder symbols for a stationary subject:

▶ Lens is rotating right to achieve focus.
◀ Lens is rotating left to achieve focus.
● Focus is achieved.
▶◀ (Blinking) Camera cannot autofocus.

Viewfinder symbols for tracking a moving subject:

▶ Focus is tracking a subject moving away from the
 camera.

◀ Focus is tracking a subject moving towards the
 camera.

● Focus is confirmed.

▶◀ (Blinking) Camera cannot autofocus.

 (With focus tracking, the camera's focus follows the motion
of a subject and predicts its position at the time the shutter is
actually fired.)

M Manual Focus—Electronic confirmation symbols appear in
 the viewfinder.

Viewfinder symbols:

◀ The subject is not in focus; rotate the focus ring to
 the left.

▶ The subject is not in focus; rotate the focus ring to
 the right.

● The subject is in focus.

Note: The focus indicators (▶ ◀) can be turned off using custom
setting #23.

 Also, some aftermarket lenses have a focusing ring that turns in a
direction opposite that of a Nikkor lens. If one of these is used, the
focus indicator arrows' meanings would be reversed.

Setting the Focusing Method

Hold down the [+] button (on the top of the camera) while rotating
the rear command dial until the desired setting appears on the top
LCD panel:

[▫] Single-Area AF—Only the AF area you select is used
 regardless of subject movement.

[⊞] Dynamic AF—The camera's focus follows the subject's
 movement and selects AF focus area based upon where
 the subject has moved in the frame.

 With a Speedlight mounted and turned on, the camera automati-
cally switches to single-area AF **even though the Dynamic AF
symbol does not change.** Set the desired focusing point with the
focus area selector on the camera back.

Setting the Active Focus Area

Press the focus area selector on the back of the camera in the
direction you want to move the active focusing sensor. In single-
area AF this selects the sensor that will be used for autofocus, while
in dynamic AF this selects the initial (or primary) sensor, and the
camera changes sensors as the subject moves from the initial sensor
location to other areas of the picture.

If spot metering is selected, the area metered corresponds to the
4mm circle (with an EC-B screen; 6mm circle with other screens)
surrounding the active AF sensor.

Only the three horizontal AF sensors are cross-hair types, and
only these sensors have additional elements for low-light detection.
The top sensor is skewed slightly, but the bottom sensor is horizon-
tal, making it the only one for which horizontal patterns (or vertical
patterns, when the camera is held in portrait format) could pose a
problem for the AF system.

The AF sensor search pattern is useful to know, as it affects how
fast focus is achieved (the camera responds faster to up-down
changes than to left-right ones):

Selected AF Sensor	2nd Sensor Searched	3rd Sensor Searched	4th Sensor Searched	5th Sensor Searched
Center	Bottom	Top	Left	Right
Bottom	Center	Top	Left	Right
Top	Center	Bottom	Left	Right
Left	Center	Bottom	Top	Right
Right	Center	Bottom	Top	Left

Locking the Focus Area

1. Press the shutter release partway to activate the meter.

2. Press the focus area selector on the back of the camera in the
 direction you want to move the active focus sensor.

3. Hold the ⊡ button on rear control panel and press the focus
 area selector until the ʟᴏᴄᴋ indicator appears above the focus
 area indicator on the top LCD panel.

4. To unlock the focus area, repeat step 3, except press the selector
 until the ʟᴏᴄᴋ indicator disappears.

Setting the Exposure Mode

Hold down the MODE button (on the top of the camera) while rotating the command dial until the desired setting appears on the LCD panel:

P Program—Camera sets both shutter speed and aperture; requires AF or AI-P lens.

S Shutter-Priority—You set the shutter speed, the camera sets the aperture; requires an AF or AI-P lens.

A Aperture-Priority—You set the aperture, the camera sets the shutter speed.

M Manual—You set both the aperture and shutter speed.

Setting Exposure Manually

1. Hold down the MODE button and rotate the rear command dial to select manual (M) exposure mode.

2. Select an aperture using the front command dial (if your lens has a CPU and is set to its minimum aperture), or set it on the lens itself. Set a shutter speed using the rear command dial. The viewfinder shows an exposure indicator: ◀⋮⋯₀⋯⋮▶ The 0 in the center is visible only with correct exposure, while each dot underneath represents 1/3 stop under- or overexposure; an arrow indicates more than 2 stops under- or overexposure.

Note: The owner's manual implies that the manual exposure settings can be locked in one step. This is misleading. Hold down the 🔲 button and individually rotate the front and rear command dials until **LOCK** appears above both the aperture and shutter speed indicators.

Setting the Aperture and Shutter Speed

The camera's meter must be active to change settings. Press the shutter release halfway to activate the meter.

With AF or AI-P lenses the aperture can be set either manually with the aperture ring, or the lens can be set to its minimum aperture to enable aperture control through the camera:

1. In aperture-priority (A) and manual (M) exposure modes, the front command dial controls the aperture in 1/3-stop increments. The lens must be set to its smallest aperture.

2. In shutter-priority (S) and manual (M) exposure modes, the rear command dial controls the shutter speed in 1/3-stop increments.

3. In program (P) exposure mode, the rear command dial shifts the program.

 When using a lens that has no CPU (those that are not AF or AI-P lenses), the aperture **must** be set on the lens' aperture ring.

Locking the Aperture Setting

Aperture lock operates only with lenses that have a CPU (AF and AI-P lenses).

1. In aperture-priority (A) and manual (M) exposure modes, rotate the front command dial to display the desired aperture.
2. Hold down the ▣ button on the rear control panel, and rotate the front command dial until the **LOCK** indicator appears above the f/stop indicator on the top LCD panel and ▣ appears in the viewfinder.

Note: The owner's manual is incorrect about how this works! The aperture must be set before pressing the ▣ button.

 To cancel aperture lock, repeat step 2, but rotate the dial until the **LOCK** and ▣ indicators disappear.

Locking the Shutter Speed Setting

1. In shutter-priority (S) and manual (M) exposure modes, rotate the rear command dial to the desired shutter speed.
2. Hold down the ▣ button on back of the camera and rotate the rear command dial until **LOCK** appears above the shutter speed indicator on the top LCD panel and ▣ appears in the viewfinder.

Note: The owner's manual is incorrect about how this works! The shutter speed must be set before pressing the ▣ button.

 To cancel shutter speed lock, repeat step 2, but rotate the dial until the **LOCK** indicator disappears.

Exposure Compensation

1. Hold down the ▣ button on top of the camera while rotating the rear command dial until the desired exposure compensation value appears on the LCD panel and viewfinder display.

 Compensation is indicated in 1/3 EV stops, within a range of +/–5 stops. A + value overexposes, a – value underexposes.

2. Exposure compensation remains set until it is cancelled by performing step 1 again and setting the compensation to 0.0.

Example: Meter white snow and compensate +2 stops. The meter sets exposure as though every subject were neutral gray. (A white subject is 2 stops brighter than neutral gray, and the exposure needs to be adjusted accordingly.)

Or (for autoexposure modes only),

1. Use center-weighted or spot metering on an appropriate area. (This method works well if there is a gray card or other subject of 18% reflectance to meter on.)

2. Lightly press and hold the shutter release to the halfway position.

 Note: Custom setting #7 locks exposure automatically when the shutter release is pressed halfway.

3. Lock the exposure using the AE-L/AF-L button on the back of the camera. This locks focus on the metered area as well. See page 170 regarding custom setting #21.

4. Re-compose and press the shutter release fully.

Setting Exposure Bracketing

1. Press the 🅱🆃 button on the rear control panel and rotate the rear command dial until the 🅱🆃 indicator appears.

2. While still holding the button, turn the front command dial until the desired bracketing combination is indicated on the back LCD:

ᒷF0.ᒾ	+◼◼	Two shots: correct and 1/3 stop overexposed.
ᒷF0.ᒾ	◼◼-	Two shots: correct and 1/3 stop underexposed.
ᒷF0.⁊	+◼◼	Two shots: correct and 2/3 stop overexposed.
ᒷF0.⁊	◼◼-	Two shots: correct and 2/3 stop underexposed.
ᒷF0.:	+◼◼	Two shots: correct and 1 stop overexposed.
ᒷF0.:	◼◼-	Two shots: correct and 1 stop underexposed.
ᒾF0.ᒾ	+◼◼◼-	Three shots: correct and 1/3 stop either side. (Default setting)
ᒾF0.⁊	+◼◼◼-	Three shots: correct and 2/3 stop either side.
ᒾF0.:	+◼◼◼-	Three shots: correct and 1 stop either side.

3. The default bracketing sequence is correct (0), under- (–), and over- (+) exposure. Custom setting #3 can be set to change this order to under- (–), correct (0), and over- (+) exposure (see page 168). Exposure compensation modifies the point around which bracketing occurs.

The aperture is changed to obtain bracketed exposures in

shutter-priority (S) exposure mode, while the shutter speed is changed in aperture-priority (A) and manual (M) modes (custom setting #17 can be used to change this default in manual mode, see page 170). Both shutter speed and aperture are changed in program (P) mode. If a Speedlight flash unit is attached and active, flash output is changed.

With single frame advance (S), each time you press the shutter release, the next shot in the bracketing series is taken. With continuous advance, hold the shutter release down, and the camera will stop when the bracketing series is complete.

If the end of a roll is reached during a bracketing sequence, rewind the film, load a new roll, and then press the shutter release again to resume the sequence.

When the MF-28 Multi-Control Back is in use, its bracketing settings have priority over the camera's settings.

To cancel bracketing, repeat step 1, but rotate the rear command dial until the 🔲 indicator disappears (the number of shots and bracketing amount setting remains displayed, however, until you release the 🔲 button).

Setting the Self-Timer

1. Hold down the film advance mode selector lock release button on the top of the camera while rotating the dial surrounding the rewind knob (film advance mode/self-timer selector) until it points to the self-timer symbol (⟳).

2. Close the eyepiece shutter to prevent stray light from affecting the exposure.

3. Press the shutter release.

4. The LED on the front of the camera blinks until the last 2 seconds prior to exposure, at which time it lights continuously.

The self-timer is set to fire after 10 seconds unless you change the duration using custom setting #16 (allowing a possible range of 2 to 60 seconds; see page 169).

If the camera body is set for single servo autofocus, the self-timer does not activate until focus is achieved. Once the self-timer is activated, the shutter fires regardless of focusing status (e.g., if the subject moves).

The bulb setting cannot be used with the self-timer. The camera defaults to a shutter speed of 1/250 second if you attempt this.

To cancel, hold down the lock release and rotate the mode selector back to the desired film advance setting.

Setting a Bulb or Long Exposure
Bulb:
With bulb, the length of the exposure is controlled by how long you hold down the shutter release.

1. Hold down the mode button and rotate the rear command dial to select manual (M) exposure mode.

2. Release the mode button; rotate the rear command dial again to set the shutter speed to ᏏᎯᏏᏏ.

3. Set the desired aperture using the front command dial (or the lens aperture ring for non-AF or AI-P lenses).

4. Press and hold the shutter release for the length of the exposure.

 Consider using an MC-20, MC-30, or other remote control release to prevent camera shake.

Long Exposure:
With long exposure, the camera's timer controls the length of the exposure.

1. Press and hold the **CSM** button on the rear control panel while rotating the rear command dial until custom setting ᜍᏏ-Ꮕ appears on the rear LCD.

2. While still holding the **CSM** button, rotate the front command dial to set ᜍᏏ- ᜍ to enable long exposure.

3. Set the shutter speed on camera as usual; instead of stopping at 30 seconds (indicated as 30"), the camera now allows additional times up to 30 minutes (30'), in 1/3-stop increments.

 To cancel long exposure capability, repeat steps 1 and 2, but set ᜍᏏ-Ꮕ instead of ᜍᏏ- ᜍ.

Note: Long exposures may exhaust the camera's batteries! With alkaline AA batteries, the camera can remain powered for a maximum of approximately 5 hours at 68° F (20° C).

Mirror Lock-Up
1. Put the camera on a tripod and frame the subject.

2. Set the camera to manual (M) exposure mode, set exposure, and focus manually. Autoexposure and autofocus modes are not possible with the mirror locked up.

3. Rotate the small mirror lock-up lever next to the lens mount away from the lens until it locks (about 90°).

4. Close the eyepiece shutter so no spurious light enters the camera through the eyepiece (there's nothing to see anyway, and this reminds you that the mirror is locked up).

Warning: Do not leave the mirror locked up with the lens cap off except during exposures. Direct sun entering the lens may damage the shutter curtain.

Taking Multiple Exposures

1. Press the ■ button just in front of the top LCD panel, and rotate the rear command dial until the ■ indicator appears in the LCD panel.

2. Set any necessary exposure compensation (often –1 EV is used for two overlapping exposures, depending upon the lighting, of course).

3. Take your first shot. The film does not advance and the multiple exposure indicator will blink. If you wish to have more than two exposures on the frame, repeat step 1 at this point.

4. Take your final shot. The multiple exposure indicator then disappears and the camera returns to normal operation.

Note: You can cancel multiple exposures *before* taking the first shot by holding the multiple exposure button and rotating the rear command dial until the ■ indicator disappears from the LCD. To cancel multiple exposures *after* taking the first shot using single servo AF, switch to manual focus, put the lens cap on, and press the shutter release. To cancel *after* taking the first shot with continuous servo AF, put the lens cap on and press the shutter release. Pressing the reset buttons also cancels the multiple exposure function after the first shot has been taken.

Custom setting #13 can be used to perform continuous multiple exposures, however I do not recommend it. While this results in less work when making more than two exposures on a frame, it is too easy to forget that the camera is set on chronic multiple exposure, resulting in lost photos. The one time this makes sense is when you want to get a large number of overlapping exposures by setting the camera to CH frame advance—to capture a "soft" feeling of leaves blowing in gentle wind, for example. Unfortunately, the F5's frame advance is so fast, that setting precise exposure in such situations is a little bit of a guess, since you're not going to be able to count how many exposures it fires off.

Depth-of-Field (DOF) Preview

1. Set the aperture.

2. Press the small, depth-of-field preview button on the front of the camera (above the mirror lock-up lever).

3. Look through the viewfinder to judge the approximate depth of field you will get at that aperture.

Note: While DOF preview is active, you cannot adjust the aperture with the front command dial; you must use the aperture ring. Also, autofocus is disabled.

Setting Rear-Curtain Sync

1. Set the Speedlight's switch to TTL mode. (Rear-curtain sync can also be used in auto and manual flash modes, however only in A, S, or M modes.)

2. To select a specific shutter speed, set the camera to shutter-priority (S) or manual (M) exposure mode. (In P or A mode, slow-sync is selected automatically.)

3. Hold the ▨ button on the camera's rear control panel and rotate the rear command dial until the ▨ indicator appears on the camera's rear LCD.

4. For SB-24, -25, and -26 only: Set the Speedlight's sync switch to the REAR setting. You should see a ▨ indicator on the camera's rear LCD.

Setting Slow-Sync Flash

1. For the most automatic operation, set the Speedlight's switches to TTL and normal modes (manual, auto, and repeating flash modes can also be set).

2. Set the camera to program (P) or aperture-priority (A) mode.

3. Hold the ▨ button on the camera's rear control panel and rotate the rear command dial until the ▨ indicator appears on the camera's rear LCD.

Adjusting the Viewfinder's Diopter Setting

1. Point the camera at a distant scene and focus the lens at infinity. Or, remove the lens and use the etchings on the focusing screen to judge sharpness.

2. To adjust focus, pull the knob labeled + – on the right side of the prism outward. Look through the viewfinder and rotate the knob until the central area of the viewfinder appears sharpest (towards – if nearsighted, towards + if farsighted).

3. Push the knob back in towards the camera to lock the setting. Be careful not to rotate it when pushing it back in.

Note: It should be possible to see the entire frame in the viewfinder, even with glasses on. If you wear glasses while shooting, make sure that the diopter setting is at –1 (the + and – symbols on the button are parallel to the plane of the top LCD).

Changing the Focusing Screen

1. Remove the prism by pressing the finder release button to the lower left of the eyepiece and pulling the viewfinder towards the back of the camera.

2. Slip a fingernail or small tweezers under the tab on the rear left-hand side of the screen and lift out.

3. Insert the new screen by sliding the front edge into place first, then lowering the rear edge.

Note: Some focusing screen-lens combinations require a compensation factor to be entered into the camera via custom setting #18.

Illuminating the LCD Panels

Rotate the camera's power switch to the light bulb symbol and let go. The LCD panels will be lit for as long as the meter remains on or until the shutter is released.

F5 Custom Settings

Setting a Custom Setting

1. Press and hold the **CSM** button on the rear control panel while rotating the rear command dial until the setting number you desire is displayed on the rear LCD.

2. While still holding the **CSM** button, rotate the front command dial until the desired option number is displayed on the rear LCD.

To cancel a custom setting, simply repeat these steps, but select the default option (typically 0) in step 2.

Function	#	Options
User's customized set of camera settings	0	**0-A** = customized settings A (default) **0-b** = customized settings B
Continuous servo AF	1	**1-0** = release priority (default) **1-1** = focus priority
Single servo AF	2	**2-0** = focus priority (default) **2-1** = release priority
Bracketing sequence	3	**3-0** = correct, under, over (default) **3-1** = under, correct, over
AF activated by shutter release button	4	**4-0** = enabled (default) **4-1** = disabled
AE lock method	5	**5-0** = exposure value (EV) used (default) **5-1** = shutter speed and aperture locked
Rotation of front and rear command dials	6	**6-0** = L to R rotation travels through sequence (default) **6-1** = R to L rotation travels through sequence
AE lock activated by shutter release button	7	**7-0** = disabled (default) **7-1** = enabled
Auto advance to frame #1 (when camera back is closed)	8	**8-0** = disabled (default) **8-1** = enabled*

Function	*#*	*Options*
Cн film advance speed	9	**۹-0** = 8 fps (default) **Cн8** = 8 fps **Cн6** = 6 fps
Cʟ film advance speed	10	**:0-0** = 3 fps (default) **CL3** = 3 fps **CL4** = 4 fps **CL5** = 5 fps
LED for time exposures	11	**: :-0** = alert LED doesn't blink† (default) **: :- :** = alert LED blinks‡
Automatic film stop	12	**:2-0** = disabled (default) **E- -** = disabled **E 35** = stop at frame 35‡ **E 36** = stop at frame 36
Multiple exposure	13	**:3-0** = cancelled after 2nd exposure* (default) **:3- :** = enabled until cancelled‡
Center-weighted area	14	**:4-0** = 12mm diameter (default) **C8** = 8mm diameter‡ **C :2** = 12mm diameter **C :5** = 15mm diameter‡ **C20** = 20mm diameter‡ **A** = average entire frame **PC** = user setting via computer
Meter shut-off delay	15	**:5-0** = 16 seconds (default) **L4** = 4 seconds† **L8** = 8 seconds **L :6** = 16 seconds **L32** = 32 seconds‡
Self-timer delay from 2 to 60 seconds	16	**:6-0** = 10 seconds (default) **Lx** (x is a number from 2 to 60 representing the number of seconds delay)

Function	*#*	*Options*
Bracketing in M mode	17	**17-0** = vary shutter speed (default) **008** = vary flash level **0 18** = vary aperture **108** = vary shutter speed **1 18** = vary shutter speed and aperture
Focus screen compensation	18	**18-0** = no compensation (default) **-2.0** to **2.0** in 1/2-stop intervals
Long shutter speeds from 30 sec. to 30 min.	19	**19-0** = disabled (default) **19-1** = enabled‡
Maximum flash sync speed .	20	**20-0** = 1/250 (default) **60** = 1/60 **80** = 1/80 **100** = 1/100 **125** = 1/125 **160** = 1/160 **200** = 1/200 **250** = 1/250 **300** = 1/300‡ (1/300 is allowed only in S or M exposure modes. Requires an SB-20, -22, -23, -24, -25, -26, -27, or -28 and reduces the flash unit's guide number to approximately 14.)
AE/AF lock button	21	**21-0** = exposure and autofocus lock (default) **AEL** = exposure lock only **AFL** = autofocus lock only‡ **L-L** = exposure and autofocus lock
Front command dial for aperture control	22	**22-0** = enabled (default) **22-1** = disabled‡
Focus indicators ▶ ◀ in AF mode	23	**23-0** = enabled (default) **23-1** = disabled†

170

Function	#	Options
Bracketing	24	ꙮ꙼-0 = ambient light and flash (default)
		0 ꙮ = bracket using ambient exposure only
		ꙮ0 = bracket using flash only
		ꙮ = ambient light and flash

Settings recommended for ease of use.

†*Settings recommended to conserve battery power.*

‡*Settings I recommend avoiding unless you understand the consequences they have on battery usage or camera operation.*

Note: You may, of course, disagree with these assessments. They represent how I use the camera and early findings on battery life. If you deviate from these recommendations, at least make sure you understand why you want to deviate from them! Random fiddling with custom settings can put your F5 into bizarre states in which the camera will operate differently than you expect, causing you to miss the picture you're trying to take.

The F5 allows additional custom settings through linkage with a personal computer using the AC-1WE or AC-1ME packages. They include:

- Slowest flash sync speed (1/60 second to 30 seconds)
- Variable aperture during zooming
- Function of lock button can be changed to alter shutter speed and aperture settings.
- Disable focus area from shifting diagonally (e.g., from left to top area); only horizontal or vertical shifts are possible.
- Adjustable shutter release delay up to 1 second
- Disable focus area indicator in viewfinder
- Data imprint on frame 0
- Bulb or time release option
- Self-timer LED lights when shutter is released (helpful in remote use).
- Focus lock in Single Servo AF with continuous motor drive
- Multiple camera synchronization (enables shooting at 16 fps!)
- Warning when data storage area is full

- Select data to be kept by camera
- Lock desired camera settings
- Display of 1005-pixel CCD color distribution
- User-settable program (P) mode

Since the F5 is rarely used in the field with a personal computer, these settings are not covered here. Consult the manual that came with the AC-1WE or AC-1ME package.

F5 Program (P) Mode Settings

Exposure Value	Setting (at ISO 100)
0	f/1.4 at 2 seconds
1	f/1.4 at 1 second
2	f/1.4 at 1/2
3	f/1.4 at 1/4
4	f/1.4 at 1/8
6	f/2 at 1/15
8	f/2.8 at 1/30
10	f/4 at 1/60
12	f/5.6 at 1/125
14	f/8 at 1/250
16	f/11 at 1/500
18	f/16 at 1/1000
20*	f/16 at 1/4000

Exceeds limit of autofocus capability

You have full control over the Programmed Auto mode and can easily alter or "shift" the above program by rotating the rear command dial until the desired shutter speed or aperture appears.

If an asterisk (*) appears after the P on the top LCD panel (**P***), this indicates that the basic program has been shifted; the camera maintains this alteration until you switch modes or turn the camera off.

Note: If the lens being used has a smaller maximum aperture than shown above, shutter speeds will be longer than shown in order to maintain correct exposure.

Maximum Aperture for Using Flash in Program (P) Mode

At ISO 100, the F5 automatically programs apertures from f/4 to the lens' minimum aperture (typically this is f/16) when flash is used. There is no benefit in using a lens faster than f/4 with an F5 in program mode using flash and ISO 100 film!

ISO Value	Maximum Aperture	ISO Value	Maximum Aperture
25	f/2.8	400	f/5.6
50	f/3.3	800	f/6.7
100	f/4	1000	f/7.1
200	f/4.8		

Note: The F5 has a limit of ISO 1600 for flash photography.

Nikkor Lenses That Can't Be Used with the F5

Lens	Comments
Non-AI lenses	F5 requires lenses with AI modification
Non-AI close-up extension tubes PK-1, PK-2, PK-3, PN-1, PB-4, and K2 ring	
28mm f/4 PC	Serial numbers up to 180900 not usable without modification
35mm f/2.8 PC	Serial numbers up to 906200 not usable without modification
35mm f/3.5 PC	
80mm f/2.8 for F3AF	No matrix metering, no P or S mode
200mm f/3.5 for F3AF	No matrix metering, no P or S mode
AF TC-16 Teleconverter for F3AF	TC-16A required

Early versions of the 500mm f/8 lens can be mounted on an F5 only if the tripod mounting collar is first rotated out of the way 90°. This is not the case with newer versions.

The PF-4 Reprocopy requires the PA-4 camera holder adapter.

The PB-6 Bellows accessory requires using a PK-12 or PK-13 extension tube, or alternately, a PK-11A extension tube and two PB-6D bellows-rail spacers.

173

Nikon F4

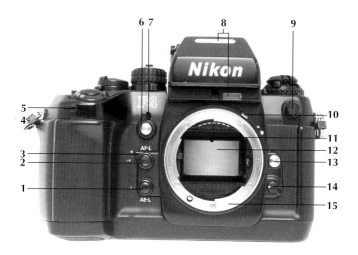

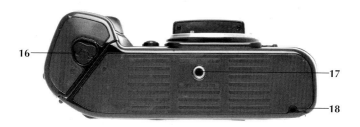

1 Autoexposure lock button
2 Autofocus lock button
3 Simultaneous AF-L/AE-L lever
4 Camera strap eyelet
5 Self-timer indicator
6 Depth-of-field preview button
7 Mirror lock-up lever
8 LCD illumination windows
9 Sync terminal
10 Meter coupling lever
11 CPU contacts
12 Reflex mirror
13 Lens release button
14 Focus mode selector
15 Lens mount
16 Battery compartment key
17 Tripod socket
18 Guide hole

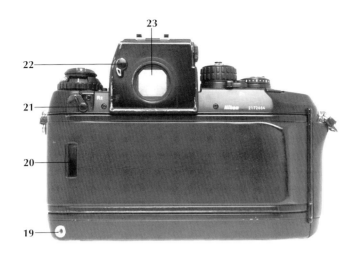

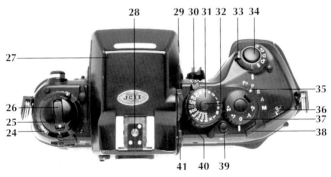

19 Release terminal
20 Film cassette window
21 Film rewind lever (R2)
22 Eyepiece shutter lever
23 Viewfinder eyepiece
24 Film speed dial
25 Film rewind knob
26 Film rewind crank
27 Prism
28 Accessory shoe
29 Compensation value scale
30 Viewfinder illuminator switch

31 Shutter speed dial
32 Shutter speed dial lock release
33 Film advance mode selector
34 Shutter release button
35 Exposure mode selector
36 Frame counter
37 Exposure compensation dial
38 Multiple exposure lever
39 Film rewind lever 1 (R1)
40 Metering mode selector
41 Diopter adjustment knob

F4 Model Nomenclature

The F4 is available in three models:

F4 The basic body with the MB-20 battery pack, which holds four AA batteries in the right hand grip.

F4s The basic body with the MB-21 battery pack, which holds six AA batteries; three in the right hand grip and three in the grip extension on the bottom of the camera body. This is the version of the camera that was sold in the U.S.

F4ε The basic body with the MB-23 battery pack, which holds six AA alkaline batteries. The MB-23 can also take the MN-20 NiCad battery pack.

F4 Viewfinder Error Messages

Red X appears Autofocus is not possible; focus manually.

◀ symbol appears Subject is not in focus or is located closer than the lens' minimum focusing distance.

▶ symbol appears Subject is not in focus or lens is not set on infinity when TC-16A is being used.

ㅂ ⋮ .. Current settings will overexpose shot (P, PH, S, and A exposure modes only).

ㄴ ⋄ .. Current settings will underexpose shot (P, PH, S, and A exposure modes only).

FEE appears Lens is not set to smallest aperture.

Red light near rewind knob illuminates Film is not loaded correctly, reload film; or, end of roll has been reached, rewind film.

Red light near rewind knob blinks rapidly Non-DX coded film was detected or DX code not interpreted; set ISO manually.

A appears (in P or S mode) Lens has no CPU to support
program (P) or shutter-priority (S)
exposure mode, camera defaults to
aperture-priority (A) mode.

⚡ blinks Flash may not have been sufficient
to provide correct exposure.

F4 Instructions

Turning the Camera On and Off

To turn the camera on, simultaneously press the lock release button
next to the film advance mode selector and rotate the selector to
one of the film advance settings (S, CH, CL, CS, or self-timer).

To turn the camera off, perform step 1, but rotate the selector to
the L (lock) position.

Note: Pressing the shutter release halfway turns on the exposure
meter, viewfinder illumination (if the viewfinder illuminator switch
is on), and, when appropriate, auto-focusing. The meter remains
active for 16 seconds with fresh batteries.

Setting the Film Advance Mode

Hold down the lock release button (next to the film advance mode
selector) and rotate the film advance mode selector (surrounding the
shutter release) to the desired setting:

S Single Frame—Press the shutter release once for each
exposure.

CS Continuous Silent—0.8 to 1 fps, depending upon battery
pack used.

CL Continuous Low Speed—3 to 3.4 fps, depending upon
battery pack used.

CH Continuous High Speed—4 to 5.7 fps, depending upon
battery pack used.

The shooting speeds for continuous advance modes apply to
shutter speeds of 1/250 second or faster using manual exposure
mode and manual focus. The lower values are typically for the
MB-20 battery pack, the higher values are achieved with the
MB-21 or MB-23 battery packs.

Setting the ISO Manually

Hold down the ISO dial lock button on the top left of the camera and rotate the ISO dial to set the film speed. Each dot represents a 1/3-stop intermediary value.

Setting the ISO Automatically with DX Encoding

Hold down the ISO button on the top left of the camera, and rotate the ISO dial to the DX setting.

Note: If the red light to the right of the ISO dial blinks rapidly after loading film in the camera, the camera was unable to set the ISO value via DX encoding. Set the film speed manually (see above).

Loading Film

1. Set the ISO manually or set DX encoding.
2. Push the release lever surrounding the rewind crank in the direction of the arrow. Then lift the rewind knob to open the camera's back.
3. Insert a film cartridge into the left-hand compartment so the film leader extends to the right.
4. Pull the film leader across to the red index mark near the take-up area.
5. Using the rewind crank, remove slack from the film so that it lies flat.
6. Close the camera back.
7. Depress the shutter release; the camera will automatically advance the film to the first frame.

Rewinding Film

1. While holding down the button in the middle of rewind lever 1 (labeled R1 on the upper right-hand side of the camera's back), pull the lever out.
2. While holding down the lock button next to rewind lever 2 (labeled R2 on the left side of the camera's back, below the ISO dial), push down rewind lever 2.

 Or,

1. While holding down the button in the middle of rewind lever 1, pull the lever out.

2. Lift the rewind crank and turn it in the direction of the arrow until the film is rewound into the cartridge (you'll feel the tension on the handle release).

Setting the Metering Method

Turn the metering system selector on the right side of the prism to the desired setting:

 □ Matrix
 Five-segment evaluative metering is used. Requires AF- or AI-type lenses.

 ⊙ Center-Weighted
 60% of the meter's sensitivity is concentrated in the 12mm circle in the viewfinder.

 ● Spot
 100% of the meter's sensitivity is concentrated on a 5mm circle in viewfinder.

Setting the Focus Mode

Move the focus mode selector on the left front of the camera to:

S Single Servo AF—Uses focus-priority (shutter cannot be released until focus is achieved).
 Viewfinder symbols:
 ▶ or ◀ Focus is in progress.
 ● Focus is locked; you need to refocus if the subject moves.
 X Focus cannot be achieved; shutter is locked.

C Continuous Servo AF—Uses release priority (shutter can be released whether or not focus is achieved). Focus is continuously updated unless AF-L button is held down (which will lock focus).
 Viewfinder symbols:
 ▶ or ◀ Focus is being sought.
 ● Focus is achieved.
 Focus tracking is activated only if C mode is used with C<small>L</small> shooting mode. (With focus tracking, the camera's focus not only follows the motion of a subject but also predicts its position at the time the shutter is actually fired.)

M Manual Focus—Electronic confirmation symbols appear in the viewfinder.

Viewfinder symbols:

◄ The subject is not in focus; rotate the lens' focus ring to the left.

► The subject is not in focus; rotate the lens' focus ring to the right.

• The subject is in focus.

Setting the Exposure Mode

Move the exposure mode selector (on the top of the camera, on the right) to the desired selection:

P Program—Camera sets both the shutter speed and aperture; requires an AF or AI-P lens.

PH High-Speed Program—Camera sets both the shutter speed and aperture with an emphasis on faster shutter speeds; requires AF or AI-P lens.

S Shutter-Priority—You set the shutter speed, the camera sets the aperture; requires an AF or AI-P lens.

A Aperture-Priority—You set the aperture, the camera sets the shutter speed.

M Manual—You choose both the aperture and the shutter speed.

Note: If you select P, PH, or S mode, the lens must be set to its smallest aperture.

Setting Exposure Manually

1. Set the camera to manual (M) exposure mode (see "Setting the Exposure Mode," above).

2. Select the aperture on the lens; select the shutter speed using the shutter speed dial.

 An exposure scale is located at the bottom of the viewfinder display. A dot below the center line indicates correct exposure. Each dot in the scale indicates 1/3-stop over- or underexposure, progressing from left (+) to right (–); a dash under the + or – symbol indicates more than 2 stops over- or underexposure.

Setting the Aperture

Rotate the aperture ring on the lens.

Note: Setting the aperture is possible only in A and M exposure modes. In P, PH, and S modes, changing the aperture results in F£́£́ appearing in the viewfinder.

Setting the Shutter Speed

Rotate the shutter speed dial on the top of the camera to the desired setting. Shutter speeds are listed from 4 seconds to 1/8000 second. B stands for bulb, T for time exposure, and X for maximum flash sync.

Note: Setting a precise shutter speed is possible only in M and S exposure modes. In P, PH, and A modes, the camera sets the shutter speed steplessly and ignores your input unless you select time exposure (T).

Locking the Exposure Settings

1. Set the metering system selector on the right side of the prism to center-weighted or spot metering and point the focus brackets at an appropriate area.

 Note: Although you can lock exposure settings using any metering mode, this function is most useful for metering on a very specific area. Center-weighted or spot metering modes offer the most control.

2. Lightly press the shutter release.

3. Lock the exposure by pressing the AE-L button on the front of the camera.

4. Recompose the frame and press the shutter release fully.

Exposure Compensation

Press the lock on the exposure compensation dial and turn the dial to the desired amount of compensation.

Compensation is indicated in 1/3 EV stops (each dot is 1/3 EV) ranging from +/– 2 EV). A + value overexposes, a – value underexposes.

Example: Meter white snow and compensate by adding 2 stops of exposure. Without compensation, the meter sets exposure as though every subject were neutral gray. (A white subject is 2 stops brighter than neutral gray, therefore the exposure needs to be adjusted accordingly.)

Exposure compensation remains set until it is cancelled by you by performing this step again and setting compensation to 0.

Setting the Self-Timer

1. Hold down the film advance lever lock release button while rotating the film advance mode selector (surrounding the shutter release) to the self-timer indicator ☉.

2. Close the eyepiece shutter to prevent stray light from entering (only necessary in A, S, P, or PH exposure modes).

3. Press the shutter release.

4. The LED on the front of the camera blinks slowly until 2 seconds prior to exposure, at which time it blinks faster.

The self-timer is set to fire after 10 seconds.

If the camera is set for single servo AF (S), the self-timer will not start until focus is achieved. If the subject moves after the self-timer has begun counting down, the subject will be out of focus.

The bulb setting cannot be used with the self-timer. If you attempt this, the camera automatically sets the shutter speed to 1/250 second except if you are using a mechanical, remote locking shutter release or the long exposure function of the MF-23 camera back.

To cancel the self-timer, hold down the lock release button and rotate the selector back to S, Cs, CL, or CH.

Setting a Bulb or Time Exposure

With bulb (B) exposure, the shutter stays open while the shutter release is pressed. With time (T) exposure, the shutter stays open until it is actively closed by turning the shutter speed dial.

1. Rotate the exposure mode selector to M for bulb (B), or to any mode for time exposure (T).

2. Rotate the shutter speed dial to B (bulb) or T (time exposure).

3. Set the desired aperture (on the lens) if necessary, depending on the mode you have chosen.

4. For bulb (B) exposure, press and hold the shutter release for the length of the exposure. For a time (T) exposure, press the shutter release once to start the exposure; turn the shutter speed dial to any setting except T to end the exposure. If the exposure was longer than 30 seconds, press the shutter release again (with the lens cap on) to advance the film.

Note: Consider using a remote release (MC-12a , MC-12b, or AR-3) to prevent camera shake. Use T mode to prevent battery depletion.

Mirror Lock-Up

Mirror lock-up is useful in three situations: 1) extreme macro magnifications, when any vibration may have an impact on sharpness; 2) use of long lenses at exposure times near 1/15 second or longer, when "mirror slap" may reduce sharpness; and 3) when using a lens that has a rear element that extends into the camera body. Autoexposure and autofocus modes are not available when the mirror is locked up.

1. Place the camera on a tripod and frame the subject.

2. Set the camera to manual (M) exposure mode, set the shutter speed and aperture, and focus.

3. Press the depth-of-field preview button (on the right front of the camera) and rotate the mirror lock-up lever surrounding it 45° away from the lens until the mirror locks.

4. Close the eyepiece shutter (there's nothing to see anyway, and this reminds you that the mirror is locked up).

 To release the mirror, push the lever 90° back towards the lens.

Warning: Do not leave mirror locked up with the lens cap off except during exposures. Direct sun entering through the lens may damage the shutter curtain.

Taking Multiple Exposures

1. Set any necessary exposure compensation (–1 EV for two overlapping exposures).

2. Pull out the multiple exposure lever (on the top of the camera, next to the exposure compensation dial).

3. Take your first shot; the film does not advance. If you wish to have more than two exposures on the frame, hold the lever out or pull it out again after each exposure.

4. Push the lever back in before the final exposure.

5. Take the final shot. The film advances to the next frame.

Note: If you need to cancel the multiple exposure mode before an exposure has been made, press the multiple exposure lever back to its normal position. If you've already taken the first exposure, put the lens cap on before taking the next exposure.

Depth-of-Field (DOF) Preview

1. Set the desired aperture.
2. Press the small chrome button on the front of the camera, to the right of the lens.
3. Look through the viewfinder to judge the approximate depth of field you will get at that aperture.
4. Repeat the procedure until you have set an aperture that will deliver the desired depth of field.

Note: While DOF preview is active, autofocus is disabled. Metering while DOF preview is active may result in incorrect readings.

Adjusting the Viewfinder's Diopter Setting

1. Point the camera at a distant scene and focus the lens at infinity. Or, remove the lens and use the etchings on the focusing screen to judge sharpness.
2. To adjust focus, pull the knob labeled + – on the right side of the prism outward. Look through the viewfinder and rotate the knob until the central area of the viewfinder appears sharpest (towards – if nearsighted, towards + if farsighted).
3. Push the knob back in towards the camera to lock the setting. Be careful not to rotate it when pushing it back in.

Note: It should be possible to see the entire frame in the viewfinder, even with glasses on. If you wear glasses while shooting, make sure that the diopter setting is at 0 (so the + and – symbols on the button are parallel to the base of the camera).

Removing the Prism and Changing the Focusing Screen

1. Remove the prism by pressing the finder release lever, to the left of the prism and on top of the camera, towards the finder. Pull the prism towards the back of the camera.
2. Slip a fingernail under the rear edge of the screen and lift it out.
3. Insert the new screen by sliding the front edge into place first, then lower the rear edge.
4. Replace the prism by sliding it back into position.

Note: Some focusing screens require an exposure compensation factor to be entered into the camera via a small dial on the

underside of the prism. See the instructions that come with the new focusing screen for more information.

Tip: The Type E screen features a grid that helps align horizons, reminds you of the rule-of-thirds points, and helps you align verticals and prevent converging lines. It is probably the most useful of the optional screens for general-purpose use.

Illuminating the Viewfinder Display

1. Move the viewfinder illuminator switch that's directly beneath the shutter speed dial clockwise, revealing the red dot below it.

2. Press the shutter release partway.

F4 Programmed Auto (P and PH) Mode Settings

(at ISO 100)

Exposure Value	P Setting	PH Setting
0	f/1.4 at 2 seconds	f/1.4 at 2 seconds
1	f/1.4 at 1 second	f/1.4 at 1 second
2	f/1.4 at 1/2	f/1.4 at 1/2
3	f/1.4 at 1/4	f/1.4 at 1/4
4	f/1.4 at 1/8	f/1.4 at 1/8
6	f/2 at 1/15	f/1.4 at 1/30
8	f/2.8 at 1/30	f/1.8 at 1/90
10	f/4 at 1/60	f/2.4 at 1/180
12	f/5.6 at 1/125	f/3.5 at 1/375
14	f/8 at 1/250	f/5 at 1/750
16	f/11 at 1/500	f/6.8 at 1/1500
18	f/16 at 1/1000	f/9.5 at 1/3000
20*	f/16 at 1/4000	f/13 at 1/6000

Exceeds limit of autofocus capability.

The figures for PH mode, above, are approximations. In short, the PH mode doesn't begin using smaller apertures until a shutter speed of at least 1/60 second is used, while the P mode begins shifting apertures when the shutter speed exceeds 1/8 second.

Note: If the lens being used has a smaller maximum aperture than shown above, shutter speeds will be longer in order to maintain correct exposure.

185

Nikkor Lenses That Can't Be Used with the F4

Lens	Comments
16mm f/3.5	Serial numbers 272281 to 290000 not compatible
28mm f/3.5	Serial numbers 625611 to 9999999 not compatible
35mm f/1.4	Serial numbers 385001 to 400000 not compatible
35mm f/3.5 PC	Not compatible unless viewfinder is removed
55mm f/1.2	Not compatible
AF TC-16	Compatible with F4, but will not fit on F4s and F4e. Use TC-16A.

Refinements to the F4

The F4 has undergone many upgrades since its introduction in 1988. Some of these may affect operation. Those with serial numbers from 2350000 include most of these modifications. Your F4 may or may not have the following features:

1. The metering system selector switch is stiffer and sticks out less to prevent unintentional changes.

2. The metal body is somewhat stronger, which cannot be detected visually.

3. The shutter speed numbers on the original F4s rubbed and flaked off, later models don't exhibit this tendency.

4. The standard prism of later models (serial numbers 2200000 and higher) has a two-step security lock to prevent its accidental removal (for instance if a Speedlight is attached, creating additional torque).

5. The prism in later models (serial numbers 2500000 and higher) has an extra hole in the hot shoe to accommodate the security pin of the SB-25, SB-26, SB-27, and SB-28 flash units.

6. The grip has more contour, and a small rubber "tooth" has been added, which sticks out in the grip to support the user's middle finger. This provides more support and a more secure feeling for your right hand.

7. Early models have a pin made of metal to detect whether the back is open or not. The pins in later models are made out of

white plastic. (Check if purchasing an F4 secondhand; metal pins can stick in humid weather.)

8. The battery switch inside later models of the MB-21 grip is labeled "Ni-Cd" instead of "KR-AA."

9. The exterior plastic was changed from a semi-gloss to a matte finish for better "gripability."

10. Earlier models (serial numbers 2350000 and lower) have a higher battery voltage threshold, shortening the life of most batteries. This can be reprogrammed when serviced.

11. The exposure compensation dial is stiffer to make it harder to move it accidentally.

12. AE-L and AF-L lever has a stronger spring catch.

Nikon N90s/F90X

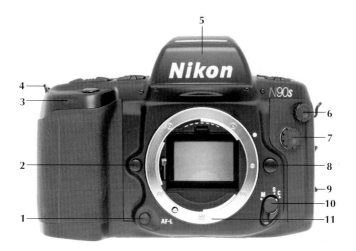

1	AF-lock button	8	Lens release button
2	Depth-of-field preview button	9	Camera back lock releases
3	Self-timer indicator LED	10	Focus mode selector
4	Camera strap eyelet	11	Lens mount
5	Prism	12	Battery compartment
6	Sync terminal	13	Battery holder lock screw
7	Remote terminal	14	Tripod socket

15 Film cassette window
16 Viewfinder/LCD panel
 illumination button
17 Eyepiece shutter lever
18 Accessory shoe
19 Viewfinder eyepiece
20 AE-lock lever
21 Self-timer button
22 Film advance mode button
23 Flash sync mode button
24 Film speed/Film rewind button
25 Exposure mode button

26 Vari-program button
27 Reset button
28 Metering system button
29 LCD illumination window
30 Film rewind button
31 Exposure compensation/
 Reset button
32 Shutter release button
33 Power switch
34 Focus area button
35 Command dial
36 LCD panel

189

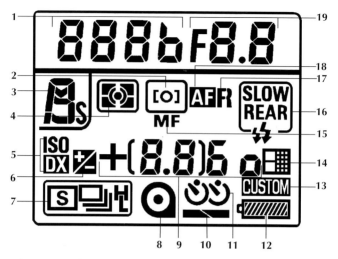

1 Shutter speed
2 Autofocus area
3 Exposure mode
4 Metering mode
5 ISO/DX indicator
6 Exposure compensation
7 Film advance mode
8 Film loading
9 Frame counter/Vari-program/
 ISO speed/Self-timer duration/
 Exposure compensation value

10 Film advance and rewind
11 Self-timer
12 Battery level indicator
13 Custom*
14 Photo technique selection*
15 Manual focus
16 Flash sync mode/Red-eye
 reduction
17 Release/Focus priority
18 Autofocus
19 Aperture

Appears when Data Link or Photo Secretary is in use.

Variations between the N90 and N90s

Note: The N90 and N90s are known as the F90 and F90X, respectively, in markets outside the U.S. The variations listed below apply to those models as well.

The N90s differs from the original N90 in several aspects:

1. The N90s allows you to select shutter speeds in 1/3-stop increments in M and S modes. The N90 allows you to choose shutter speeds in whole stops only.

2. The predictive autofocus system and motor drive on the N90s are faster, operating at up to 4.1 frames per second, as opposed to only 3 frames per second with the N90.

3. The N90s has better gaskets and weather seals than the N90.

4. The N90s does not allow you to set the self-timer to take two sequential pictures. The N90 does.

5. The N90s does not have the warning beep function of the N90, unless you use the Sharp Wizard Electronic Organizer or Nikon Photo Secretary.

6. The MB-10 grip's vertical shutter release works when used with the N90s, but does not function when used with the N90 unless you have your camera modified by Nikon.

7. The N90s uses the AC-2E card when used with a Sharp Wizard Electronic Organizer; the N90 uses the original AC-1E card.

8. The N90s has enough memory to keep 36 rolls of exposure information to pass to a PC or Sharp Wizard Electronic Organizer; the N90 can store a maximum of only two rolls of exposure information.

N90s/F90X LCD Error Messages

ᴴ ¡ ... Current settings will overexpose shot.

ᴸᴏ ... Current settings will underexpose shot.

FΣΣ ... AF lens is not set to smallest aperture in Multi-program (P) or shutter-priority (S) modes, or Speedlight is not set to TTL mode in P mode.

Σₙd and **◐▬** symbol blink End of roll has been reached, rewind film.

▭▬ blinks Batteries are low; replace them.

Σ .. Frame counter indicates that no film is loaded in camera.

Σ and **◐▬** blink Roll has been rewound.

F⁻ ⁻ .. Lens has no CPU to support matrix metering.

▣ blinks (in matrix mode) Lens has no CPU to support matrix metering; camera automatically resets to center-weighted metering.

bᴜᴸb blinks Cannot set bulb shutter speed in shutter-priority (S) exposure mode.

Σ⁻⁻, ᴵˢᴼ, and **DX** blinks Non-DX coded film or incorrect DX code detected.

◐▬ blinks Film is loaded incorrectly.

[] blinks when Speedlight is used ... Wide-area AF not available with flash; camera automatically defaults to spot AF.

LCD all black Camera is too hot.

LCD slow to respond Camera is too cold.

N90s/F90X Viewfinder Error Messages

▶ ◀ symbol blinks Autofocus is not possible.

◀ symbol appears Subject is not in focus, or is located closer than lens' minimum focusing distance.

▶ symbol appears Subject not in focus, or lens not set on infinity when TC-16A is being used.

Hi .. Current settings will overexpose shot.

Lo .. Current settings will underexpose shot.

FEE .. AF lens is not set to smallest aperture in Multi-program (P) or shutter-priority (S) modes, or Speedlight is not set to TTL mode in P mode.

F- - .. Lens has no CPU to support matrix metering.

Green ⚡ symbol appears Camera recommends using flash.

Red ⚡ symbol appears Flash is ready.

⚡ blinks Flash may not have been sufficient for proper exposure.

SL blinks Camera is in silhouette exposure mode; turn off your Speedlight flash unit.

N90s/F90X Instructions

Turning the Camera On and Off

Move the power switch located just behind the shutter release from the Off to the On position.

Note: When the camera is on, pressing the shutter release halfway turns on the exposure meter, viewfinder illumination, and, when appropriate, autofocusing.

To turn power off, move the switch to the Off position.

Resetting the Camera to Its Default Settings

Simultaneously pressing the two reset buttons (labeled with a green •) for more than two seconds causes the N90s/F90X to revert to the following settings:

- Single-frame film advance
- Matrix metering pattern
- Multi-Program (P) exposure mode
- Wide focus area
- No exposure compensation
- Normal flash sync (unless Speedlight is set to rear-curtain)
- MF-26 Multi-Control Back: Factory default settings cancel bracketing, multiple exposure, auto sequence, long exposure, interval timer, and focus priority. However, you can set your own custom reset options rather than use the factury default settings.
- With Data Link: Custom reset settings are reloaded. (If you don't want them to be reloaded, continue to hold the buttons down until CUSTOM blinks. Then press the two buttons once again.

Setting the Film Advance Mode

Hold down the drive button on the top left of the camera while rotating the command dial until the desired setting appears on the LCD panel:

S Single Frame—Press the shutter once for each exposure.

🗖L Continuous Low Speed —About 2 fps (frames per second) while the shutter is held down.

🗖ᴴ Continuous High Speed—About 4.3 fps while the shutter is held down.

The quoted frames per second are for shutter speeds of 1/250 second or faster in manual exposure and manual focus mode. The fastest rate for autofocus tracking is 4.1 fps.

Note: When imprinting data on film with the MF-26, don't set film advance to ⏏ᴴ.

Setting the ISO Manually

Hold down the ᴵˢᴼ button on the left top of the camera, and rotate the command dial to set the film speed (displayed on the LCD panel).

Setting the ISO Automatically with DX Encoding

1. Hold down the ᴵˢᴼ button on the top left of the camera and rotate the command dial until the LCD displays **DX**.

2. Pressing the ᴵˢᴼ button at any time will display the current ISO setting on the LCD in place of the frame number.

Loading Film

1. Set the ISO manually or set DX encoding.

2. Open the camera back using the two camera back releases on the left side of the camera body.

3. Insert the film cartridge into the film chamber.

4. Pull the film leader across to the red index mark in take-up area.

5. Remove slack from the film leader so that it lies flat.

6. Close the camera back.

7. Press the shutter release; the camera automatically advances film to the first frame.

Rewinding Film

Simultaneously press the two buttons labeled with the red ⊙ᴀ symbol (one is on the camera's top left and the other is on the top right).

Setting the Metering Method

Hold down the ▣ button on the left top of camera while rotating the command dial until the desired setting appears on the LCD panel:

▣ Matrix
 8-segment evaluative metering is used. Requires AF or AI-P type lenses. With D-type lenses, the focusing distance is also taken into account.

⊙ Center-Weighted
 75% of the meter's sensitivity is concentrated in the central 12mm circle in the viewfinder.

⊡ Spot
 100% of the meter's sensitivity is concentrated on the innermost 3mm ring in the viewfinder.

Setting the Focus Mode

Move the focus mode selector on the front of the camera, on the lower left, to:

S Single Servo AF—Uses focus-priority (shutter cannot be released until focus is achieved).
 Viewfinder symbols:
 ▶ or ◀ Focus is in progress.
 ● Focus is locked; you need to refocus if the subject moves.

C Continuous Servo AF—Uses release priority (shutter can be released whether or not focus is achieved). Focus is continuously updated while the release button is pressed halfway. Focus is locked if the AF-L button is held down.
 Viewfinder symbols:
 ▶ or ◀ Focus is being sought.
 ● Focus is achieved.

M Manual Focus—Electronic confirmation symbols appear in the viewfinder.
 Viewfinder symbols:
 ◀ Rotate the lens' focus ring to the left; the subject is not in focus.
 ▶ Rotate the lens' focus ring to the right; the subject is not in focus.
 ● Focus is achieved.
 ▶ ◀ (Blinking) Camera cannot autofocus.

Setting the Active Focusing Area

Hold down the focus area ⌐○¬ button (in front of the command dial) while rotating the command dial until the desired setting appears on the LCD panel:

⌐ ⌐ Wide area AF selected
⌐ ○ ¬ Spot area AF selected

Note: If the Speedlight is on, the N90s/F90X automatically switches to the spot area, regardless of what focusing area you set (the wide-area symbol blinks on the LCD panel if this is done). The camera reverts to your setting when you turn the Speedlight off or detach it.

Setting the Exposure Mode

Hold down the mode button on top left of the camera while rotating the command dial until the desired setting appears on the LCD panel:

P Multi-Program—Camera sets both the shutter speed and aperture; requires AF or AI-P lens.

S Shutter-Priority—You choose the shutter speed, the camera sets the aperture; requires AF or AI-P lens.

A Aperture-Priority—You choose the aperture, the camera sets the shutter speed.

M Manual—You choose both the aperture and shutter speed.

Or,

Hold down the Ps button on the top left of the camera while rotating the command dial until the desired vari-program symbol appears on the LCD panel:

P○ Portrait mode—Sets a wide aperture to minimize depth of field.

rE Portrait mode with red-eye reduction—Same as portrait mode, except sets flash to red-eye reduction.

HF Hyperfocal mode—Sets a slow shutter speed and a narrow aperture to get subject and background in focus; **does not** set hyperfocal distance! A tripod is recommended.

LA Landscape mode—Virtually the same as HF, but intended for landscapes without a foreground subject. A tripod is recommended.

SL Silhouette mode—Underexposes the foreground subject; background should be 2 EV brighter to work effectively.

SP Sport mode—Sets a program that is biased towards a fast shutter speed.

☘ Close-Up mode—Tries to set an aperture of f/4 or f/5.6.

To cancel these programs, hold down the mode button and set a regular exposure mode (P, S, A, or M).

Flexible Program (Program Shift)

In auto multi-program (P) mode, you can shift the programmed exposure in 1/3-stop increments to give you the creative effect you are looking for (e.g., greater depth of field).

To shift the program, turn the command dial until the desired shutter speed-aperture combination is displayed on the LCD panel and viewfinder displays. **P*** appears in the LCD panel to confirm that the program has been shifted.

After the shutter has been released, flexible program is cancelled.

Locking Exposure

1. Use center-weighted or spot metering on an appropriate area.

 Note: Although you can lock exposure settings using any metering mode, this function is most useful for metering on a very specific area. Center-weighted or spot metering modes offer the most control.

2. Lightly press the shutter release.

3. Lock exposure by sliding the AE-L button on the back of the camera.

4. Recompose, and press the shutter release fully to take the picture.

Exposure Compensation

Hold down the ▨ button on the top right of the camera while rotating the command dial until the desired exposure compensation value appears on the LCD panel.

Compensation is indicated in 1/3 EV stops with a range of +/– 5 EV. A + value overexposes, a – value underexposes.

Example: Meter white snow and compensate by adding 2 stops of exposure. Without compensation, the meter sets exposure as though every subject were neutral gray. (A white subject is 2 stops brighter than neutral gray, therefore the exposure needs to be adjusted accordingly.)

Setting the Self-Timer

1. Hold down the ☾ button on the top left of the camera, and rotate the command dial to set the duration of the delay in seconds (ranges from 2 to 30 seconds).

2. Close the eyepiece shutter with the switch to the left of the eyepiece.

3. Hold down the ☾ button and press the shutter release.

4. The LED on the front of the camera blinks until the last 2 seconds prior to exposure, at which time it lights continuously.

If the camera is set for single servo AF (S), the self-timer will not start until focus is achieved. If the subject moves after the self-timer has begun counting down, the subject will be out of focus.

To cancel the countdown after the shutter release has been pressed, press the ☾ button again before the shutter is fired.

Setting a Bulb Exposure

1. Hold down the mode button and rotate the command dial to select manual (M) exposure mode.

2. Rotate the command dial again to set bulb shutter speed (ᏏᏬᏞᏬ).

3. Set the desired aperture on the lens.

4. Press the shutter release for the duration of the exposure.

Consider using an MC-20, MC-30, ML-3, or other remote control release to prevent camera shake.

Note: When using an MF-26 Multi-Control Back or MC-20, long exposures may exhaust the camera's batteries!

Setting Rear-Curtain Sync

1. To select a specific shutter speed, set the camera to shutter-priority (S) or manual (M) exposure mode. In multi-program (P) and aperture-priority (A) mode, slow sync is set automatically.

2. Set the Speedlight's mode switch to ▣. (Rear-curtain sync can also be used in auto and manual flash modes, however only in A or M exposure modes.)

3. For an SB-24, -25, or -26: Set the flash unit's sync switch to the REAR setting.

4. For other Nikon flashes: Hold the flash sync mode button on the top left of the camera and rotate the command dial until ▣ appears in the LCD panel.

Note: Rear-curtain sync cannot be set with vari-program modes or used in conjunction with red-eye reduction.

Setting Slow-Sync Flash

1. Make sure the camera is set to multi-program (P) or aperture-priority (A) exposure mode.

2. For the most automatic operation, set the Speedlight's mode switch to ▥. (Manual and auto flash modes can also be used.)

3. Hold the 🔳 button on the top left of the camera and rotate the command dial until ⟨SLOW⟩ appears in the LCD panel.

4. A tripod is recommended to prevent camera shake.

Setting Red-Eye Reduction (SB-25, SB-26, SB-27, and SB-28)

Red-eye reduction can be set in M, P, A, and S modes. It is automatically set in Portrait program with red-eye reduction (**P**ₛ with ⟨ ⟩). It cannot be set in any other vari-program.

1. Set the Speedlight's mode switch to ▥.

2. Hold down the camera's flash sync button and rotate the command dial until the red-eye indicator (double lightning symbols for the N90, an eye symbol for the N90s) appears in the LCD panel.

Changing the Focusing Screen

1. Turn the camera off. Remove the lens.

2. Slip the tip of the tweezers provided with the new screen under the focusing screen's release latch and pull outward. The latch is in the middle of the front edge of the screen.

3. Hold the tab on the screen with the tweezers and remove the screen.

4. Hold the tab on the replacement screen with the tweezers and insert the new screen in place.

5. Lock the screen holder in place by pushing upward.

Tip: The Type E screen features a lined grid that helps align horizons, reminds you of the rule-of-thirds points, and helps you detect converging lines, especially when using extreme wide-angle lenses. It is probably the most useful of the optional screens for general-purpose use.

Using AA Lithium Batteries in the N90s/F90X

Nikon now allows use of AA lithium batteries in the N90s/F90X without voiding the warranty. However, note that the use of the ML-3 module is not recommended if you're using AA lithium batteries with this camera. The ML-3 draws its power from the camera and cannot accept the transient high voltage of AA lithium batteries.

Note: This warning doesn't apply to CR3 lithium batteries used in the optional MB-10 accessory grip.

N90s/F90X Multi-Program (P) Mode Settings

(at ISO 100)

Exposure Value	Lens <85mm	Lens 85-210mm	Lens >210mm
0	f/1.4 at 2 secs.	f/1.4 at 2 secs.	f/1.4 at 2 secs.
2	f/1.4 at 1/2 sec.	f/1.4 at 1/2 sec.	f/1.4 at 1/2 sec.
4	f/1.4 at 1/8	f/1.4 at 1/8	f/1.4 at 1/8
6	f/2 at 1/15	f/1.4 at 1/30	f/1.4 at 1/30
8	f/2.8 at 1/30	f/2 at 1/60	f/1.4 at 1/125
10	f/4 at 1/60	f/2.8 at 1/125	f/2 at 1/250
12	f/5.6 at 1/125	f/4 at 1/250	f/2.8 at 1/500
14	f/8 at 1/250	f/5.6 at 1/500	f/4 at 1/1000
16	f/11 at 1/500	f/8 at 1/1000	f/5.6 at 1/2000
18	f/16 at 1/1000	f/11 at 1/2000	f/8 at 1/4000
20*	f/22 at 1/2000	f/16 at 1/4000	f/11 at 1/8000
22*	f/32 at 1/4000	f/22 at 1/8000	f/22 at 1/8000

Exceeds limit of autofocus capability.

Note: If the lens being used has a smaller maximum aperture than shown above, shutter speeds will be slower than shown in order to maintain correct exposure.

N90s/F90X Flash Settings

(at ISO 100)

Exposure Value	*Multi-Program*	*Shutter-Priority**	*Aperture-Priority**
0	f/4 at 15 secs.†	f/1 at 1sec. to f/5.6 at 30 secs.	f/1.4 at 2 secs.† to f/5.6 at 30 secs.†
2	f/4 at 4 secs.†	f/1 at 1/2 sec. to f/11 at 30 secs.	f/1.4 at 1/2 sec.† to f/11 at 30 secs.†
4	f/4 at 1 sec.†	f/1 at 1/15 sec. to f/16 at 15 secs.	f/1.4 at 1/8 sec.† to f/16 at 15 secs.†
6	f/4 at 1/4 sec.†	f/1 at 1/60 sec. to f/16 at 4 secs.	f/1.4 at 1/30 sec.† to f/16 at 4 secs.†
8	f/4 at 1/15 sec.†	f/1 at 1/250 sec. to f/16 at 1 sec.	f/1.4 at 1/125 sec. to f/16 at 1/2 sec.†
10	f/4 at 1/60 sec.	f/2 at 1/250 sec. to f/16 at 1/4 sec.	f/2 at 1/250 sec. to f/16 at 1/4 sec.†
12	f/4 at 1/250 sec.	f/4 at 1/250 sec. to f/16 at 1/15 sec.	f/2.8 at 1/250 sec. to f/16 at 1/8 sec.†
14	f/8 at 1/250 sec.	f/8 at 1/250 sec. to f/16 at 1/60 sec.	f/8 at 1/250 sec. to f/16 at 1/60 sec.
16	f/16 at 1/250 sec.	f/16 at 1/250 sec.	f/16 at 1/250 sec.

**Indicates the potential range. As Nikon makes no f/1 lenses at the time of this writing, exposure values cited using f/1 are purely theoretical.*

†Slow-sync only

Nikkor Lenses That Can't Be Used with the N90s/F90x

Lens	*Comments*
AF Nikkor lenses for F3AF	Calculate exposure incorrectly
Non-AI lenses	Camera requires AI coupling
6mm f/5.6	Lens requires mirror to be locked up
10mm f/5.6	Lens requires mirror to be locked up
28mm f/4 PC	Serial numbers 180900 and below need modification
35mm f2.8 PC	Serial numbers 851001 to 906200 need modification
80mm f/2.8	Calculates exposure incorrectly
180-600mm f8 ED	Serial numbers 174041 to 174180 incompatible
200-600mm f/9.5	Serial numbers 280001 to 301922 incompatible
200mm f/3.5 IF	Calculates exposure incorrectly
360-1200mm f/11 ED	Serial numbers 174031 to 174127 incompatible
400mm f/5.6	Doesn't work with Focusing Unit AU-1
600mm f/5.6	Doesn't work with Focusing Unit AU-1
1000mm f/11 Reflex	Serial numbers 142361 to 143000 need modification
2000mm f/11 Reflex	Serial numbers 200111 to 200310 need modification
AF TC-16	Calculates exposure incorrectly

Nikon N70/F70

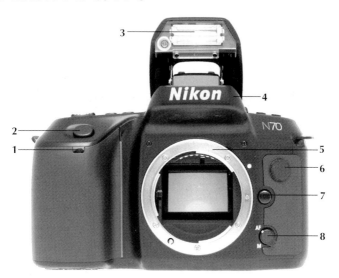

1 Self-timer indicator LED
2 Shutter release
3 Built-in flash
4 Prism
5 Lens mount
6 Remote terminal
7 Lens release button
8 Focus mode selector
9 Battery chamber lock release
10 Battery chamber
11 Tripod socket

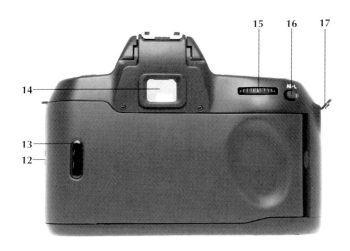

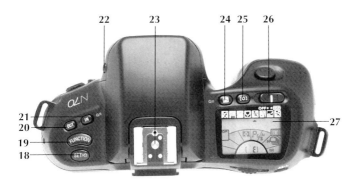

12 Camera back lock release
13 Film cassette window
14 Viewfinder eyepiece
15 Command dial
16 AE-lock button
17 Camera strap eyelet
18 Set/Self-timer button
19 Function button

20 QR call (out) button
21 QR set (in)/Film rewind button
22 Flash lock release button
23 Accessory shoe
24 Vari-Program/Film rewind button
25 Focus area button
26 Power switch
27 LCD panel

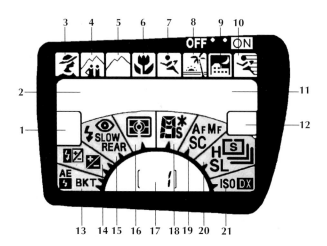

1 Quick recall
2 Shutter speed
3 Portrait mode
4 Hyperfocal mode
5 Landscape mode
6 Close-Up mode
7 Sport mode
8 Silhouette mode
9 Night Scene mode
10 Motion Effect mode
11 Aperture

12 Spot/Wide autofocus
13 AE/Flash bracketing
14 Exposure compensation
15 Flash control mode
16 Metering mode
17 Frame counter/Film speed
18 Exposure mode
19 Autofocus mode
20 Film advance/Rewind mode
21 ISO/DX film speed mode

N70/F70 LCD Error Messages

Hi ... Current settings will overexpose shot.

Lo ... Current settings will underexpose shot.

FEE blinks Lens not set to smallest aperture, or Speedlight not set to TTL mode in P mode.

End blinks End of roll has been reached; rewind film.

⊏▱ symbol blinks Batteries are low; replace them.

E ... No film is loaded in the camera.

E appears and E-- blinks Film didn't load correctly; reload film.

F-- ... In P, S, A, and M modes, the lens has no CPU to support the mode when used with matrix metering.

◉ blinks (in matrix mode) Lens has no CPU to support matrix metering; camera automatically resets to center-weighted metering.

P or S blinks Lens has no CPU to support P or S exposure mode; camera defaults to A mode automatically.

AF blinks Non-AF lens is mounted.

E-- blinks Camera detects a shutter problem; turn camera off and on. If problem persists, take the camera to a repair center.

bulb blinks Cannot set bulb shutter speed in S exposure mode; set camera to M mode or select another shutter speed.

E--, ISO, and DX blinks Non-DX coded film or incorrect DX code detected; set ISO manually.

Shutter speed blinks Shutter speed is faster than flash sync speed (1/125 second).

LCD all black Camera is too hot (but likely still operable).

LCD slow to update Camera is too cold (but likely still operable).

⊡ blinks when Speedlight is used .. Wide-area AF not available with flash; camera automatically defaults to spot AF.

N70/F70 Viewfinder Error Messages

▶ ◀ symbols blink Autofocus not possible; focus manually.

◀ symbol Subject is not in focus or subject located closer than lens' minimum focusing distance.

▶ symbol Subject is not in focus.

Ⱨ ⁞ ... Current settings will overexpose shot.

ʟᴏ ... Current settings will underexpose shot.

FEE blinks Lens is not set to the smallest aperture.

F – – In P, S, A, and M modes, the lens has no CPU to support the mode when used with matrix metering.

E appears and E-- blinks Film not loaded correctly; reload.

E-- blinks Non-DX coded film was detected or DX code not interpreted; set ISO manually.

bulb blinks Cannot set bulb in S exposure mode; set camera to M mode or select another shutter speed.

P or S blinks (in P or S mode) . Lens has no CPU to support P or S exposure mode, camera automatically defaults to A mode.

⊡ symbol blinks (in matrix mode) Lens has no CPU to support matrix metering; camera automatically resets to center-weighted metering.

End blinks End of roll has been reached; rewind film.

Green ⚡ symbol Flash is recommended.

Red ⚡ symbol Flash is ready.

⚡ symbol blinks Flash may not have been sufficient to provide exposure.

208

N70/F70 Instructions

Turning the Camera On and Off

To turn the camera on, move the power switch located just behind the shutter release from the Off to the On position.

Note: When the camera is on, pressing the shutter release halfway turns on the exposure meter, viewfinder illumination, and, when appropriate, autofocusing.

To turn the power off, move the switch to the Off position.

Resetting the Camera to Its Default Settings

Press the OUT button on the top left of the camera and turn the command dial until a ⏻ is displayed in the yellow QR box on the left side of the LCD. This resets the camera to the following settings:

- Multi-Program (P) exposure mode
- Wide-area autofocus detection
- Single-servo autofocus mode (S AF) (However, camera cannot reset to this if manual focus is selected.)
- Single-frame advance
- Matrix metering
- No exposure compensation
- No exposure or flash bracketing

Creating "Custom" Quick Recall (QR) Settings

The N70/F70 allows you to create up to three combinations of customized settings and store them in the camera's memory.

1. Set all the camera functions exactly the way you want them (exposure mode, autofocus method, exposure compensation, bracketing, etc.).

2. Press the IN button and turn the command dial until one of the three available custom setting values (1, 2, or 3) appears in the yellow Quick Recall (QR) box on the left of the LCD panel.

3. As soon as you let go of the IN button, the camera's current settings are stored.

Calling Up a QR Setting

Press the OUT button and turn the command dial until the custom setting value you desire (1, 2, or 3) is displayed in the yellow QR box on the left side of the LCD panel.

Note: If the focus mode selector on the camera body is set to manual focus (M), the focus mode cannot be changed to AF by using the QR function.

Setting the Film Advance Mode

1. Hold down the function button on the top left of the camera and use the command dial to select the film advance setting field (second from the right) on the LCD.

2. Hold down the SET button and use the command dial to set the film advance method:

 ⓢ Single Frame—Press the shutter once for each exposure.

 ᴸ❑ⱼ Continuous Low Speed —About 2 fps (frames per second) while the shutter release is held.

 ᴴ❑ⱼ Continuous High Speed—About 3.7 fps while the shutter release is held.

 ˢᴸ❑ⱼ Silent Rewind mode—Rewind is performed more slowly to keep sound from being intrusive, otherwise it is the same as Single Frame.

The stated frame rates are for shutter speeds of 1/250 second or faster in manual exposure mode and with manual focus.

Setting the ISO Manually

1. Hold down the function button on the top left of the camera, and use the command dial to select the film speed field (first from the right) on the LCD panel.

2. Hold down the SET button and use the command dial to set the desired film speed. The ISO setting is shown on the LCD where the frame number usually appears.

Setting the ISO Automatically with DX Encoding

1. Hold down the function button on the top left of the camera, and use the command dial to select the ISO field (first from the right) on the LCD panel.

2. Hold down the SET button and turn the command dial until **DX** appears.

Loading Film

1. Set the ISO film speed either automatically or manually.

2. Open the camera back using the camera back lock release on the left side of the camera body.

3. Insert the film cartridge.

4. Pull the film leader across to the red index mark in the take-up area.

5. Remove slack from the film leader so that it lies flat.

6. Close the camera back.

7. Press the shutter release; the camera automatically advances film to the first frame. Verify the ISO film speed by holding the function button and then pressing the SET button.

Rewinding Film

1. Simultaneously press the **Pₛ** and IN buttons (both have a ⊙�461 symbol next to them) on the top of the camera. Keep them pressed until rewind commences. Film rewinds automatically.

2. To rewind film more quietly, set silent rewind mode. See "Setting the Film Advance Mode" on page 210.

Setting the Metering Method

1. Hold down the function button on the top left of the camera, and use the command dial to select the metering method field (fourth from the left) on the LCD.

2. Hold down the SET button and use the command dial to set the metering method. One of the following symbols appears in the field:

⚙ Matrix
 Multi-segment evaluative metering is used. Requires AF or AI-P type lenses. With D-type lenses, the focusing distance is also taken into account in adjusting the evaluation.

⊡ Center-Weighted
 75% of the meter's sensitivity is concentrated within the central 12mm circle in the viewfinder.

⊡ Spot
 100% of the meter's sensitivity is concentrated on the 3mm area (inner ring) in the viewfinder.

Setting the Focus Mode

1. Move the focus mode selector on the left side of the front of the camera body to:

 AF Autofocus

 M Manual focus—Electronic confirmation symbols appear in the viewfinder.

2. If the focus mode selector is set to AF, hold down the function button on the top left of the camera and use the command dial to select the autofocus mode field (third from the right) on the LCD panel.

3. Hold down the SET button and use the command dial to set the autofocus mode:

 S AF Single Servo AF—Uses focus priority.

 Viewfinder symbols:

 ▶ or ◀ Focus is tracking.

 • Focus is locked; you need to refocus if the subject moves.

C AF Continuous Servo AF—Uses release priority. You can
release the shutter at any time, regardless of whether the
subject is in focus.

▶ or ◀ Focus is tracking.

• Focus is achieved.

4. If M has been chosen on the focus mode selector, the following
will appear in the AF mode field on the LCD panel:

MF Manual Focus—Electronic confirmation symbols appear in
the viewfinder.

Viewfinder symbols:

◀ The subject is not in focus; rotate the lens' focusing
ring to the left.

▶ The subject is not in focus; rotate the lens' focusing
ring to the right.

• The subject is in focus.

Setting the Focus Area

Hold down the ⌐o¬ button (just to the left of the power switch on the
top of the camera) while rotating the command dial until the
desired setting appears in the viewfinder display and in the blue box
on the LCD panel:

[ɪ] Wide area AF selected
Uses the wide-area autofocus area to determine focus.

[o] Spot area AF selected
Uses only the innermost 3mm area to determine focus.

Note: If a Speedlight is mounted and turned on, the camera
automatically switches to spot AF.

Setting the Exposure Mode

1. Hold down the function button on the top left of the camera,
and use the command dial to select the exposure mode field
(fourth from the right) on the LCD.

2. Hold down the SET button and use the command dial to set the
exposure mode:

ℙ Multi-Program—The camera sets both the shutter speed
and aperture; requires AF or AI-P lens.

213

ꙅ Shutter-Priority—You set the shutter speed and the camera
sets the aperture; requires AF or AI-P lens.

Ⴔ Aperture-Priority—You set the aperture and the camera
sets the shutter speed.

ꓥ Manual—You set both the aperture and shutter speed.

Or,

1. Hold down the **Pꜱ** button on the camera's top right and use the
command dial to select one of the vari-programs displayed
above the LCD panel. An arrow points to the vari-program icon
you have selected.

Ⓩ Portrait program—Sets a relatively large aperture for a
shallow depth of field to isolate the subject from the
background.

⅏ Depth-of-Field (or Hyperfocal) program—Sets the lens to a
small aperture (often only f/8, however) for extensive depth
of field.

⌒ Landscape program—Sets the lens to a small aperture,
based on the focal length of the lens (often only f/8,
however), for extensive depth of field and biases the matrix
metering to the lower half of a horizontal frame (to
account for sky in the top half of the frame). This is a
problem with vertical shots as the matrix metering is
biased toward one side of the lengthwise frame (the side
that gets the bias depends on if you are a left-handed or a
right-handed shooter!).

♣ Close-Up program—Selects a mid-range f/stop (f/5.6 or f/8,
typically) for a relatively shallow depth of field.

ꛉ Sports program—Biased towards shutter speeds of at least
1/1000 second to freeze motion and have the background
be out of focus.

⬒ Silhouette program—Exposure is biased towards the
background, and the central subject is significantly
underexposed. Generally requires a 2-stop differential
between the background (outer areas of the picture) and
the subject (near the autofocus sensor).

▰ Night Scene program—Selects slow shutter speeds for low-
light scenes and mid-sized aperture (f/8) for relatively wide
depth of field. Sets slow sync if flash is used.

⌐⌐ Motion-Effect program—Selects a slow shutter speed
(typically only 1/60 second, however), in order to blur fast
action or flowing water.

Flexible Program (Program Shift)

If the exposure settings that the multi-program or any of the vari-
program modes has selected are unsatisfactory for achieving the
effect you desire (too little depth of field, for instance) the exposure
can be shifted in 1/3-stop increments by turning the control dial. **P***
(for P mode) or **Pₛ*** (for a vari-program mode) appears in the expo-
sure mode field (fourth from the right) of the LCD panel to indicate
that exposure has been shifted.

Setting Exposure Manually

1. Set the camera to manual (M) exposure mode (see "Setting the
 Exposure Mode" on page 213).
2. The viewfinder shows an exposure indicator, ◄║║║║▬:║ indicates
 correct exposure, while each dot in the bar underneath the
 indicator indicates 1/3-stop under- or overexposure; an arrow by
 the scale's + or – sign indicates more than 1 stop over- or
 underexposure, respectively.
3. Adjust the aperture using the aperture ring on the lens and the
 shutter speed using the camera's command dial to set the
 correct exposure.

Locking the Exposure Setting

1. Set center-weighted or spot metering and meter on an appropri-
 ate area. (See "Setting the Metering Method" on page 212.)

 Note: Although you can lock exposure settings using any
 metering mode, this function is most useful for metering on a
 very specific area. Center-weighted or spot metering modes offer
 the most control.
2. Lightly touch the shutter release to take a meter reading.
3. Press and hold the AE-L button on the back of the camera.
4. Recompose and press the shutter release fully to take the picture.

Exposure Compensation

Compensation is indicated in 1/3 stops and can be set in a range of +/– 5 EV. A + value overexposes, a – value underexposes.

1. Hold down the function button on the top left of the camera, and use the command dial to select the exposure compensation field (🔁) (second from the left on the LCD panel).

2. Hold down the SET button and use the command dial to set the desired exposure compensation value, which appears at the base of the LCD panel.

This amount of exposure compensation remains set until it is cancelled by you.

To cancel it, perform steps 1 and 2 again and set the compensation value to 0.0.

Example: Meter white snow and compensate by adding 2 stops of exposure. Without compensation, the meter sets exposure as though every subject were neutral gray. (A white subject is 2 stops brighter than neutral gray, therefore the exposure needs to be adjusted accordingly.)

Note: If the built-in flash is popped up or a Speedlight is mounted and turned on when you perform steps 1 and 2, you are setting flash exposure compensation rather than regular exposure compensation. In other words, flash compensation set on the N70/F70 overrides flash compensation values set on an SB-24, SB-25, SB-26, or SB-28 Speedlight. Flash compensation that has been set on the camera resets to 0 when the built-in flash is put back down or the Speedlight is switched off.

Setting Exposure Bracketing

The N70/F70 always takes three shots during bracketing: underexposed, normal, and overexposed, in that order. Bracketing can be set in a range of +1 to –3 EV in all autoexposure and vari-program modes. To set autoexposure bracketing:

1. Hold down the function button on camera's top left and use the command dial to select the exposure bracketing field (first on the left) on the LCD.

2. Hold down the SET button and use the command dial to set the bracketing value (0.3, 0.5, 0.7, or 1 stop). The bracket setting is displayed on the LCD where the frame number usually appears.

In shutter-priority (S) exposure mode the aperture is changed to obtain bracketed exposures, in aperture-priority (A) and manual (M) modes the shutter speed is changed, and in automatic multi-program (P) mode both shutter speed and aperture are changed.

Exposure compensation modifies the point around which bracketing occurs.

Bracketing is automatically cancelled after each series of three exposures. If you use exposure bracketing often, set up one of the custom settings with your normal bracketing value and save it. This makes resetting bracketing a little simpler (not a lot, but enough to make a difference).

If the end of the roll is reached during a bracketing sequence, rewind the film, load a new roll, and then press the shutter release again to resume.

Setting Flash Exposure Bracketing

The N70/F70 allows you to vary flash output with flash exposure bracketing. Three shots are taken: underexposed, normal, and overexposed, in that order. Bracketing can be set in a range of +1 to −3 EV. To set flash exposure bracketing:

1. Pop up the built-in flash.

2. Use the command dial to select the exposure bracketing field (first from the left) on the LCD.

3. Hold down the function button on the camera's top left and press the flash lock release button (⚡ BKT will appear in the LCD field).

4. Hold down the SET button and use the command dial to set the bracketing value (0.3, 0.5, 0.7, or ¹ stop). The bracket setting is displayed on the LCD where the frame number usually appears.

Setting the Self-Timer

1. Hold down the set button and turn the command dial one click in either direction. The self-timer indicator ♂ appears on the LCD panel.

2. Cover the eyepiece with the DK-5 cover (supplied with the camera) to prevent stray light from affecting the exposure.

3. Press the shutter release.

4. The LED on the front of the camera blinks until 2 seconds prior to exposure, then it lights continuously.

If the camera is set for single servo autofocus (S AF), the self-timer won't release the shutter until the subject is in focus.

The bulb setting cannot be used with the self-timer—the camera automatically sets a shutter speed of 1/250 second if you attempt this.

The self-timer is cancelled automatically after the shot has been made. To cancel the self-timer before the shutter release has been pressed, repeat step 1. To cancel the countdown after the shutter release has been pressed, turn the camera off and back on again.

Setting a Bulb Exposure

1. Set the camera to manual (M) exposure mode (see "Setting the Exposure Mode" on page 213).
2. Rotate the command dial to set the shutter speed to ʙᴜʟʙ.
3. Set the desired aperture using the lens' aperture ring.
4. Press and hold the shutter release for the duration of the exposure.

Note: Long exposures may exhaust the camera's batteries! Consider using an MC-12b or ML-2 remote release to prevent camera shake.

Setting Slow-Sync Flash

1. For the most automatic operation while using an accessory flash unit, set the flash unit to TTL mode, or use the built-in flash.
2. Set the camera to either program (P) or aperture-priority (A) exposure mode.
3. Hold down the function button on camera's top left and use the command dial to select the flash control mode field (third from the left) on the LCD panel.
4. Hold down the SET button and use the command dial until ꜱʟᴏᴡ appears.

To cancel slow sync flash, repeat steps 3 and 4 and set another flash setting or no flash.

Setting Rear-Curtain Sync

1. If you are using an accessory flash unit, set the Speedlight to TTL mode; otherwise, make sure the camera's built-in flash is active.
2. Hold down the function button on the camera's top left and use the command dial to select the flash control mode field (third from the left) on the LCD.

3. Hold down the SET button and use the command dial until **REAR**
appears in the field. For the SB-24, -25, and -26 only, set the
Speedlight's sync switch to the **REAR** setting.

To cancel rear-curtain sync, repeat steps 2 and 3 and set another
flash setting.

N70/F70 Auto Multi-Program (P) Mode Settings

(at ISO 100)

Exposure Value	*Setting*
0	f/1.4 at 2 seconds
1	f/1.4 at 1 second
2	f/1.4 at 1/2
3	f/1.4 at 1/4
4	f/1.4 at 1/8
6	f/2 at 1/15
8	f/2.8 at 1/30
10	f/4 at 1/60
12	f/5.6 at 1/125
14	f/8 at 1/250
16	f/11 at 1/500
18	f/16 at 1/1000
20*	f/16 at 1/4000

Exceeds limit of autofocus capability.

You have full control over the programmed autoexposure mode
because you can easily "shift" (alter) the above exposures by
rotating the command dial until the desired shutter speed or
aperture appears in the LCD panel. If **P*** or **Pₛ*** appear on the
camera's LCD, the exposure has been shifted from the basic
programmed exposures. The camera maintains this alteration as
long as the meter is on (see "Flexible Program" on page 215).

Note: If the lens being used has a smaller maximum aperture than
shown above, shutter speeds are different in order to maintain
correct exposure.

Built-in Flash Specifications

The guide number for the built-in flash of the N70/F70 is 14 at ISO 100. The ISO range for the built-in TTL flash unit is ISO 25 to 800.

The built-in TTL flash is effective for lenses 28mm and longer. Also, some zoom lenses have limitations when used with the built-in flash (see the instruction manual).

Its fastest sync speed is 1/125 second.

N70/F70 Aperture and Flash Range

(in feet, at ISO 100)

Aperture	Flash Range
f/1.4	6.6–32.5 feet
f/2	4.6–23.0
f/2.8	3.3–16.4
f/4	2.3–11.5
f/5.6	2.0–8.2
f/8	2.0–5.9
f/11	2.0–4.3
f/16	2.0–3.0

(in meters, at ISO 100)

Aperture	Flash Range
f/1.4	2–10 meters
f/2	1.4–7
f/2.8	1–5
f/4	0.7–3.5
f/5.6	0.6–2.5
f/8	0.6–1.8
f/11	0.6–1.3
f/16	0.6–0.9

When the ISO value is doubled, read the row above the aperture you are using (e.g., with ISO 200 film, read the range given for f/4 if using f/5.6); if the ISO is halved, read the aperture row below the aperture you are using.

Maximum Aperture for Using Flash in Auto Multi-Program (P) Mode

At ISO 100, the N70/F70 automatically programs apertures from f/4 to the lens' minimum aperture (typically this is f/16) when flash is used. There is no benefit in using a lens faster than f/4 with an N70/F70 in auto multi-program mode using flash and ISO 100 film!

ISO Value	*Maximum Aperture*
25	f/2.8
50	f/3.3
100	f/4
200	f/4.8
400	f/5.6
800	f/6.7
1000	f/7.1

Note: The N70/F70 has a limit of ISO 1600 for flash photography.

Nikkor Lenses That Can't Be Used with the N70/F70

Lens	Comments
Non-AI lenses	Camera requires AI coupling
6mm f/5.6	Lens requires mirror to be locked up
10mm f/5.6	Lens requires mirror to be locked up
28mm f/4 PC	Serial numbers 180900 and before need modification
35mm f2.8 PC	Serial numbers 906200 and before need modification
80mm f/2.8 for F3AF	Calculates exposure incorrectly
180-600mm f8 ED	Serial numbers 174166 and before are incompatible
200mm f/3.5 for F3AF	Calculates exposure incorrectly
200-600mm f/9.5	Serial numbers 300490 and before are incompatible
360-1200mm f/11 ED	Serial numbers 174087 and before are incompatible
400mm f/4.5	Doesn't work with Focusing Unit AU-1
600mm f/5.6	Doesn't work with Focusing Unit AU-1
1000mm f/11 Reflex	Serial numbers 142361 to 143000 need modification
2000mm f/11 Reflex	Serial numbers 200310 and before need modification
AF TC-16	Calculates exposure incorrectly
AF TC-16A	May damage camera

Notes

Nikon FM2n

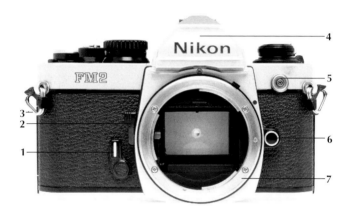

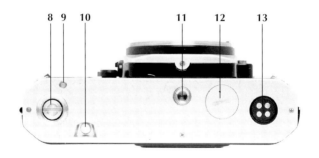

1 Self-timer lever	8 Motor drive coupling
2 Depth-of-field preview lever	9 Motor drive shutter contact
3 Camera strap eyelet	10 Film rewind button
4 Prism	11 Tripod socket
5 PC flash sync terminal	12 Battery compartment cover
6 Lens release button	13 Motor drive contacts
7 Lens mount	

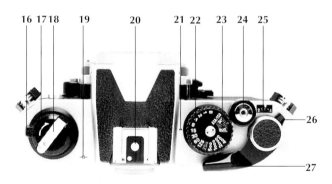

14 Memo holder
15 Viewfinder eyepiece
16 Camera back lock release lever
17 Film rewind knob
18 Film rewind crank
19 Film plane indicator
20 Accessory shoe

21 Shutter speed indicator
22 Shutter speed dial
23 Film speed scale
24 Shutter release button
25 Frame counter
26 Multiple exposure lever
27 Film advance lever

FM2n Viewfinder Display

Shutter speeds are visible at the center of the left side of
the viewfinder.

Apertures are visible at the center of the top edge of the
viewfinder. The apertures shown are actually the ones that are
printed on the lens. Nikon calls this Aperture Direct Readout (ADR).
In dim light they may not be visible, and some aftermarket lenses do
not have the necessary aperture markings.

The following exposure symbols appear on the right side of
the viewfinder:

+ Scene overexposed by more than 1 stop, close aperture
 down or use higher shutter speed.

o Scene properly exposed.

– Scene underexposed by more than 1 stop, open aperture
 up or use slower shutter speed.

If the + and o, or the – and o LEDs are both lit, it means an over-
or underexposure of 1/5 to 1 stop. You may use an intermediate
aperture to get a proper exposure, but not an intermediate shutter
speed (the FM2n doesn't offer stepless shutter speeds).

A small flash ready light is built into the top edge of the eye-
piece and is easily visible when looking through the camera, even
though it isn't technically in the viewfinder. This light comes on
when a compatible flash is in the hot shoe, charged, and ready to
fire. If the light blinks, you've probably set a shutter speed that is
outside the sync range of the camera (i.e., a shutter speed faster than
1/250 second).

FM2n Instructions

Turning the Camera On and Off

1. The shutter release is locked and the exposure meter off until
 you pull out the film advance lever (it should "click" into place,
 extending slightly from the camera).

 The camera turns the exposure meter off automatically after
 30 seconds of inactivity. Turn it back on by pressing the shutter
 release halfway. The film advance lever must still be out.

2. To shut the battery's power off entirely, push the film advance
 lever in until it is flush against the camera's body.

Loading Film

1. Open the camera back by moving the camera back lock release (at the base of the rewind knob) clockwise, and lifting the rewind knob up from the camera.

2. Put film into the film chamber (on the left).

3. Push the rewind crank back down until the fork engages with the cassette's spool to hold the film cassette in place.

4. Insert the film leader into the take-up spool. Slowly rotate the take-up spool using the knurled knob at its base.

5. Use the film advance lever to make sure that the film is properly engaged with the take-up spool and aligned with the film sprockets correctly.

6. Use the rewind crank to take up slack in the film (turn clockwise until resistance is encountered).

7. Close the camera back. (This could be postponed until after a frame has been advanced to make sure that the film is properly engaged.)

8. Press the shutter release and wind the film advance lever to make blank exposures until the frame counter reaches frame 1.

9. Set the ISO value for the film by lifting the shutter speed ring and turning it until the film speed lines up with the red index mark.

10. Trim the end off the film box and insert it into the memo holder on the camera's back, if desired. This helps you remember what type of film is loaded, since the FM2n does not have a window to show the film cartridge information.

Rewinding Film

1. Press in the film rewind button on the right side of the camera's base plate.

2. Lift the rewind crank handle and turn it in the direction of the arrow until the film is rewound into the cartridge (you'll feel a release of the tension on the handle).

3. Open the camera back by moving the camera back lock release at the base of the rewind knob in the arrow's direction, and lifting the rewind knob up from the camera.

4. Remove the film from the chamber.

Setting Exposure

The FM2n's meter is center-weighted, which means that 60% of the total exposure recommendation is based on the larger circle visible in the viewfinder, while the rest of the frame receives only 40%. The camera's metering range is EV 1 to 18.

The FM2n is completely manual. It has no autoexposure modes such as P, A, or S. Therefore, you, the photographer, have complete control over the exposure setting.

1. Set the aperture on the lens. The aperture is displayed at the top of the viewfinder screen if a Nikkor lens is used.

2. Set the shutter speed using the shutter speed dial. The shutter speed is displayed on the left side of the viewfinder screen.

3. Press the shutter release partway and look at the viewfinder display on the right side of the viewing screen.

4. If a red o lights, exposure is correct. If a red – or + appear, under- or overexposure is indicated (respectively).

5. Adjust the aperture or shutter speed until the desired exposure has been set.

6. Press the shutter release fully.

Exposure Compensation

Rotate the ISO dial to another value. ISO values are indicated in 1/3 EV stops. Higher values underexpose, lower values overexpose.

Example: Meter on white snow and set the ISO to 1/4 the current value—ISO 25 instead of 100 (a white subject is 2 stops brighter than neutral gray, and the exposure needs to be adjusted accordingly).

Or,

Set the correct exposure (o appears in the viewfinder display). Adjust the aperture and shutter speed to the desired amount of exposure compensation. By using intermediate aperture settings you can fine-tune the exposure. You'll learn where the "1/2 stops" are in the viewfinder's ADR (aperture direct readout) window.

Note: You cannot set intermediate shutter speeds with the FM2n.

Setting the Self-Timer

1. Move the self-timer lever on the right side of the front of the camera approximately 75° (away from the lens).

2. Press the shutter release button.

3. The mirror goes up and the self-timer begins counting down immediately. The picture is taken the moment the self-timer lever returns to its original position. A full setting is about 10 seconds; intermediate settings are possible, but difficult to predict.

You can cancel the self-timer **before** you press the shutter release by moving the lever to its original position. After the shutter release is pressed, the self-timer cannot be cancelled.

Note: In B (bulb) mode, the self-timer works only when a cable release (AR-3) is used.

Setting a Bulb Exposure

1. Rotate the shutter speed dial to B.

2. Set the desired aperture on the lens.

3. Press and hold the shutter release for the length of the exposure.

Tip: A tripod and a cable release AR-3 are recommended to prevent blurred images.

Taking Multiple Exposures

1. Take a picture.

2. Move the multiple exposure lever (surrounding the film advance lever) towards the back of the camera as you wind the film advance lever. (Watch the frame counter. If the counter does not advance to the next frame, you have done it correctly.)

3. Take another picture.

Note: Unless the pictures have complementary areas of black (i.e., picture 1 has detail in an area that is black in picture 2, and vice versa), you'll need to adjust the exposure to compensate for the multiple exposures.

Depth-of-Field (DOF) Preview

Push the depth-of-field lever (on the right side of the lens mount) towards the camera body and hold it while looking through the lens to preview depth of field at any aperture.

Note: Make sure you hold the lever in as far as it will go, otherwise the lens may not stop down completely.

Changing the Focusing Screen

1. Remove the lens.
2. Slip the tip of the tweezers provided with the replacement screen under the focusing screen's release latch and pull outward. The latch is at the top of the mirror box area.
3. Hold the tab on the focusing screen with the tweezers and remove the screen.
4. Hold the tab on the replacement screen and insert the screen.
5. Lock the screen in place by pushing upward on the front edge of the screen holder.

Tip: The Type E screen features a lined grid that helps align the horizon, reminds you of the rule-of-thirds points, and helps you detect converging lines when using extreme wide-angle lenses. For general use, it is probably the most useful of the screens.

FM2n Maximum Flash Sync Speeds

The FM2n's maximum sync speed when used with Speedlights SB-16 through SB-28 is 1/250 second.

Nikkor Lenses That Can't Be Used with the FM2n

Lens	*Comments*
Non-AI modified lenses	Camera requires AI modification
6mm f/5.6 Fisheye Nikkor	Requires mirror to be locked up
10mm f/5.6 OP Fisheye Nikkor	Requires mirror to be locked up
28mm f/4 PC-Nikkor	Hits camera's meter coupling lever
35mm f/2.8 PC-Nikkor	Hits camera's meter coupling lever
200-600mm f/9.5 Zoom Nikkor	Serial numbers below 300491 are not usable
180-600mm f/8 Zoom Nikkor	Serial numbers below 174167 are not usable
360-1200mm f/11 Zoom Nikkor	Serial numbers below 174088 are not usable
1000mm f/11 Reflex Nikkor	Serial numbers 142361 to 143000 are not usable
2000mm f/11 Reflex Nikkor	Serial numbers below 200311 are not usable

Nikon F100

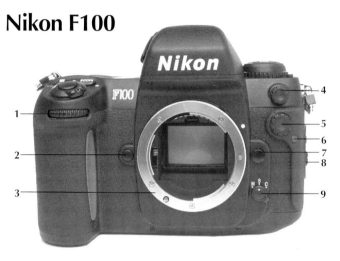

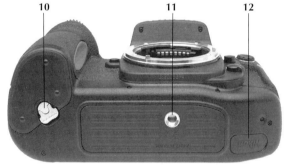

1 Front command dial
2 Depth-of-field preview button
3 Lens mount
4 Sync terminal
5 10-pin remote terminal
6 Self-timer indicator LED
7 Lens release button
8 Camera back release
9 Focus mode selector
10 Battery holder release
11 Tripod socket
12 Contacts for MB-15

13 Film confirmation window
14 Camera strap eyelet
15 Custom settings button/
 Camera reset button (1 of 2)
16 Shutter/Aperture lock button
17 Viewfinder
18 Diopter adjustment
19 Exposure/Focus lock button
20 AF start button
21 Rear command dial
22 Focus area selector
23 Focus area selector lock

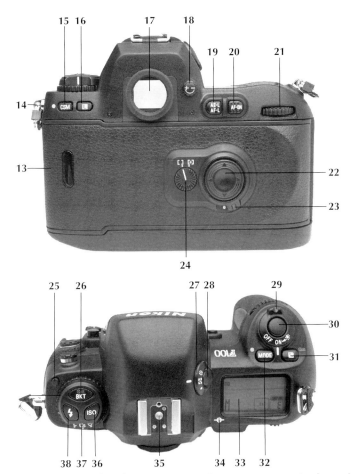

24 Focus area mode selector
25 Film advance mode
 selector release
26 Exposure/flash bracket button/
 Film rewind button (1 of 2)
27 Metering mode selector
28 Metering mode selector release
29 Power switch
30 Shutter release button

31 Exposure compensation button/
 Film rewind button (2 of 2)
32 Exposure mode button/
 Camera reset button (2 of 2)
33 LCD panel
34 Film plane indicator
35 Flash accessory shoe
36 ISO setting button
37 Film advance mode selector
38 Flash mode button

F100 LCD Error Messages

ʜⁱ ... Current settings will overexpose shot.

ᴸᵒ ... Current settings will underexpose shot.

Fᴇᴇ blinks Lens not set to smallest aperture.

Eⁿᵈ blinks End of roll has been reached, rewind film.

⊏▬◢ symbol blinks Replace batteries, they are low.

ᴇ ... No film is loaded in camera.

ᴇ blinks Film remains in camera after rewind. Remove film and reload.

ᴇ and ᴇʳʳ blink Film didn't load correctly; reload film.

F⁻⁻ ... Lens has no CPU or no lens attached.

ᴘ or ꜱ blinks Lens has no CPU to support P or S exposure mode; camera sets to A mode automatically.

ᴇʳʳ blinks Camera detected a malfunction. Press shutter release again—if problem persists take camera to repair center.

ᵇᵘᴸᵇ blinks Cannot set bulb shutter speed in S exposure mode; set camera to M mode or select another shutter speed.

ᴇʳʳ, ᴵˢᴼ, and ᴅˣ blinks Non-DX coded film or incorrect DX code detected; set ISO manually.

Shutter speed blinks Shutter speed is faster than flash sync speed. Shutter speed is automatically set to 1/250.

ʙᴋᴛ .. Camera is set for exposure or flash bracketing.

⊬⌷ blinks Camera is in middle of bracketing sequence. Press shutter release to complete or cancel bracketing.

👁 blinks Camera was set to red-eye
 reduction, but attached flash does
 not support that function. Cancel
 red-eye or attach appropriate flash.

⊙.. and frame counter blink Low battery power caused film to
 stop rewinding. Replace batteries
 and start rewind operation again.

Fᴜʟ blinks Camera's film data is full (80 rolls
 normally, 160 rolls with memory
 upgrade); download data to PC.
 Turn power Off and back On to
 clear indicator and stop recording
 new data.

LCD all black Camera is too hot (but likely still
 operable).

LCD slow Camera is too cold (but likely still
 operable).

F100 Viewfinder Error Messages

►◄ symbols blink Autofocus not possible; focus
 manually.

◄ symbol Subject is not in focus, or subject
 is closer than the minimum focus
 distance.

► symbol Subject not in focus, or lens not set
 on infinity when TC-16A is being
 used.

ʜɪ ... Current settings will overexpose
 shot.

ʟᴏ ... Current settings will underexpose
 shot.

FEE blinks Lens is not set to smallest aperture.

F-- ... Lens has no CPU or no lens
 attached.

Eʀʀ blinks Non-DX coded film was detected
 or DX code not interpreted; set
 ISO manually.

ᏌᏌᏑᏌ blinks Cannot set bulb shutter speed in S
exposure mode; set camera to M
mode or select another shutter
speed.

Ꭿ appears (in P or S mode) Lens has no CPU to support P or S
exposure mode, camera automati-
cally resets to aperture-priority (A)
mode.

⊡ symbol appears

(in matrix mode) Lens has no CPU to support matrix
metering, camera automatically
resets to center-weighted metering.

Ᏹnᗞ blinks End of roll has been reached;
rewind film.

ϟ symbol blinks for 3 secs Flash may not have been sufficient
to provide exposure.

◔.. and frame counter blink Low battery power caused film to
stop rewinding. Replace batteries
and start rewind operation again.

F100 Instructions

Turning the Camera On and Off

1. Rotate power switch surrounding the shutter release to the On
position. To turn power off, perform step 1 but rotate the switch
to Off.

Note: When the camera is on, pressing the shutter release halfway
turns on the exposure meter, viewfinder illumination, and, when
appropriate, autofocus. Unless modified by custom setting #15, the
meter remains active for 6 seconds.

Resetting the Camera to Its Default Settings

1. Simultaneously press the **CSM** button on the back of the camera
and the Mode button next to the shutter release (both identified
with a small green dot next to them) for more than two seconds.
Resetting the F100 causes the camera to revert to the following
settings:

• Multi-program (P) exposure mode
• Focus area using the center sensor
• Front curtain flash sync
• No exposure compensation
• No exposure and flash bracketing (values are retained)
• No shutter speed or aperture lock

Custom settings are remembered unless you:
1. Hold the two buttons until you see **CUSTOM** blink.
2. Release one of the two reset buttons.
3. Repress the button you released. **CUSTOM** blinks for only about two seconds (after the initial two-second wait), so you need to watch carefully if you want to cancel custom settings during a reset.

Setting the ISO Manually
1. Hold down the **ISO** button on the top of the camera and rotate the rear command dial to set an ISO value.

Setting the ISO Automatically with DX Encoding
1. Hold down the **ISO** button on the top of the camera and rotate the rear command dial until the LCD displays the DX indicator.

Loading Film
1. If you want the camera to automatically detect ISO values, make sure the **DX** indicator appears in the LCD.

2. Simultaneously push the button and pull down on the release lever on the left side of the F100 to open camera back.

3. Insert film cartridge from bottom (slide top under small bracket at top of the film chamber).

4. Pull the film leader across to the red index mark in take-up area.

5. Remove slack from film, if any, so that it lies flat.

6. Close the camera back.

 Note: You may postpone this step until after step 7 to confirm that film is being wound into take-up reel correctly, but you'll lose several frames in the process.

7. Press the shutter release; the camera advances film to the first frame. Press the ISO button to confirm the ISO setting.

Note: Custom setting #8 can be set to automatically advance the film to the first frame when you close the camera's back, in which case step 7 is no longer necessary.

Rewinding Film

1. Simultaneously press and hold the two buttons labeled ⊙ᴤ (The ⊠ and BKT buttons). Rewind begins approximately one second after you begin holding both buttons.

You can program the F100 to rewind automatically when it reaches the end of a roll with custom setting #1.

Note: If ⊙ and the frame number blink and rewind stops, this means that the F100 does not have enough power to rewind the film. Change batteries and start the rewind operation again.

Setting the Film Advance Mode

1. Hold down the button on left top of camera (when looking at camera from back) while rotating dial around the left-hand control cluster to desired setting:

S Single-frame (you must press the shutter for each expo-
 sure).

Cs Silent-speed continuous (about 3 frames per second while
 the shutter release held). Rewind speed is also slowed in
 this mode to reduce noise.

C High-speed continuous (about 4.5 frames a second while
 the shutter release held).

Note: The stated frame rates are for shutter speeds of 1/250th or faster in manual exposure and continuous (C) focus mode.

↻ Sets the camera for self-timer mode. A single frame is taken
 with each shutter release press using a delay controlled by
 Custom setting #16 (2, 5, 10, or 20 seconds).

▣ Sets the camera to stop advancing the frame upon shutter
 release (See "Taking Multiple Exposures," page 245 for
 more information).

Setting the Metering Method

On the right side of prism (from the back of camera), hold in the button and turn the metering system indicator to the desired setting:

⊡ Matrix

10-segment evaluative metering is used. With D-type lenses, focus distance is also taken into account to adjust evaluation. Requires AF or AI-P type lenses.

⊙ Center Weighted

75% of meter's sensitivity is concentrated in central 12mm ring in viewfinder.

⊡ Spot

100% of meter's sensitivity is concentrated on a 4mm area in the viewfinder, centered on the currently selected autofocus area.

Spot metering area will always use the center AF sensor if you use a lens with no CPU, or if you are in Dynamic AF Mode and have enabled Closest Subject Priority (see "Setting a Custom Setting," page 247). Note that the F100 comes from the factory with Closest Subject Priority enabled in Single Servo AF (S on the Focus Method selector on the front of the camera).

Setting the Focus Mode

Move the focus mode selector on the front of the camera body to:

S Single Servo AF—Uses focus-priority (shutter cannot be released until focus is achieved).

Viewfinder symbols:

● Focus is locked—you must refocus if subject moves.

▶◀ Focus is tracking—no need to refocus.

C Continuous Servo AF—Uses release priority (shutter can be released even if the subject is not in focus).

Focus is continuously updated unless AF-L button is held down.

Note: Custom setting #9 can set the F100 to focus on the closest object to the camera (Closest Subject Priority) when using the S focusing method. Custom setting #10 can be set to use Closest Subject Priority when using the C focusing method.

M Manual focus, with electronic confirmation.

Viewfinder symbols:

◀ Rotate lens focus ring to left, subject is not in focus.

▶ Rotate lens focus ring to right, subject is not in focus.

● Subject is in focus.

Setting the Focus Area Mode

Move the focus area mode selector on the back of the camera to:

[⊡] Single-Area AF—Only the AF area you select is used regardless of subject movement.

[⣿] Dynamic AF—The camera's focus follows the subject's movement and selects AF focus area based upon where the subject has moved in the frame.

With a Speedlight mounted and turned on, the camera automatically switches to single-area AF **even though the Dynamic AF symbol does not change.** Set the desired focusing point with the focus area selector on the camera back.

Selecting the Active Focus Area

Press the AF area selector (on the back of the camera) in the direction you want to move the active focus sensor.

In single AF mode, this sets the sensor to use for autofocus, while in dynamic AF mode, you are selecting the initial (or primary) sensor, and the camera changes sensors as the subject moves to other areas in the viewfinder.

Only the three horizontal AF sensors are cross-hair types, and only these sensors have additional elements for low-light detection. The top sensor is skewed slightly, but the bottom sensor is horizontal, making it the only one susceptible to horizontal patterns.

Note: If spot metering is selected and Closest Subject Priority is inactive (custom settings #9 and #10), the area metered is the 4mm circle centered on the active AF sensor.

Locking the Focus Area

1. On the back of the camera, use the focus area selector to choose the active focus sensor.

2. Rotate the focus area selector lock just underneath the focus area selector so that the L is revealed.

 To unlock the focus area, rotate the focus area selector lock to display the white dot.

Setting the Exposure Mode

Hold down the Mode button (on the top of camera) while rotating the rear command dial to the desired setting:

ℙ Multi-program (camera chooses both shutter speed and f/stop; requires AF or AI-P lens).

S Shutter-priority (you choose shutter speed, camera chooses f/stop; requires AF or AI-P lens).

A Aperture-priority (you choose aperture, camera chooses shutter speed).

M Manual (you choose both aperture and shutter speed).

Setting the Aperture and Shutter Speed

The camera's meter must be active to change settings. Press the shutter release halfway to activate meter.

1. In aperture-priority (A) and manual (M) exposure modes, the front command dial controls the aperture in 1/3-stop increments.

2. In shutter priority (S) and manual (M) exposure modes, the rear command dial controls the shutter speed in 1/3-stop increments.

3. In program (P) exposure mode, the rear command dial shifts the program.

 When using a lens that has no CPU (those that are not AF or AI-P lenses) that aperture must be set using the lens' aperture ring.

 Note: Custom setting #2 can be used to set 1/3-stop, 1/2-stop, or full-stop increments for apertures and shutter speeds.

Setting Exposure Manually

1. Set the camera to manual (M) exposure mode.

2. Select an aperture using the front command dial and a shutter speed using the rear command dial. The viewfinder shows an exposure indicator: ◀⁞⁞⁞⁞₀⁞⁞⁞▶ The 0 indicates a correct exposure, while each dot in the bar underneath the indicator indicates a third stop under- or overexposure; an arrow indicates under- or overexposure of more than two stops.

Note: To lock a manual exposure, hold down the ⬛ button and rotate both the front and rear command dials until ◾ appears near both the aperture and shutter speed indicators.

Locking the Aperture Setting

1. In aperture priority (A) and manual (M) exposure modes, rotate the front command dial to the desired aperture.

2. Hold down the ⬛ button on the back of the camera and rotate the rear command dial until ◾ appears above the f/stop on the LCD panel and in the viewfinder.

To cancel aperture lock, repeat step 2, but rotate the dial until the Lock indicators disappear.

Note: Aperture lock operates only with lenses that have a CPU (e.g., AF and AI-P lenses).

Locking the Shutter Speed Setting

1. In shutter priority (S) and manual (M) exposure modes, rotate the rear command dial to desired shutter speed.

2. Hold down the ⬛ button on back of and rotate command dial until ◾ appears next to the shutter speed on the LCD panel and in the viewfinder.

To cancel shutter speed lock, repeat step 2, but rotate dial until lock indicators disappear.

Setting Exposure Compensation

Hold down the 🔲 exposure button on top of the camera while rotating the rear command dial to the desired exposure compensation value. Exposure compensation remains set until cancelled.
 Compensation is indicated in 1/3-stops (unless changed using custom setting #2). A + value overexposes, a - value underexposes.

To cancel exposure compensation repeat the above instructions, but set the compensation to 0.0.

Or (for autoexposure modes only),

1. Use center-weighted or spot metering on an appropriate area.
2. Lightly press and hold the shutter release to the halfway position.
3. Lock exposure using the AE-L button on the back of the camera.
4. Re-compose and press the shutter release fully.

Setting Exposure Bracketing

1. Press the **BKT** button on the top of the camera and rotate the rear command dial until the **BKT** indicator appears on the LCD.

2. To set the bracketing value, continue to hold down the **BKT** button and turn the front command dial until the desired combination is indicated on the LCD:

+2F0.3 Two exposures, correct and 1/3 stop overexposed

-2F0.3 Two exposures, correct and 1/3 stop underexposed

+2F0.7 Two exposures, correct and 2/3 stop overexposed

-2F0.7 Two exposures, correct and 2/3 stop underexposed

+2F1.0 Two exposures, correct and full stop overexposed

-2F1.0 Two exposures, correct and full stop underexposed

3F0.3 Three exposures, correct and 1/3 stop on either side

3F0.7 Three exposures, correct and 2/3 stop on either side

3F1.0 Three exposures, correct and full stop on either side

+3F0.3 Three exposures, correct, 1/3 and 2/3 stop overexposed

+3F0.7 Three exposures, correct, 2/3 and 1-1/3 stop overexposed

+3F1.0 Three exposures, correct, 1 and 2 stops overexposed

-3F0.3 Three exposures, correct, 1/3 and 2/3 stop underexposed

-3F0.7 Three exposures, correct, 2/3 and 1 1/3 stop underexposed

-3F1.0 Three exposures, correct, 1 and 2 stops underexposed

To cancel bracketing, repeat step 1, but rotate the rear command dial until the 🔲 indicator disappears.

The aperture is changed to obtain bracketed exposures in shutter priority (S) exposure mode, shutter speed is changed in aperture priority (A) or manual (M) modes, both shutter speed and aperture are changed in program (P) mode. If a Speedlight flash is attached and active, flash output is varied instead.

Exposure compensation modifies the point around which bracketing occurs.

If the end of a roll is reached during a bracket sequence, rewind film, load a new roll, and then press the shutter release again to resume the sequence.

Note: Several custom settings impact bracketing:

1. Custom setting #2 controls the exposure increment by which the bracketing values are separated, with 1/3 stop being the default, and 1/2 and 1 stop being alternate values. When the camera is set via custom setting #2 to compensate in 1/2 or full stops (instead of 1/3 stops), the number of bracketing options is reduced.

2. Custom setting #3 controls bracketing ordering, with a value of 0 (the default) providing +, normal, and - EV shots, and a value of 1 providing -, normal, and + EV shots.

3. Custom setting #11 allows you to set simultaneous exposure and flash bracket (AS, the default setting), exposure-only bracketing (AE), or flash-only bracketing (Sb).

Setting the Self-Timer

1. Press the film advance mode selector release on top of the camera while rotating the film advance mode selector to the ○ symbol.

2. Cover the viewfinder with the supplied eyepiece cover.

3. Press the shutter release.

4. The LED on the camera front blinks until the last two seconds prior to exposure, when it lights continuously.

Self-timer is set to fire after 10 seconds unless you change the duration using custom setting #16.

To cancel, set the film advance mode selector to any position other than ○.

The bulb setting may not be used with the self-timer—the camera automatically sets the shutter speed to approximately 1/10 if you accidentally attempt this.

If the camera body is set for single servo autofocus, the self-timer won't release the shutter until the subject is in focus.

Taking Multiple Exposures

1. Press the film advance mode selector release on top of the camera while rotating the film advance mode selector to the ■ symbol.

2. Set any necessary exposure compensation (typically -1 EV is used for two overlapping exposures).

3. Take your first shot. The film does not advanced and the frame counter does not change. Each additional exposure will be made on the same frame of film until the film advance mode selector is set to any position other than ■.

Note: Custom setting #14 can be set to change the film advance to continuous shooting. In this mode, multiple exposures are made for as long as you hold down the shutter release (as opposed to one each time you press the shutter release).

Using the Bulb Setting

With bulb, the length of the exposure is controlled by how long you hold down the shutter release.

1. Hold down the Mode button and rotate the rear command dial to select manual (M) exposure mode

2. Release the Mode button; rotate the rear command dial again to set the shutter speed to bulb.

3. Set the desired aperture using the front dial (or lens aperture ring for non-AF or AI-P lenses).

4. Press and hold the shutter release for the length of the exposure.

Consider using an MC-20, MC-30 or other remote control release to avoid camera shake and battery depletion.

Note: Long exposures may exhaust the camera's batteries! With alkaline AA batteries, the camera can remain powered for approximately 4 hours maximum at 68 degrees F (20 degrees C).

Previewing Depth of Field

1. Set the aperture.
2. Press the depth of field preview button (on the front of the camera).
3. Allow your eyes to adjust to the lower level of light and then evaluate the approximate depth of field provided by the set aperture.

Note: While DOF preview is active, you cannot adjust the aperture and autofocus is disabled.

Setting Rear-Curtain Sync

1. Set the Speedlight to TTL mode.
2. Make sure the camera is set to program (P) or manual (M) exposure mode.
3. Hold the [⚡] button on top of the camera and rotate the rear command dial until [REAR] appears on the LCD panel.
4. For the SB-24, -25, -26 only: set the Speedlight sync switch to Rear setting.

 To cancel, repeat step 3 until the [REAR] indicator disappears.

Setting Slow-Sync Flash

1. Set the Nikon Speedlight to TTL mode.
2. Make sure the camera is set to program (P) or aperture-priority (A) exposure mode.
3. Hold the [⚡] button on the top of the camera and rotate the rear command dial until [SLOW] appears on the camera's LCD panel.

 To cancel, repeat step 3 until the [SLOW] indicator disappears.

Adjusting the Viewfinder's Diopter Setting

1. Point the camera at a distant scene and either use autofocus or focus the lens manually at infinity.
2. On the shutter release side of the prism, pull the knob labeled +- away from the prism. Look through the viewfinder and rotate the knob until the central area of the viewfinder appears sharpest (towards – side if nearsighted, + side of farsighted).

3. Push the knob back towards camera to lock setting. Be careful not to rotate it when pushing it back in.

Note: It should be possible to see the entire frame in the viewfinder, even with glasses on. If you wear glasses, make sure the diopter setting is at 0 (the + and – symbols on the button are parallel to the plane of the LCD panel).

Illuminating the LCD Panel

Rotate the camera's power switch to the lightbulb symbol and let go. The LCD displays remain lit for as long as the meter is on or until the shutter is released.

Changing the Focusing Screen

1. Remove the lens from the camera body.

2. Use the small tweezers supplied with the screen to pull the focusing screen release latch towards you.

3. Remove the current screen by grasping the small tab on it with the supplied tweezers.

4. Insert the new screen by sliding the front edge upward into the holder until it cliks into place.

Tip: The Type E screen features a grid that helps align horizons, reminds you of the rule of thirds points, and helps you detect converging lines when using extreme wide-angle lenses. It is probably the most useful of the optional screens for general-purpose use.

F100 Custom Settings

Setting a Custom Setting

1. Press and hold the 🔲 button on the back of the camera while rotating the rear command dial until the custom function number you desire is displayed on the back LCD.

2. While *still* holding the 🔲 button, rotate the front command dial until the desired setting is displayed on the LCD panel.

To cancel a custom setting, simply repeat these steps, but select the default option (typically 0) for the function in step 2.

Function	#	Options
Automatic end-of-roll rewind	1	1-0 = disabled (default) 1-1 = enabled*
Bracketing step value	2	2-3 = 1/3 stop increments (default) 2-2 = 1/2 stop increments 2-1 = 1 stop increments
Bracketing order	3	3-0 = correct, under, over (default) 3-1 = under, correct, over
Release activated AF	4	4-0 = enabled (default) 4-1 = disabled *(use AF-On button!)
Non DX-code warning	5	5-0 = after film is advanced to frame 1 (default) 5-1 = when Power switch is moved to On
Focus indicator selection	6	6-0 = stops at outermost sensor (default) 6-1 = sensor selection wraps around (e.g., you can scroll through AF area selection with the arrow key.)
Release activated AE lock	7	7-0 = disabled (default) 7-1 = enabled *(to function like F5)
Film advance when back closed	8	8-0 = disabled (default) 8-1 = enabled*
Closest Subject Priority in Single Servo AF	9	9-0 = enabled (default) 9-1 =disabled*
Closest Subject Priority in Continuous AF	10	10-0 = disabled (default)* 10-1 = enabled
Flash and Exposure bracketing	11	11-AS = Simultaneous flash/exposure (default) 11-AE = Exposure bracketing only* 11-Sb = Flash bracketing only
Switch dial controls	12	12-0 = Disabled (default) 12-1 = enabled

Function	#	Options
Easy exposure compensation	13	13-0 = disabled (default) 13-1 = enabled (exposure compensation can be set without pressing the ⊠ button. In A or M mode, the rear command dial controls exposure compensation; in P or S mode, the front dial controls exposure compensation.
Film advance for multiple exposures	14	14-0 = single frame (default) 14-1 = continuous (multiple) frames#
Meter on length	15	15-4 = 4 seconds* 15-6 = 6 seconds (default) 15-8 = 8 seconds 15-16 = 16 seconds#
Self Timer delay	16	16-2 = 2 seconds 16-5 = 5 seconds 16-10 = 10 seconds 16-20 = 20 seconds
Illumination	17	17-0 = normal (default) 17-1 = activated on any button press
Data imprint	18	18-0 = disabled (default) 18-1 = enabled (yy/mm/dd hh/mm on first frame) Note: requires MF-29 camera back for imprint capability.
Aperture control	19	19-0 = use set aperture value (default) 19-1 = use variable aperture value Setting 19-0 means that you want the camera to maintain the aperture you originally set (if possible), while setting 19-1 means that you'll allow the camera to vary the aperture as you zoom or extend a Micro-Nikkor.

Function	#	Options
LED confirms exposure taken	20	20-0 = disabled except on self-timer (default) 20-1 = enabled always
AE/AF lock button	21	21-0 = simultaneous exposure/AF lock (default) 21-1 = exposure lock only* 21-2 = autofocus lock only 21-3 = autofocus lock only, remains locked after releasing the button 　　　When 21-3 (autofocus only lock) is set, the first press of the AE/AF lock button locks autofocus. A subsequent press unlocks autofocus.
Front dial Apertures	22	22-0 = enabled (default) 22-1 = disabled#

Settings recommended to conserve battery power or for ease of use.

Settings I recommend avoiding unless you understand the consequences on battery usage or camera operation.

Note: You may, of course, disagree with these assessments. They represent how I use the camera and early findings on battery life. If you deviate from these recommendations, at least make sure you understand why you want to deviate from them! Random fiddling with custom settings can put your F100 into bizarre states where the camera will operate differently than you expect, causing you to miss the picture you're trying to take.

F100 Program (P) Mode Settings

Exposure Value	Setting (at ISO 100)
0	f/1.4 at 2 seconds
1	f/1.4 at 1 seconds
2	f/1.4 at 1/2
3	f/1.4 at 1/4
4	f/1.4 at 1/8
6	f/2 at 1/15
8	f/2.8 at 1/30
10	f/4 at 1/60
12	f/5.6 at 1/125
14	f/8 at 1/250

16	f/11 at 1/500
18*	f/16 at 1/1000
20*	f/16 at 1/4000

*exceeds limit of matrix metering capability. With ISO 100 film, the
F100 uses the program setting of 16 1/3 EV for these brighter
subjects. The minimum and maximum EV for the P mode varies
with ISO.*

You have full control over the Program mode, and can easily "shift"
the program settings by rotating the rear command dial until the
desired shutter speed or aperture appears.

If * appears after **P** on the F100's LCD (i.e., **P***), this indicates that
that the basic program has been shifted; the camera maintains this
alteration as long as the meter is on.

Nikkor Lenses That Can't Be Used with the F100

Lens	*Comments*
8mm f/8 Fisheye Nikkor	Special finder can't be mounted
21mm f/4 Nikkor	Special finder (black mount) can't be mounted; later versions compatible
28mm f/4 PC-Nikkor	Serial #'s <1180900 incompatible
35mm f/2.8 PC-Nikkor	Serial #'s <906200 incompatible
35mm f/3.5 PC-Nikkor	Incompatible
80mm f/2.8 Nikkor	Incompatible
180-600mm f/8 ED Nikkor	#'s <174180 incompatible
200mm f/3.5 Nikkor	Incompatible
200-600 f/9.5 Nikkor	#'s <300490 incompatible
360-1200mm f/11 ED Nikkor	#'s <174127 incompatible
1000mm f/6.3 Reflex Nikkor	Not able to modify for AI?
1000mm f/11 Reflex	#'s 142361-14300 incompatible
2000mm f/11 Reflex	#'s <200310 incompatible
TC-16A Teleconverter	Incompatible, may damage body
K2 ring	Incompatible
Non-AI modified lenses	Camera body may be damaged

When AI or AI-S lenses are used on an F100, **F- -** appears instead of
an aperture; apertures cannot be set by the front dial and must be
set on the lens aperture ring. Further, the camera will only work in
the A or M exposure modes.

Exposure compensation may be necessary when using AI or AI-S
teleconverters on the F100. (Nikon hasn't specified values.)

The 400mm f/4.5, 600mm f/5.6, 800mm f/8, and 1200mm f/11
with focusing unit AU-1 are also incompatible.

Nikon N60/F60

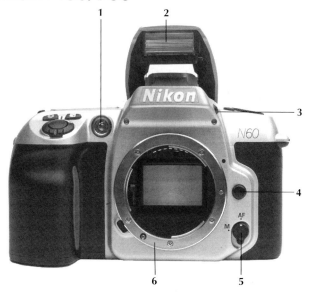

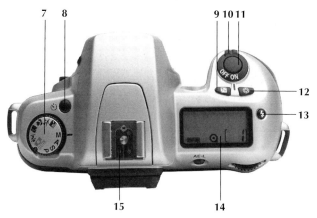

1 AF assist illuminator/
 Red-eye reduction light/
 Self-timer indicator
2 Built-in flash

3 Flash release button
4 Lens release button
5 Focus mode selector
6 Lens mount

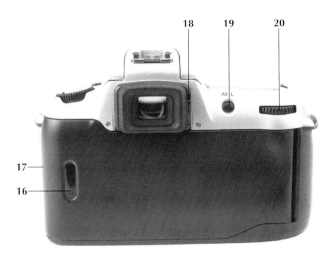

7 Exposure mode dial
8 Self-timer button
9 Exposure compensation button
10 Power switch
11 Shutter release
12 Aperture button
13 Flash sync mode button
14 LCD panel
15 Accessory shoe

16 Film confirmation window
17 Camera back release
18 Diopter adjustment lever
19 AE-L (autoexposure lock)
 button
20 Command dial
21 Battery compartment
22 Mid-roll rewind button
23 Tripod mount

N60/F60 LCD Error Messages

ʜɪ .. Current settings will overexpose shot.

ʟo .. Current settings will underexpose shot.

FEE blinks Lens not set to smallest aperture.

⊂▭ symbol blinks Replace batteries, they are low.

E ... No film is loaded in camera.

E appears and ⊙__ blinks Non-DX-coded film in camera; replace with DX-coded film.

E appears, Err and ⊙__ blink .. Film is loaded incorrectly.

⊙__ blinks Rewound film remains in camera.

Err and ⊙__ blink Battery is too weak to rewind (or temperature is too low to rewind).

F - - blinks Lens has no CPU to support metering (in M exposure mode, F - - appears without blinking).

- - blinks Shutter speed was set to long time exposure in S exposure mode (should be M).

Err and ⚡ blink Flash mode selector on Speedlight is not set to TTL (required for S or P modes).

LCD all black Camera is too hot (but likely still operable).

LCD slow to update Camera is too cold (but likely still operable).

N60/F60 Viewfinder Error Messages

• symbol appears Subject is in focus.

• symbol blinks Autofocus not possible; focus manually.

ʜɪ .. Current settings will overexpose shot.

ʟo .. Current settings will underexpose shot.

FEE blinks Lens is not set to smallest aperture.

F - - blinks Lens has no CPU to support
metering (in M exposure mode,
F - - appears without blinking).

E-- blinks Film not loaded correctly; reload
film.

- - blinks Shutter speed was set to long time
exposure in S exposure mode
(should be M).

⚡ symbol blinks Before shot: flash recommended.
For three seconds after shot: flash
may not have been sufficient to
provide exposure.

E-- and ⚡ blink Flash mode selector on Speedlight
is not set to TTL (required for S or P
modes).

N60/F60 Instructions

Turning the Camera On and Off

1. Move the power switch surrounding the shutter release from the
Off to the On position.

To turn the power off, move the power switch to the Off position.

Note: When the camera is on, pressing the shutter release halfway
turns on the exposure meter, viewfinder illumination, and, when
appropriate, autofocusing.

Resetting the Camera to Its Default Settings

1. Press the ⊡ and Aperture buttons simultaneously for more than
two seconds. The camera reverts to the following settings:

• Flexible program is cancelled
• No exposure compensation.
• Self-timer is cancelled.
• Flash sync is set to normal sync except in Night mode

Loading Film

1. Open the camera back using the camera back release on the side on the camera.
2. Insert a roll of film into the film chamber.
3. Pull the film leader across to the red index mark in take-up area.
5. Remove slack from film, if any, so that it lies flat.
6. Close the camera back; the film automatically advances to the first frame.

Verifying the ISO

The N60/F60 sets the ISO automatically, requiring DX-coded film. It does not allow you to set the ISO manually or override the set ISO.
1. Verify the ISO by pressing the +- and Iris buttons. Do not hold the buttons for more than two seconds, or the camera will be reset to default settings.

> **Tip:** You can fool the camera into exposing to a different ISO value by setting an exposure compensation value. For example, if you load ISO 100 film and want it exposed at ISO 200, set the exposure compensation to -1 stop (e.g., doubling the ISO value is the same as underexposing by one stop; halving the ISO value is the same as overexposing by one stop).

Rewinding Film

Normally, film is rewound automatically when the end of a roll is reached. If you'd like to rewind film prior to the end of a roll:
1. Use a small-tipped tool to press the mid-roll rewind button on the bottom of the camera.

Setting the Film Advance Mode

You cannot set a film advance mode on the N60/F60. The camera's normal film advance mode is single frame mode. You must press the shutter release button for each exposure. However, if set to Sports mode, the N60/F60 will continuouslyadvance the film at about 1 frame per second while the shutter release button is held down.

1. Turn the exposure mode dial on the top of the camera to ⌧.

To cancel, select any other exposure mode—Auto, P, S, A, M, or any of the other vari-program modes other than Sports.

Setting the Metering Method

You cannot set a metering mode on the N60/F60. Generally, the camera uses matrix metering to calculate exposure. The metering mode will change from matrix metering to center-weighted metering when you:

• Press the AE-L button on the back of the camera.

 Or,

• Switch the camera to manual (M) exposure mode.

Setting the Focus Mode

Move the focus mode selector on the camera body (on the front of the camera) to:

 AF Camera body autofocuses the lens.

 M Manual focus, with electronic confirmation.

 Viewfinder symbols:

 • Focus has been achieved. Camera will refocus if subject moves.

 blinking • Autofocus is not possible.

Note: The AF assist illuminator has a range of 1.6 to 9.8 feet (.5 to 3 meters). The AF assist illuminator is automatically activated and cannot be cancelled (but does not function in Landscape or Sport program modes).

Setting the Exposure Mode

Turn the exposure mode dial to the desired exposure mode:

 AUTO General-Purpose Program mode—The camera chooses both shutter speed and aperture; you cannot override settings.

 P Program mode—The camera chooses both shutter speed and aperture; you can override settings using the command dial.

 S Shutter-Priority—You choose a shutter speed using the command dial, the camera chooses the aperture.

 A Aperture-priority—You choose an aperture using the command dial, camera chooses the shutter speed.

 M Manual—You choose both aperture and shutter speed.

257

⊡ Sport program—Camera typically chooses fast shutter speeds (1/250 or higher). Also switches camera into 1 frame per second continuous motor drive; autofocus stays locked on subject until you let go of the shutter release.

☒ Portrait program—Sets a relatively large aperture for shallow depth of field to isolate the subject from the background.

⌒ Landscape program—camera selects both shutter speed and f/stop, typically choosing a small aperture, although often only f/8).

⊡ Close-up program—camera selects a mid-range aperture, typically f/5.6 or f/8, even though the manual says it chooses large apertures.

▄ Night program—camera selects slow shutter speeds for low-light scenes and mid-range aperture for relatively wide depth of field; automatically sets slow-sync flash.

Setting Exposure Manually

1. Set the camera to manual (M) exposure mode.
2. Select a shutter speed using the command dial. Select an aperture by holding the aperture button and turning the command dial. (Do not use the aperture ring on the lens.)

The viewfinder's metering display: î indicates a correct exposure, while each bar underneath the indicator indicates a 1/2 to 1 1/2-stops under- or overexposure; an arrow indicates more than 1 1/2-stops under- or overexposure.

Setting Exposure Compensation

Compensation is indicated in 1/2 EV stops. A + value overexposes, a - value underexposes.

1. Hold down the ⊠ button (on the top of the camera
2. Use the command dial to select the desired compensation value.

Example: Meter white snow and compensate by adding 2 stops of exposure. Without compensation, the meter sets exposure as though every subject were neutral gray. (A white subject is 2 stops brighter than neutral gray, therefore the exposure needs to be adjusted accordingly.)

Note: Exposure compensation only works in P, S, A, and M expo-
sure modes; you cannot override exposure in Auto or any of the
vari-program modes (Sport, Landscape, Night, Close-up, or Portrait).

Setting the Self-Timer

1. Press the ☉ button. You should see the self-timer icon appear on
 the top LCD.
2. Cover the eyepiece to prevent stray light from affecting the
 exposure.
3. Press the shutter release.
4. The AF-assist illuminator on front of camera blinks until last
 second prior to exposure, when it lights continuously.

 To cancel, before pressing the shutter release, repeat step 1. To
 cancel after the shutter release has been pressed, turn the camera
 Off and back On.

Setting a Long Exposure

To take an exposure longer than 30 seconds:

1. Set the camera to manual (M) exposure mode.
2. Rotate the command dial until a shutter speed of -- appears.
3. Set the desired aperture by holding the aperture button down
 and using the turning the command dial.
4. Press the shutter release button to start the exposure. Note that
 the LCD is turned off during exposure to conserve power.
5. Press the shutter release again to stop the exposure.

Note: Long exposures exhaust the camera's batteries! With fresh
batteries, the longest possible exposure is about 15 hours.

Activating the Flash

Hold in the flash release button on the side of the prism and the
flash will pop up and be activated.

Setting Slow-Sync Flash

1. Make sure the camera is set to program (P) or aperture-priority
 (A) exposure mode. (Slow sync is also set automatically in Night
 mode.)

2. Hold down the ⚡ button on the right top of camera and turn the command dial until ⚡slow appears on the LCD panel.

3. If using an external flash, set the Speedlight to TTL mode.

To cancel slow-sync flash, repeat step 2 and set another flash setting.

Setting Red-Eye Reduction

1. Hold down the ⚡ button on the right top of camera and turn the command dial until ⚡👁 appears on the LCD panel.

2. If using an external flash, set the Speedlight to TTL mode.

To cancel red-eye reduction, repeat step 1 and set another flash setting.

Adjusting the Viewfinder's Diopter Setting

1. Move the lever just to the right of the viewfinder eyepiece up for + settings, down for - settings.

Note: The N60/F60 allows settings of -1.5 to +1.0 diopters with the built-in finder; -5.0 to +3.0 diopters with optional eyepiece correction lenses.

N60/F60 Program (P) Mode Settings

Exposure Value	Setting
0	f/1.4 at 2 seconds
1	f/1.4 at 1 second
2	f/1.4 at 1/2
3	f/1.4 at 1/4
4	f/1.4 at 1/8
6	f/2 at 1/15
8	f/2.8 at 1/30
10	f/4 at 1/60
12	f/5.6 at 1/125
14	f/8 at 1/250
16	f/11 at 1/500
18*	f/16 at 1/1000
20*	f/16 at 1/4000

exceeds limit of matrix metering capability

You have full control over the Program mode, and can easily "shift" (alter) the above program by rotating the command dial until the desired shutter speed or aperture appears. If * appears above **P** on the N60/F60's LCD panel, this indicates that the exposure has been shifted from the basic program; the camera maintains this alteration as long as the meter is on.

Built-in Flash Specifications

The guide number for the built-in flash of the N60/F60 is 49 (in feet) 15 (in meters) at ISO 100. The built-in flash unit provides adequate coverage for lenses with a 28mm or longer focal length. The fastest sync speed is 1/125 second.

N60/F60 Aperture and Flash Range

(in feet, at ISO 100)

Aperture	Flash Range
f/1.4	6.6–35 feet
f/2	4.6–25
f/2.8	3.3–17
f/4	2.3–13
f/5.6	2.0–8.9
f/8	2.0–6.2
f/11	2.0–4.3
f/16	2.0–3.0

(in meters, at ISO 100)

Aperture	Flash Range
f/1.4	2–10.6 meters
f/2	1.4–7.5
f/2.8	1–5.3
f/4	.7–3.8
f/5.6	.6–2.7
f/8	.6–1.9
f/11	.6–1.3
f/16	.6–.9

When the ISO value is doubled, read the flash range above the aperture you are using (e.g., with ISO 200 film, use the flash range for f/4 with an aperture of f/5.6); when the ISO is halved, read the flash range below the aperture you are using.

261

Maximum Aperture for Using Flash in Program Mode

With the N60/F60's Built-in Flash

ISO value	Maximum aperture
25	f/2
50	f/2.4
100	f/2.8
200	f/3.3
400	f/4
800	f/4.8

With a Nikon Speedlight

ISO value	Maximum aperture
25	f/2.8
50	f/3.3
100	f/4
200	f/4.8
400	f/5.6
800	f/6.7

At ISO 100, the N60/F60 automatically programs apertures from f/2.8 to the minimum aperture of the lens (typically f/16) when flash is used. There is no benefit in using a lens faster than f/2.8 for flash photography with an N60/F60 in program mode with ISO 100 film.

Note: For red-eye reduction, the AF assist illuminator on the N60/F60 is used instead of the one on the Speedlight.

Nikkor Lenses That Can't Be Used with the N60/F60

Lens	*Comments*
non-AI	N60/F60 requires AI coupling
6mm f/5.6	protrudes into mirror area
10mm f/5.6	protrudes into mirror area
200-600mm f/9.5	serial #s 300490 or smaller incompatible
ED180-600mm f8	serial #s 174166 or smaller incompatible
ED360-1200mm f/11	serial #s 174087 or smaller incompatible
400mm f/4.5	doesn't work with Focusing Unit AU-1
600mm f/5.6	doesn't work with Focusing Unit AU-1
PC 28mm f/4	serial #s 180900 or smaller need modification
PC 35mm f2.8	serial #s 906200 or smaller need modification
Reflex 1000mm f/11	serial #s 142361-143000 need modification
Reflex 2000mm f/11	serial #s 200310 or smaller need modification
AF TC-16A	may damage camera

Medical Nikkor 200mm f/5.6 requires Sync Terminal Adapter AS-15

Note: If you use lenses without CPUs on the N60/F60 (e.g., non-AF and non-P lenses), you must put the camera into manual (M) exposure mode and set the aperture on the lens.

Notes

Useful Equations

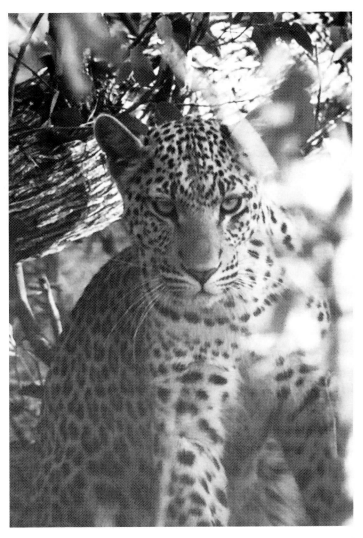

A long lens and a good eye are sometimes necessary to find and photograph the more elusive animals of the Okavango Delta. I was looking right at this leopard and was still not sure that my eyes weren't playing tricks on me.

"Sunny 16" Rule

When taking photographs on a sunny, cloudless day, you can determine exposure settings by using the following rule of thumb:

Use f/16 and 1/ISO Film Speed (for the shutter speed), or any equivalent exposure setting.

If the conditions are cloudy, you can extrapolate an approximate exposure setting from this guideline.

Exposure Value (EV)

EV is a measurement of light intensity. To calculate EV:

EV = log base 2 (f^2/T)

Where: EV = exposure value

f = f/stop (aperture)

T = exposure time (in seconds)

Hyperfocal Distance

Hyperfocal distance is the closest distance at which one should focus so that infinity is also in focus.

$$H = \frac{F \times F}{f \times d}$$

Where: H = hyperfocal distance

F = focal length of lens

f = f/stop (aperture)

d = diameter of the circle of least confusion

Depth of Field

$$DN = \frac{D}{(1 + [D \times f/1000 \times L])}$$

$$DF = \frac{D}{(1 - [D \times f/1000 \times L])}$$

Where: DN = near distance

DF = far distance

D = camera-to-subject distance

f = f/stop (aperture)

L = focal length of the lens in use

Or,

DN = $\dfrac{\textbf{H x S}}{\textbf{H + (S – F)}}$

DF = $\dfrac{\textbf{H x S}}{\textbf{H – (S – F)}}$

Where: H = hyperfocal distance

S = camera-to-subject distance

F = focal length of the lens in use

Determining Correct Focal Length

This formula can be used to determine the focal length to use in order to reproduce an object a particular image size on film.

Focal Length = $\dfrac{\textbf{Image Size x Lens-to-Subject Distance}}{\textbf{Subject Size}}$

Magnification Ratio

The magnification ratio is the ratio between the image distance and the object distance. This ratio is used in close-up or macro photography. It is expressed, for example, as 2:1 (or 2x, twice life-size), or 1:4 (0.25x or 1/4 life-size).

M = $\dfrac{\textbf{Image Distance}}{\textbf{Distance of Object to Optical Center of Lens}}$

Where: M = magnification ratio

Effective Aperture

In macro photography, using a bellows or extension tube on a lens changes the maximum aperture, rendering a new, "effective" aperture. The effective aperture is the one you should use in your exposure calculations. If you use an automatic exposure mode (P, A, or S), the camera will automatically compensate, but if you use extensions that put the camera in manual (M) exposure mode, you must calculate the correct, effective aperture yourself.

f = **a x (1 + m)**

Where: f = effective aperture

a = aperture indicated on lens

m = image magnification

Normal Flash

When shooting with flash, you can calculate the proper aperture to set if you know your flash unit's guide number and the flash-to-subject distance.

f = **GN**
 FD

Where: f = f/stop (aperture)

GN = guide number (in feet or meters)

FD = flash-to-subject distance (in feet or meters)

 Example: If GN = 100 in feet and FD = 25 feet, the aperture should be f/4.

Flash Falloff

Flash falloff tells you by how much a background will be underexposed compared to the foreground when the flash is set correctly to illuminate the foreground subject.

F = **(SD/BD)²**

Where: F = falloff

SD = subject distance

BD = background distance

Bounce Flash

When shooting with bounce flash some light is lost, therefore you need to use a different formula for calculating the correct aperture to use. This formula takes into account the average light loss resulting from the indirect path traveled by the light.

$$f = \frac{0.7 \times GN}{(FCD + CSD)}$$

Where: f = f/stop (aperture)

GN = guide number

FCD = flash-to-ceiling distance

CSD = ceiling-to-subject distance

Example: If GN = 100, flash-to-ceiling distance = 5 feet, and ceiling-to-subject distance = 5 feet, the aperture should be about f/8.

Nikon Contact Information

Nikon Headquarters

Nikon Inc.
1300 Walt Whitman Road
Melville, NY 11747-3064, USA
phone: (516) 547-4200
fax: (516) 547-0299
U.S. Customer Information: (800) NIKON-US ([800] 645-6687)
U.S. Repair Service: (800) NIKON-SV ([800] 645-6678)
U.S. Web Site: www.nikonusa.com

Nikon Corporation
Fuji Building 2-3
Marunouchi 3-chome, Chiyoda-ku
Tokyo 100, Japan
phone: 011 81 3 3214 5311
fax: 011 81 3 3201 5856
International Web Site: www.klt.co.jp/nikon/

Nikon Authorized Repair Facilities (U.S.)

Arizona

Phoenix Camera Repair Inc.
3232 N. 16th St.
Phoenix, AZ 85016
phone: (602) 277-1811
fax: (602) 277-1803

Tucson Camera Repair
742 West Limber Lost
Tucson, AZ 85705
phone: (520) 887-1841
fax: (520) 888-6608

California

Authorized Camera Service
12918 Riverside Dr.
Sherman Oaks, CA 91423
phone: (818) 788-0404
fax: (818) 788-0409

California Precision Service
1714 28th St.
Sacramento, CA 95816
phone: (916) 451-1330
fax: (916) 451-7460

Horizon Electronics
3961 Horner St.
Union City, CA 94587
phone: (510) 489-9091
toll free phone: (800) 233-6169
fax: (510) 489-9019

Metro Camera Service Inc.
30 Mason St.
San Francisco, CA 94102-2113
phone: (415) 421-3551
fax: (415) 421-3558

Pro Camera Service Inc.
2965 E. Hillcrest Dr. #302
Thousand Oaks, CA 91362
phone: (805) 497-7240
fax: (805) 497-0826

Kurt's Camera Repair Inc.
7811 #P Mission Gorge Rd.
San Diego, CA 92120
phone: (619) 286-1810
fax: (619) 286-6093

Nikon Inc.
19601 Hamilton Ave.
Torrance, CA 90502-1309
toll free phone: (800) 645-6678

Colorado

Metro Camera Service Inc.
425 Federal Blvd.
Denver, CO 80204
phone: (303) 934-2471
fax: (303) 935-5854

Rocky Mountain Camera
Repair
240 Broadway
Denver, CO 80203
phone: (303) 744-3459
fax: (303) 722-6259

Florida

Green's Camera Tech
1246 Ridgewood Ave.
Holly Hill, FL 32117
phone: (904) 257-1366
fax: (904) 258-7065

Southern Photo Technical
Service Inc.
3247 Beach Blvd.
Jacksonville, FL 32207
phone: (904) 398-7577
fax: (904) 398-2516

Southern Photo Technical
Service Inc.
14352 Biscayne Blvd.
Miami, FL 33181-1204
phone: (305) 949-4566
fax: (305) 940-2579

Southern Photo Technical
Service of Orlando Inc.
614 Virginia Dr.
Orlando, FL 32803
phone: (407) 896-0322
fax: (407) 897-1455

Southern Photo Technical
Service Inc.
1750 9th Ave. North
St. Petersburg, FL 33713
phone: (813) 896-6141
fax: (813) 894-8097

Georgia

Camera Repair Japan Co.
5555 Oakbrook Pkwy., Suite 400
Norcross, GA 30093
phone: (770) 849-0555
fax: (770) 449-7999

Camera Service Company
4391 Atlanta Rd.
Smyrna, GA 30080
phone: (770) 432-4257
fax: (770) 432-4258

K & M Electronics
2649 Mountain Industrial Blvd.
Tucker, GA 30084
phone: (770) 934-2151
fax: (770) 934-1386

Nikon Inc.
5355 Oakbrook Pkwy.
Norcross, BA 30093
toll free phone: (800) 645-6678

Illinois

Authorized Photo Service
8120 N. Lehigh Ave., Suite 105
Morton Grove, IL 60053
phone: (847) 966-4091
toll free phone: (800) 406-2046
fax: (847) 966-4101

International Camera Corp.
517 S. Jefferson St.
Chicago, IL 60607
phone: (312) 341-6340
fax: (312) 341-6346

Indiana

Focal Point Camera Service
3309 E. State Blvd.
Ft. Wayne, IN 46805
toll free phone: (800) 636-6892
fax: (219) 484-2644

Kansas

Pho-Tech Service Center
110 N. Main St., P.O. Box 638
Hesston, KS 67062
phone: (316) 327-2190
fax: (316) 327-3036

Louisiana

Southern Photo Technical Service Inc.
1101 N. Causeway Blvd.
Metaire, LA 70001
phone: (504) 835-3379
fax: (504) 831-4284

Massachusetts

Precision Camera Repair Inc.
41 Sheridan St.
Chicopee Falls, MA 01020
toll free phone: (800) 665-6515
fax: (413) 594-7298

Sanford Camera Repair
1056 Massachusetts Ave.
Arlington, MA 02174
phone: (617) 648-2505
fax: (617) 648-2508

S. K. Grimes Camera Repair
23 Drydock Ave.
Boston, MA 02210
phone: (617) 951-1480
fax: (617) 951-1466

Michigan

Midwest Camera Inc.
318 Oak St.
Wyandotte, MI 48192
phone: (313) 285-2220
fax: (313) 283-7478

Minnesota

Custom Camera and Electronic
Service Inc.
823 W. Lake St.
Minneapolis, MN 55408
phone: (612) 822-2421
fax: (612) 822-9121

Marquette Camera Repair Inc.
6311 Wayzata Blvd.
Minneapolis, MN 55416
phone: (612) 541-1212
fax: (612) 541-0234

Nevada

Lamb's Camera Inc.
4229 W. Sahara
Las Vegas, NV 89102
phone: (702) 876-0966
fax: (702) 876-9599

New Hampshire

Apex Photo-Technical Services
13 Columbia Dr. Unit 16A
Amherst, NH 03031
phone: (603) 881-5500
toll free phone: (800) 845-5553
fax: (603) 881-7701
toll free fax: (888) 881-7701

New Mexico

AP-T Camera Repair
(Albuquerque Photo-Technologies)
2500 Garfield Ave. S.E.
Albuquerque, NM 87106
phone: (505) 256-0006
toll free phone: (800) 962-4749
fax: (505) 265-5929

New York

Hudson Valley Camera Repair Inc.
233 W. Route 59
Nanuet, NY 10954
phone: (914) 623-8057
fax: (914) 623-8124

Nikon USA
1300 Walt Whitman Rd.
Melville, NY 11747-3064
toll free phone: (800) 645-6678

Photo-Tech Repair Service Inc.
110 E. 13th St.
New York, NY 10003
phone: (212) 673-8400
fax: (212) 673-8451

Professional Camera Repair
Service, Inc.
37 W. 47th St.
New York, NY 10036
phone: (212) 382-0550
fax: (212) 382-2537

North Carolina

Southern Photo Technical
Service Inc.
2610 South Blvd.
Charlotte, NC 28209
phone: (704) 523-0012
fax: (704) 523-7787

Ohio

Camtronics Camera & Video Repair
4547 N. High St.
Columbus, OH 43214
phone: (614) 262-2784
fax: (614) 262-6527

Oklahoma

Photo Products Repair Inc.
3109 Classen Blvd.
Oklahoma City, OK 73118
phone: (405) 521-8022
fax: (405) 528-7156

Oregon

Associated Camera Repair Inc.
3401 N.E. Sandy Blvd.
Portland, OR 97232
phone: (503) 232-5625
fax: (503) 236-2421

Sharper Video
2645 S.E. 50th Ave.
Portland, OR 97206
phone: (503) 233-5971
fax: (503) 239-8455

Pennsylvania

Comet Camera Repair Shop
460 N. 9th St.
Philadelphia, PA 19123
phone: (215) 765-6431
fax: (215) 235-5212

Texas

Alma Engineering
723 W. Mt. Houston
Houston, TX 77038
phone: (281) 999-4443
fax: (281) 999-4449

Archinal Camera Repair
203 W. Main St.
Richardson, TX 75081
phone: (972) 644-7555
fax: (972) 644-7766

Camera Services Inc.
3407 S. Shepherd
Houston, TX 77098-3398
phone: (713) 528-6652
fax: (713) 520-7757

Havel Camera Service Inc.
1102 Basse Rd.
San Antonio, TX 78212-1095
phone: (210) 735-7412
fax: (210) 734-2715

Utah

Forster's Camera Service Inc.
40 West 2950 South
Salt Lake City, UT 84115
phone: (801) 487-1288
fax: (801) 487-1350

Virginia

Strauss Photo-Tech Service
434 W. 21st St.
Norfolk, VA 23517
phone: (757) 625-5341
fax: (757) 627-8029

Washington (State)

Photo-Tronics Inc.
513 Dexter Ave. North
Seattle, WA 98109
phone: (206) 682-2646
fax: (206) 622-8283

Washington, D.C.

Strauss Photo-Tech Services Inc.
1240 Mt. Olivet Rd. NE
Washington, DC 20002
phone: (202) 529-3200
fax: (202) 526-6465

Wisconsin

BDC Enterprises Inc.
313 W. Johnson St.
Madison, WI 53703
phone: (608) 257-6315
fax: (608) 257-0939

Wyoming

Photo-Electronics
145 S. Washington St.
Casper, WY 82601
phone: (307) 234-8282
fax: (307) 266-9156

Note: This list is current as of the date of publication and is subject to change.

Nikon Service Facilities (Worldwide)

Argentina Eduardo Udenio y Cia S.A.C.I.F.I.
 P. O. Box 410 Ayacucho 1235
 Buenos Aires
 +54-1-425538

Australia Maxwell Optical Industries Pty. Ltd.
 Unit 4, Northbank Industrial Park
 20-36 Nancarrow Ave.
 Meadowbank, N.S.W. 2114
 +61-2-390 0200

Austria Prihoda & Beck GmbH
 Schottenfedgasse 14
 A-1072 Wien
 +43-1-523 1521

Belgium H. DeBeukelaer & Co.
 Peter Benoitstraat 7-9
 B-2018 Antwerpen
 +32-3-216 0060

Brazil T. Tanaka & Cia. Ltda.
 Rua Martim Francisco
 438 (Sta. Cecilia) São Paulo
 +55-11-825 2255

Canada Nikon Canada Inc.
 1366 Aerowood Drive
 Mississauga, Ontario L4W 1C1
 +1-905-625 9910

Canary Islands Maya S.A.
 Candelaria 31
 P. O Box757
 38003 Santa Cruz de Tenerife
 +34-22-245096

Chile Reifschneider Foto S.A.C.I.
 Jose Manuel Infante 1639
 Casilla 4216 Santiago
 +56-2-204 9030

Cyprus K.H. Papasian Ltd.
 240 Ledra Street
 Nicosia P. O. Box 1607
 +357-2-463795

Czech Republic Nikon s.r.o.
 Stepánská 45/640
 111 21 Praha 1
 P. O. Box 431
 +42-2-242 27590

Denmark Dansk Fotoagentur A/S
 Produktionsvej 23B
 DK 2600 Glostrup
 +45-42-847022

Finland Nikon Svenska AB
 Ojahaanrinne 4
 01600 Vantaa
 +358-0-566 0060

France Nikon France S.A.
 191 rue de Marché Rollay
 94504 Champigny-sur-Marne Cedex
 +33-1-4516 4516

Germany Nikon GmbH
 Tiefenbroicher Weg 25
 40472 Düsseldorf
 +49-211-94140

Greece D. & J. Damkalidis S.A.
 44 Zefyrou St.
 175 64 Paleo Faliro
 Athens
 +30-1-941 0888

Hong Kong Shriro (H.K.) Ltd.
 2nd Floor, Hutchison House
 10 Harcourt Road (G.P.O. Box 181)
 +852-2-524-5031

Hungary Nikon Kft
 H-1134 Budapest
 Devai u. 26-28. l. em.
 +36-1-270 5525

India Mazda Camera Centre
 306, Veena Killedar Bldg.
 Pais Street
 K. Khadye Marg, Jacob Circle
 Bombay 400 011
 +91-22-3079284

 Photo Vision
 223, Okhla Industrial Estate
 New Delhi 110020
 +91-11-6831936

Israel Hadar Photo Supply Agencies Ltd.
 36-38 Achad Haam Street
 Tel Aviv 65817
 +972 3 560 3947

Italy Nital S.p.A.
 Via Tabacchi 33
 10132 Torino
 +39-11-310 2151

Kuwait Ashraf & Co., Ltd.
 P. O. Box 3555
 Safat P. Code 13036-Safat
 +965-5312960, 5312961, 5312962

Malaysia Shriro (Malaysia) Sdn. Bhd.
 Lots 22 & 24, Jalan 225, Section 51A
 46100 Petaling Jaya, Selangor
 P. O. Box 10571
 50718 Kuala Lumpur
 +60-3-774 9842

Mexico Mayoristas Fotograficos, S.A.
 Dr. Jimenez 159
 Mexico 7, D.F.
 +52-5-588 7011

Netherlands Inca B.V.
 Rutherfordstraat 7
 2014 Ka Haarlem
 +31-23-249 181

New Caledonia Phocidis
 B.P. 2359
 Noumea
 +687-28-6670

New Zealand T. A. Macalister Ltd.
 Private Bag 92146
 65-73 Parnell Rise
 Auckland
 +64-9-303 4334

Norway Interfoto A.S.
 O. H. Bangs Vei 51
 1322 Hovik
 +47-67-534 990

Poland Camera Sp. Z.O.O.
 00514 Warszawa
 uL. Marszaikowska B4/92
 +48-22-291180

Portugal Sifoto-Soc. Import. de Fotografia, S.A.
 Praca Afonso do Paco, 11-A
 1300 Lisboa
 +351-1-690 342, 388 6584, 659820

Réunion Dimaciphot S.A.
 5-7, rue Amiral Lacaze
 B.P. 288
 97467 Saint-Denis Cedex
 +262-21-78-51

Saudi Arabia Ahmed Abdulwahed
 Abdullah Trading Establishment
 P. O. Box 3611
 Jeddah (Postal Address)
 Hail Commercial Centre
 3rd Floor, Hail Road, beside Caravan Centre
 Jeddah
 +966-2-6425333, 6425777

Singapore Shriro (Singapore) Pte. Ltd.
 11 Chang Charn Road
 0600 Shriro House
 Singapore 0315
 +65-472-7777

Spain Finicon S.A.
 Calle Laforja, 95, Pral., 3
 08021 Barcelona
 +34-3-200 1521, or 200 1132

 Calle Reina Marcedes, 7
 Madrid-20
 +34-1-553 9392

Sweden Nikon Svenska AB
 Anton Tamms Väg 3, Box 84
 194 22 Upplands-Väsby
 +46-8-5941 0900

Switzerland Nikon AG
 Kaspar-Fenner-Strasse 6
 8700 Küsnacht/ZH
 +41-1-913 6111

Taiwan Yang Tai Trading Corp. Ltd.
 6F, 90 Huai-Ning Street
 Taipei 10037
 +886-2-311 7975, 371 2128, 331 3480

Thailand Niks (Thailand) Co., Ltd.
 166 Silom Road 12
 Bangkok 10500
 +66-2-235 2929

United Arab Grand Stores
Emirates Zayed the 1st Street
 P. O. Box 425
 Abu Dhabi
 +971-2-312 100

United Kingdom Nikon U.K. Ltd.
& Ireland 380 Richmond Road
 Kingston upon Thames
 Surrey KT2 5PR
 +44-181-5414440

Uruguay Micro S.C.
 Avda. 18 de Julio 1202
 Montevideo
 +598-2-915516, 982639

Note: This list is current as of the date of publication and is subject to change.

Checklists and Forms

Field Equipment List

Bodies

__ FM2n
__ N6006/F-601
__ N8008s/F-801s
__ N70/F70
__ N90s/F90X
__ other _____

__ F3
__ F4
__ F5
__ Polaroid
__ Data Back

Flash Units

__ SB-20
__ SB-21
__ SB-22
__ SB-23
__ SB-24
__ SB-25

__ SB-26
__ SB-27
__ SB-28
__ SC-17 off-camera cable
__ flash bracket
__other _____

Lenses

__ 16mm
__ 18mm
__ 20mm
__ 24mm
__ 28mm
__ 35mm
__ 50mm/60mm
__ 85mm
__ 100mm
__ 135mm
__ 180mm
__ 200mm
__ 300mm
__ 400mm
__ 500mm
__ other_____
__ other_____

__ 600mm
__ 20-35mm
__ 24-50mm
__ 24-120mm
__ 28-70mm
__ 28-85mm
__ 35-70mm
__ 35-80mm
__ 35-105mm
__ 35-200mm
__ 70-210mm
__ 75-300mm
__ 80-200mm
__ 50-300mm
__ 180-600mm
__ other_____
__ other_____

Lens Accessories

__ bellows __ 1.4x teleconverter
__ close-up lens __ 2x teleconverter
__ reversing ring __ extension rings

Filters

__ fluorescent	__52mm	__62mm	__77mm	__other
__ graduated	__52mm	__62mm	__77mm	__other
__ polarizer	__52mm	__62mm	__77mm	__other
__ skylight	__52mm	__62mm	__77mm	__other
__ UV	__52mm	__62mm	__77mm	__other
__ warming	__52mm	__62mm	__77mm	__other
__ 80A	__52mm	__62mm	__77mm	__other
__ 85C	__52mm	__62mm	__77mm	__other
_____ other	__52mm	__62mm	__77mm	__other
_____ other	__52mm	__62mm	__77mm	__other
_____ other	__52mm	__62mm	__77mm	__other
_____ other	__52mm	__62mm	__77mm	__other
_____ other	__52mm	__62mm	__77mm	__other

Film

__ rolls of _____
__ rolls of _____
__ rolls of _____
__ rolls of _____
__ numbered stickers to apply to identify exposed rolls

Accessories

__ batteries __ lens cloth
__ battery tester __ motor drive
__ beanbags __ mounting plates
__ bubble level __ remote release
__ cable release __ tripod
__ car or window mount __ ballhead
__ hand-held meter __ leg wraps
__ lens brush __ monopod
__ lens-cleaning fluid __ tripod case
__ lens-cleaning tissue __ other_____
__ other _____ __ other_____
__ other _____ __ other_____

Miscellaneous

__ black cloth (to reduce reflections)
__ bristle (lens) brush
__ business cards
__ cotton swabs
__ dark bag
__ compass
__ dulling spray
__ film leader retriever
__ flashlight
__ glue (rubber cement)
__ hand wipes
__ large garbage bags
__ large self-sealing plastic bags
__ magnifying glass
__ other _____
__ other _____
__ other _____
__ other _____

__ maps
__ masking tape, gaffer tape
__ model releases
__ notepad
__ pen and pencil
__ poncho
__ serial number/customs list
__ set of small screwdrivers
__ small tool set
__ spray bottle (for misting)
__ Swiss Army knife
__ towel
__ umbrella
__ watch
__ other_____
__ other_____
__ other_____
__ other_____

Equipment ID Numbers

Item	Model	Serial Number	Other Information
e.g.:			
Nikon body	FM2n	N 7780041	Scratch on base

Make sure that you store an equipment list separate from your equipment when you're traveling internationally. This will help you report theft and give you the best shot at recovering your equipment if the culprit is caught.

Model Release

For valuable consideration, I hereby authorize and consent to the use and reproduction by _____, or anyone authorized agent(s) or assignee of any and all photographs which you have this day taken of me or my property, for any purpose whatsoever, without further compensation to me. All film, together with any prints, shall constitute your property, solely and completely.

_____ _____

Signature of model Date

Name (please print)

Address

_____ _____

City/State/ZIP/Country Phone

_____ _____

Signature of parent or guardian of minor Witness

_____ _____

Name (please print) Name (please print)

Acknowledgements

My writing has been considerably enhanced by 15 years of eagle-eye editing by the likes of Eva Langfeldt and Cheryl England. Likewise, my photographic skills have benefited from being able to observe and work with several great professionals in the field: Johnathan Katz, Galen Rowell, Barbara Cushman Rowell, and John Senser. I also wish to thank Steven Keirstead, Rich Troy, and the faithful readers of *The Nikon Digest*. I thank all of these helpful photographers for the insights and information they've passed on to me, and I hope I've done their ideas justice in this book.

Finally, thanks are also due to Gray Levett and Tony Munday of Grays of Westminster, Exclusively...Nikon, London, for sharing their technical expertise.

About the Author

Currently executive editor of *BACKPACKER* magazine, Thom Hogan tried careers in music, filmmaking, and television before succumbing to the seduction of the personal computer industry. Thom's most recent accomplishments include managing the development of one the first digital cameras (QuickCam) and the digital photo editing package, Connectix PhotoMate. When he's not sitting behind a computer, you'll find Thom out hiking and photographing the world. This is Thom's tenth book, his first on photography.